TE

Richmond upon Thames Libraries

Renew online at www.richmond.gov.uk/libraries

LONDON BOROUGH OF
RICHMOND UPON THAMES

The First
500 Million Years

increased the average global temperature by 1°C within 150 years. Climate change at such a rate is unprecedented.

It is impossible to claim any particular extreme weather event was caused by human-driven climate change, we are able to say with increasing confidence that recent record-breaking heatwaves, droughts, fires and floods have been made worse by our interference in the Earth's climate.

In the final section we peer into our possible future. If the burning of coal, oil and gas is rapidly halted, the conditions at the end of this century will be stabilized, and warming will be limited to around 2°C. Adapting to this very rapid warming will challenge societies across the world, but with further efforts, temperatures could be reduced as we enter the next century.

However, if we continue to burn fossil fuels, the world may warm beyond 4°C by the end of this century. This would be a profoundly different climate to the one that has nurtured successive human civilizations for the past 11,000 years. Large areas in the tropics would become uninhabitable, with some regions experiencing lethal levels of heat and humidity; coral reefs would vanish, along with huge swathes of tropical rainforests; and lush farmlands would be reduced to desert. It seems unimaginable that humans could produce such devastating impacts on our home planet, but the sheer scale and power of our civilization means we are now capable of transforming Earth into a world of fires, storms and floods.

James Dyke

exploring just how extreme ancient climate change could be. Perhaps the most well-known event is the plunging temperatures and darkened skies that followed a massive asteroid impact and led to the extinction of the dinosaurs. But the effects that life has had on the climate have been even more profound. The evolution of photosynthesis, for example, reshaped the entire biosphere and allowed the emergence of complex vertebrate organisms, including humans. Since then, the fortunes of human civilization have been tightly entwined with the changing climate, and climatic forces that gave birth to great civilizations have also brutally ended them.

The second part of this book tells the story of today's changing climate, and how it has developed over the past two centuries. In many ways, the rapid process of industrialization has made us much more resilient to our turbulent world, but we now know that industrialization also comes with a cost to the climate. Our collective emissions of greenhouse gases has

While Earth is an oasis in which life can thrive, it still experiences extremes in local conditions. During winter, the wind chill in Antarctica would freeze a glass of water solid in seconds. Meanwhile, the surface temperature in Death Valley, USA, can approach an egg-frying 94°C. These vastly contrasting temperatures are accompanied by huge differences in rainfall across the globe. Some regions of the Atacama Desert of South America have never recorded rainfall, while Mawsynram in the Meghalaya State in India receives more than 35 feet of rain each year – enough to leave Rio de Janeiro's Christ the Redeemer statue knee-deep in water. But across the entire planet, differences in local weather can be averaged to produce a planetary climate description. When we do that, we discover that Earth is a moist world with an average temperature of 14°C.

Earth has not always been supportive of life, though. There have been periods when it was more like today's Venus or Mars. When Earth was born it was a hellish place, its surface a roiling mass of lava and its atmosphere a lethal cocktail of hot gases. Then, hundreds of millions of years ago it was plunged into a cooling spiral that produced vast ice sheets that almost covered the entire globe. Tens of millions of years ago it experienced rapid periods of warming in which global temperatures transformed the oceans and land surface. These events, and other past climate change episodes, have at times produced mass extinctions in which most of Earth's species perished.

It is only very recently that we have discovered that humans have also been affecting the climate. If we compressed the entire 4.6 billion-year history of Earth into a single year, we would see the first life appear in late February and all of human history happen within the last 82 seconds of 31 December. The Industrial Revolution would last for less than one hundredth of a second, and our scientific understanding of greenhouse gases and possible future climate impacts would be less than one thousandth of a second old.

This book tells the remarkable history of climate change on our home planet in three parts, starting with the formation of Earth's atmosphere and

Introduction

Earth, our home in the cosmos, is an extraordinarily complex system. Large oceans, an oxygen-rich atmosphere and abundant life produce a diverse and continually changing surface. Seen from space, Earth's atmosphere is a thin film that blankets the planet; if Earth were the size of a football, the thickness of its atmosphere would be less than that of a postage stamp. Yet it is within this narrow band that all life on Earth thrives – beyond its boundaries lies the inhospitable vacuum of space.

Comparing Earth to its nearest neighbours in the Solar System highlights how special our home planet is. Mars is an airless frozen world. It is possible that life once flourished there, but it would have perished billions of years ago when it lost its oceans and atmosphere. Venus is a hothouse planet. It is hard to imagine how life could survive the extreme temperatures and crushing pressure on the Venusian surface. Earth, however, is in the 'Goldilocks' zone, enjoying a position that is neither too far from the Sun, nor too close.

Contents

First published in 2021 by Head of Zeus Ltd
by arrangement with UniPress Books Ltd

Copyright © UniPress Books Ltd, 2021

Commissioning Editor: Kate Shanahan
Project Manager: Chris Gatcum
Design & Art Direction: Sean Keogh
Picture Research: Alison Stevens

Back jacket image:
Craig Warga/NY Daily News Archive via Getty Images

Author's note: Earth's climate and our understanding of it continues to rapidly
change. Consequently some of the research used in this book will become dated
before its publication, while some of the weather records discussed are
sure to be broken in the near future. The author recommends
reviewing the latest findings from the Intergovernmental
Panel on Climate Change to keep informed.

9 7 5 3 1 2 4 6 8

A CIP catalogue record for this book is available
from the British Library.

ISBN (HB): 978-180024-249-4
ISBN (E): 978-180024-298-2

Printed in China

Head of Zeus Ltd
5–8 Hardwick Street
London EC1R 4RG
www.headofzeus.com

Fire, Storm & Flood

The Violence of Climate Change

James Dyke

HEAD
of ZEUS

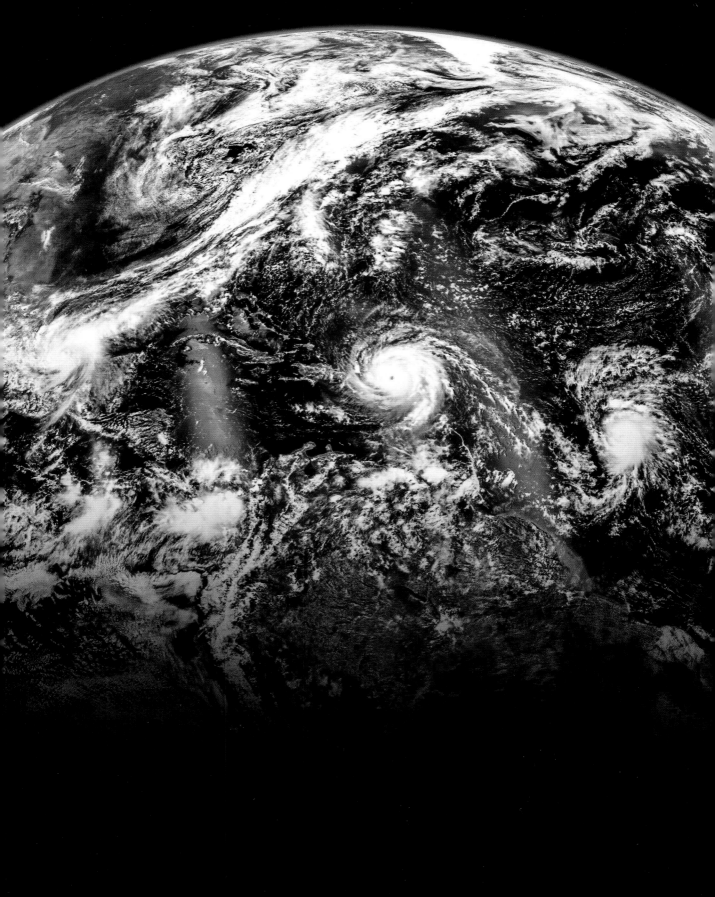

Fire,
Storm
&
Flood

Billions of years ago, life emerged on this ancient planet. Since then, Earth's climate has been intimately involved in biological evolution. Periods of past climate change have profoundly shaped the biosphere, while life has also changed the climate. This complex dance between life and climate continues to this day.

>>>

Five Extinction Events

We will probably never know how life started. Maybe it began in a shallow sunlit pool, or perhaps in the crushing depths of the oceans. Whatever its origin, the oldest evidence we have for life is tiny fragments of what could be the first photosynthetic organisms, which were found in rocks from Greenland that were formed 3.7 billion years ago. If we imagine evolution progressing over time like the growth of a tree, then the initial seed of life produced a shoot that split to form branches, which divided further over time. In this way, all of the organisms that are alive today, and all of the fossilized remains that we discover in rocks, are related; there is a single, unbroken chain that connects all life back billions of years. If all life had become extinct at some point in the past we would not be here today to marvel at it. However, the fact we are here does not mean life has had an easy ride on planet Earth. In fact, there have been numerous events that have meant life has faced calamitous conditions, and in some instances, near annihilation.

Species becoming extinct is as natural a process as new species forming. If the rate of extinction is the same as the rate of evolution, the total number of species on Earth would remain the same, but this is not what we see in the fossil record. Over geological time – millions and tens of millions of years – we see gradual increases in the total number of species, so the biosphere becomes more diverse. But on five occasions during Earth's history this trend has been interrupted suddenly. These are mass extinction events that saw unimaginable violence unleashed on the biosphere, with millions of species and trillions of individual organisms perishing as a result.

The most widely known mass extinction is the K-T event, which covers the period, some 66 million years ago, when a massive asteroid crashed into what is now Mexico's Yucatan Peninsula. This produced a vast cloud of dust that dimmed the Sun's energy for several years. Plunging temperatures and a vast die-off of vegetation produced a mass extinction in which almost no land animals heavier than 55lbs survived.

The most famous victims of this event were the flightless dinosaurs, and this gave the mammal species of the time – small, rat-like animals – the opportunity

4.6Gya (billion years ago)
Around 4.6 billion years ago, and over the course of tens of millions of years, countless collisions of dust, gas and rock produce the early Earth and planets in the Solar System.

4.4Gya
Vast amounts of water delivered to Earth from meteorites. Along with the release of water from within the crust the first ocean of liquid water forms.

3.7Gya
Evidence of first life. Tiny fragments of carbon deposits have been proposed as showing a primitive form of photosynthesis.

2.6Gya
Cyanobacteria start to use carbon dioxide in the process of photosynthesis. Oxygen is produced as a waste gas.

4.5Gya
The moon is created as Earth collides with the proto-planetary object Theia. This event would have melted Earth's crust.

4.1–3.8Gya
Late Heavy Bombardment period. Earth sustains repeated impacts from asteroids and other material, which would have likely sterilized any life.

3.7Gya
Earth's atmosphere consisted largely of nitrogen and carbon dioxide.

2.5–1.8Gya
As photosynthetic life becomes more abundant, oxygen begins to build up in the atmosphere and upper parts of the oceans.

to move into the ecological gaps the dinosaurs had left. These mammals quickly diversified and have now become the dominant group of large land animals, which includes humans.

As important as the K-T event was for our eventual evolution, an even more violent event occurred around 250 million years ago. During a period of rapid climate change, temperatures soared and ocean oxygen levels collapsed, leading to the extinction of more than 90 per cent of all marine species. It took life on Earth tens of millions of years to recover and as a species we may be extremely fortunate to be here – a slightly more intense period of climate change could have led to the complete extinction of life in the oceans, vastly altering the trajectory of life on Earth.

Climate change is a common factor in these mass extinction events. Whether driven by massive volcanic eruptions, asteroid impacts, or some other process, large and sudden changes in Earth's climate have wrought havoc on the planet's life. A period of rapid global warming 55 million years ago saw global temperatures rise by 5°C. What caused this sudden

increase in temperature was likely an intense series of volcanic eruptions that released huge amounts of carbon dioxide into Earth's atmosphere. This rapid increase of the greenhouse effect led to a sudden spike in global temperatures. The impact this had on deep-sea life was devastating, with even more species becoming extinct than during the K-T event. On land, life either had to adapt rapidly to sudden temperature and precipitation changes, or perish.

This period of Earth's history can teach us important lessons, as it echoes the impacts that human-driven climate change are having today. If we do not change course, then we may warm Earth's climate beyond 5°C within a century. Earth's distant past presents us with clear warnings about how disruptive and dangerous such climate change would be.

0.8Gya
Great Oxidation event produces a series of pulses of oxygen into the atmosphere, leading to today's concentrations of 21 per cent.

540Mya
Cambrian explosion. Life forms rapidly become more complex. Within 20 million years all major phyla of animals evolve.

425Mya
Rapid colonization of the land by plants reduces atmospheric concentrations of carbon dioxide.

230Mya
Evolution of the first large land reptiles – the dinosaurs.

650Mya (million years ago)
Cryogenian Snowball Earth. Ice sheets encompass almost the entire globe, restricting life to small refuges in warmer ocean areas.

450Mya
First mass extinction event recorded in fossil record. Probably driven by a period of dramatic global cooling.

252Mya
The Great Dying. The greatest mass extinction event in the history of life on Earth. Rapid global warming leads to the extinction of more than 90 per cent of marine species.

65Mya
Massive asteroid impact off Yucatan Peninsula, Mexico, ends the 200-million-year reign of the dinosaurs.

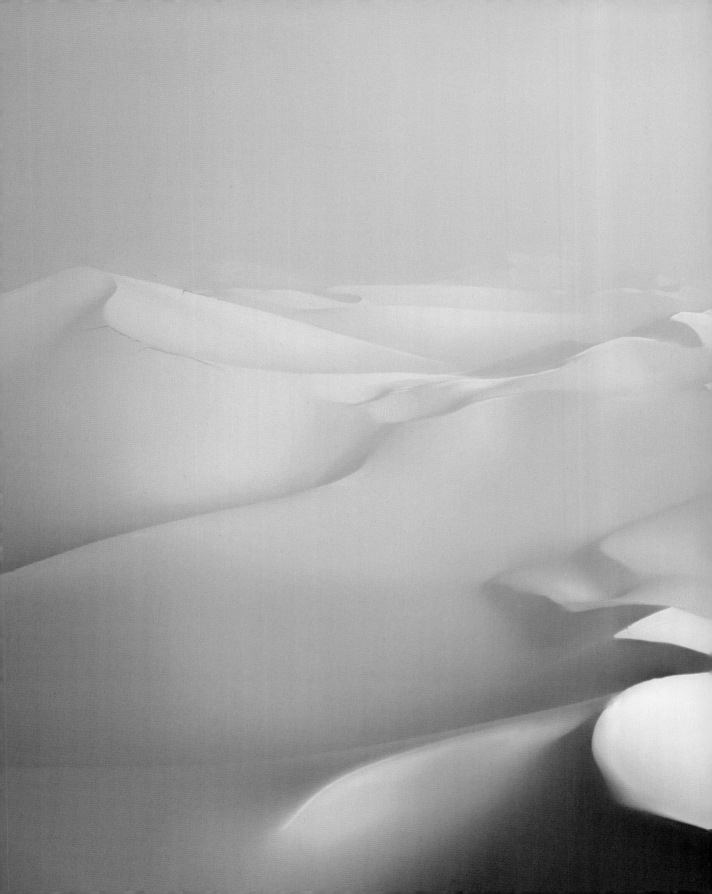

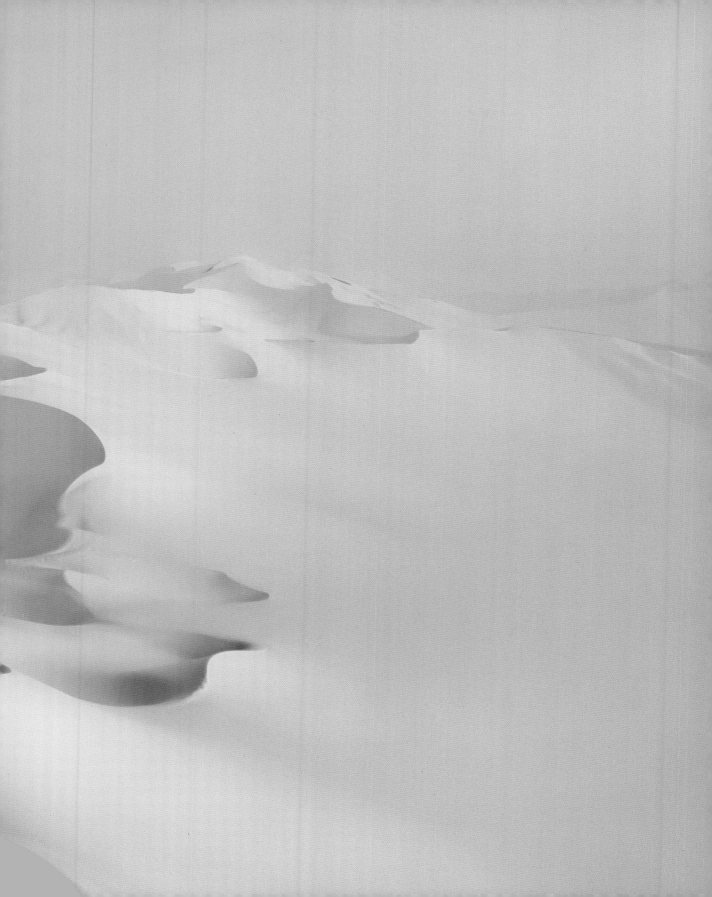

‹‹ Snowball Earth

Lying in the rain shadow of the Himalayas, the Kumtag desert in north-west China is a land of environmental extremes. Temperatures regularly reach 40°C during the summer, but can plunge to –20°C in the winter, when rare precipitation during cold spells produces a surreal landscape of vast sand dunes powdered with snow.

However, while this might be unusual today, such scenes would have been quite normal during the onset of a global climate phenomenon known as Snowball Earth. Due to runaway climate cooling, Earth has experienced a number of episodes of intense cold, at which point vast ice sheets extended into the tropics, covering almost the entire planet. There is good evidence to suggest this has happened up to five times over the past 3 billion years, with Snowball Earth events lasting anywhere from a few million years to tens of millions of years. During the most intense Snowball Earths, very few areas of open ocean would have existed; only waters warmed by undersea volcanoes would have remained relatively clement.

It is possible that this dramatic climate change has had profound evolutionary consequences. The last Snowball Earth event, which occurred 600 million years ago, would have concentrated any surviving organisms in warmer-water refuges. There, intense competition for resources and increases in predation produced an evolutionary 'arms race', in which species evolved ever-more elaborate ways to either capture prey or evade predators. This period of intense evolution has been dubbed the Cambrian explosion, with rocks from the time showing an extraordinary proliferation of different fossils. It is possible that the complex forms of life that we see today – ourselves included – may have emerged as a result of this type of dramatic climate change in Earth's distant past.

Stromatolites

They may look like small rocks littering the shoreline of Shark Bay in Western Australia, but these stromatolites are organic structures comprising countless layers of photosynthetic bacteria. The outermost living cells grow on a mix of sediment and the remains of dead bacteria, and over time form rock-like mounds that can measure up to three feet wide. Today, stromatolites are found mostly in inhospitable waters that have very high salt concentrations, and may be providing us with a glimpse of what the earliest life on our planet looked like, more than 3 billion years ago.

Soon after it emerged on Earth, life started to capture energy from the Sun through photosynthesis. This chemical reaction is an exquisitely crafted dance that is led by high-energy photons from the Sun. These are used by chloroplasts to drive a series of reactions that produce sugars. The very first forms of photosynthesis used water and elements such as sulphur to complete the process, but while water was abundant, the relative scarcity of sulphur meant that photosynthesis was limited. However, concentrations of carbon dioxide were more than ten times higher than they are today, and over a period of some 800 million years, early life evolved the capability to use this more common gas for photosynthesis. No longer dependent on scarce elements, life on Earth flourished. As it did, the oxygen produced as a by-product of photosynthesis transformed the biosphere, with a series of 'pulses' increasing the concentration of oxygen in the atmosphere from under 1 per cent to today's level of 21 per cent.

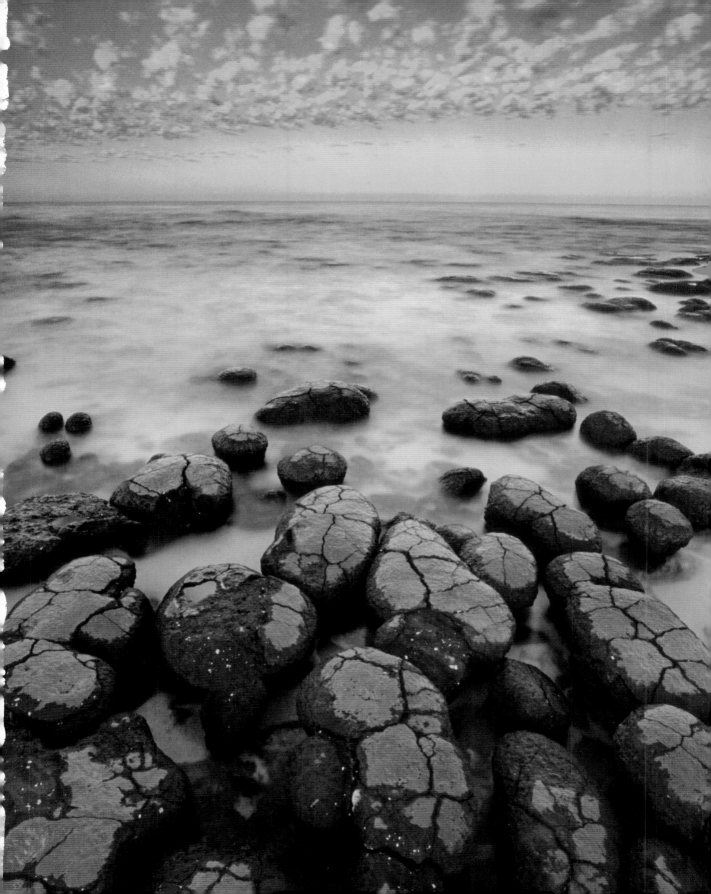

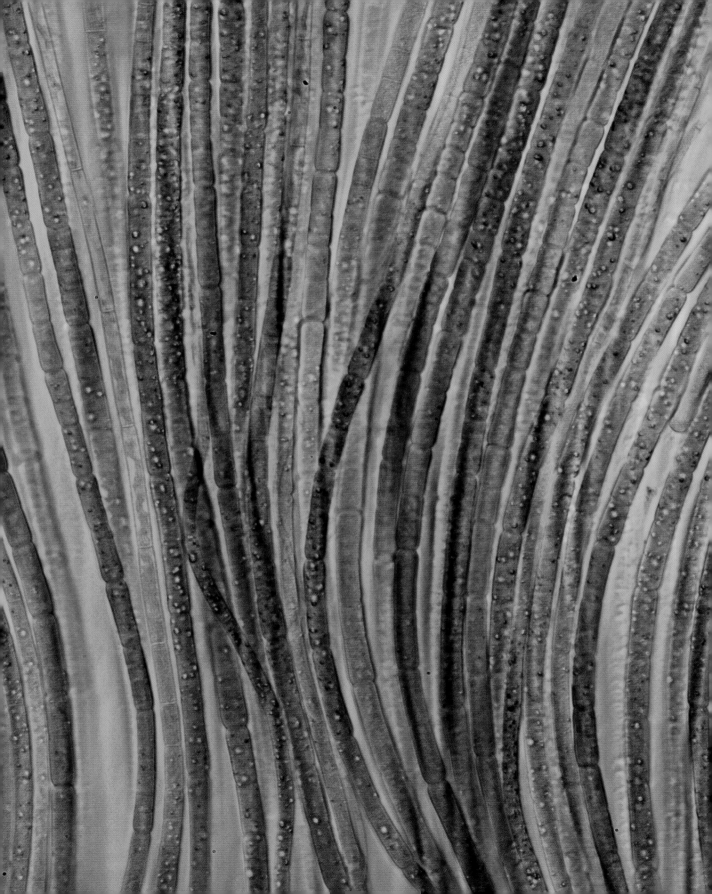

Cyanobacteria

They may be diminutive, but cyanobacteria are one of the most important drivers of Earth-system evolution. This highly diverse set of photosynthetic bacteria includes the genus *Rivularia*, shown here, which can be found clinging to submerged rocks or in other damp, freshwater environments. *Rivularia* cyanobacteria often produces bacterial colonies comprising many thousands of individuals, with these colonies taking the form of sheets, clumps or ribbons (as in this polarized light micrograph).

Like all photosynthetic organisms, *Rivularia* uses energy from the Sun to drive a series of chemical reactions that use carbon dioxide, water and sunlight to produce the range of complex organic molecules required for life. A by-product of this chemical reaction is oxygen, and about half of the total amount of oxygen released today through photosynthesis comes from bacteria. In fact, more than 20 per cent of the biosphere's oxygen is generated by the marine cyanobacteria *Prochlorococcus*. A colony of more than 500 of these tiny organisms could be accommodated comfortably within the space occupied by the full-stop at the end of this sentence, yet it has a greater atmospheric impact than all of today's tropical rainforests combined.

High concentrations of oxygen are required for complex organisms such as humans to live, as we burn oxygen in our cells in order to derive additional energy from the food we eat. However, when oxygen-producing photosynthesis evolved some 2.7 billion years ago, its impact on the climate and biosphere would have been profound. It would not only have been a lethal gas to almost all early life, but as the young Earth's atmosphere had a much stronger greenhouse effect than today, the increasing amount of oxygen would have caused havoc in the biosphere. Part of the reason for this was the much higher concentrations of methane in the atmosphere. Oxygen reacts quickly with methane, so as photosynthesis increased, and oxygen levels rose, the amount of methane in the atmosphere would have decreased. As it did, global temperatures would have dropped precipitously, perhaps leading to Snowball Earth events.

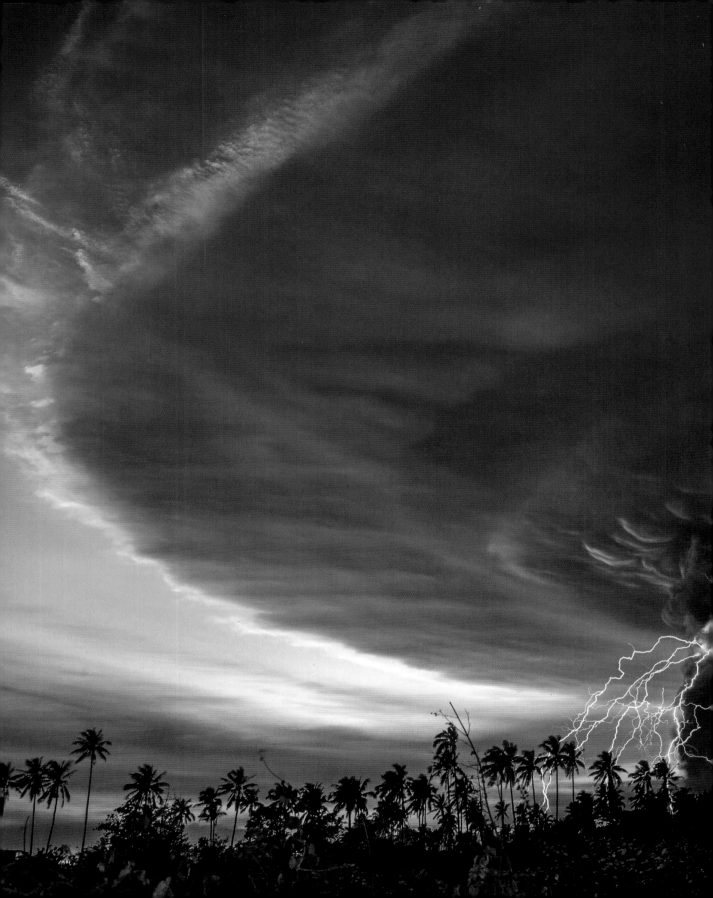

‹‹ Volcanic Activity

On the afternoon of 12 January 2020, Taal volcano on the Philippine island of Luzon roared violently into life, having lain dormant for more than forty years. By the evening, a plume of ash and fine rock had been ejected up into a column extending more than six miles into the atmosphere. The constant collision of tiny particles of volcanic ash within this plume generated a huge field of static electricity, producing spectacular lightning storms.

The impacts that volcanoes can have on the weather can extend well beyond the eruption site; they are one of the largest drivers of climate change over geological timescales. The vast majority of the 65,500 billion tons of carbon on Earth is held within rocks. The remainder resides in the oceans, atmosphere, plants, soil and fossil fuels. Carbon dioxide inside Earth is released continually during volcanic eruptions, and before the Industrial Revolution volcanoes were the largest source of carbon dioxide entering Earth's atmosphere. However, the release of carbon is largely regulated by the natural carbon cycle, which draws down as much carbon from the atmosphere as volcanoes release into it, acting as a planetary scale thermostat. If temperatures increase due to a period of intense volcanism, more carbon will be drawn down from the atmosphere, which will take temperatures back to their previous levels. However, given the slow rate of some of these chemical reactions it can take hundreds of thousands of years for the system to stabilize.

Coccolithophores

This scanning electron micrograph reveals the intricate beauty of coccolithophores. These marine photosynthetic organisms are so small that ten of them could fit within the width of a human hair, and yet they have a planetary effect due to their enormous numbers. Vast populations of coccolithophores draw down millions of tons of carbon dioxide from the atmosphere, making them as important as tropical rainforests or grasslands when it comes to regulating Earth's climate.

These organisms are studied extensively, not just because of the role they play in today's climate, but also because of what they can tell us about the climate in the past. As coccolithophores grow they form calcium-rich plates called coccospheres, which come in a wide variety of geometric shapes. It is not clear what the exact function of these coccospheres is, but they have proved vitally important to climate scientists, as they do not decay after the coccolithophore has died. This means the remains of coccosphere shells are preserved in marine sediments that can be several miles thick on the sea floor. Over geological timescales, these layers of mud are compressed to form calcium-rich sedimentary rocks, such as chalk. Careful sampling of these rocks can reveal important clues as to the amount of carbon dioxide and the temperatures that the coccolithophores experienced many millions of years ago. They can also reveal periods of ocean acidification, indicating higher concentrations of carbon dioxide in the atmosphere. At these points, ocean water could have become so acidic that it effectively dissolved the calcium-rich coccospheres, so their sudden disappearance in sedimentary rocks can indicate periods of intense global warming that happened millions of years ago.

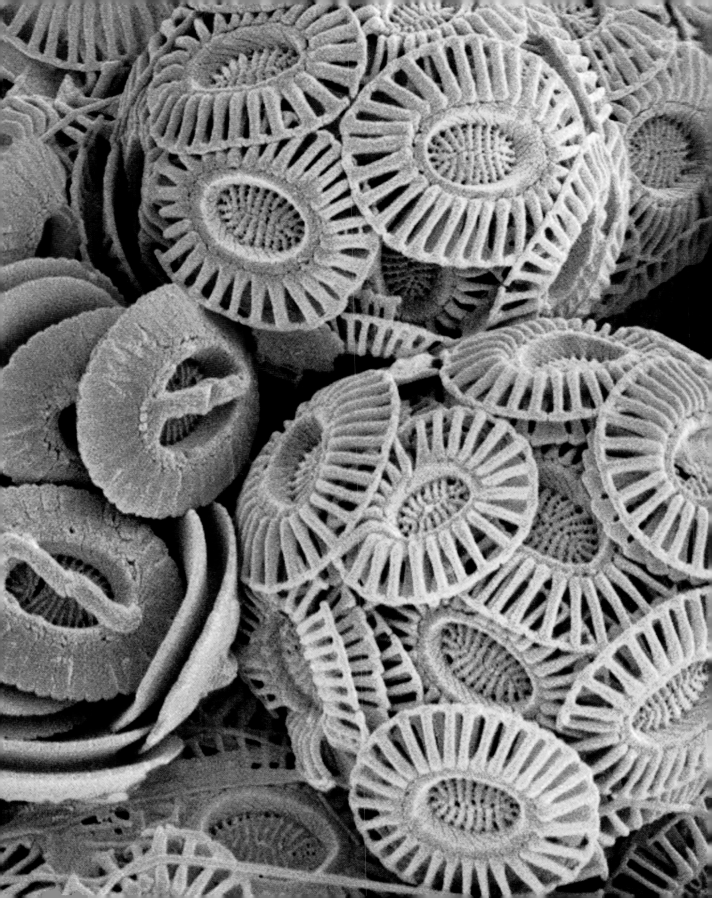

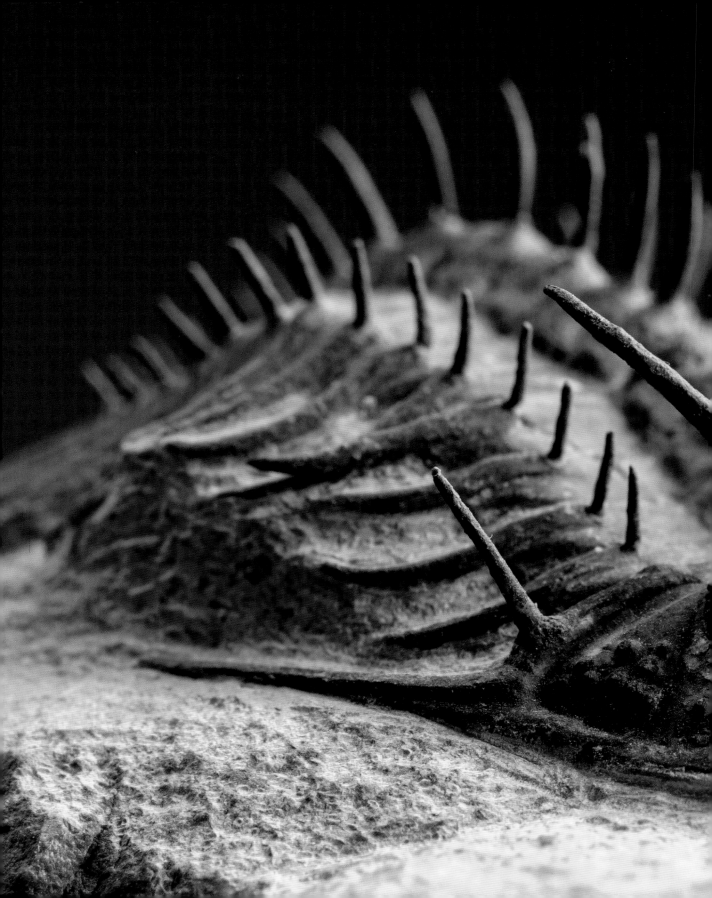

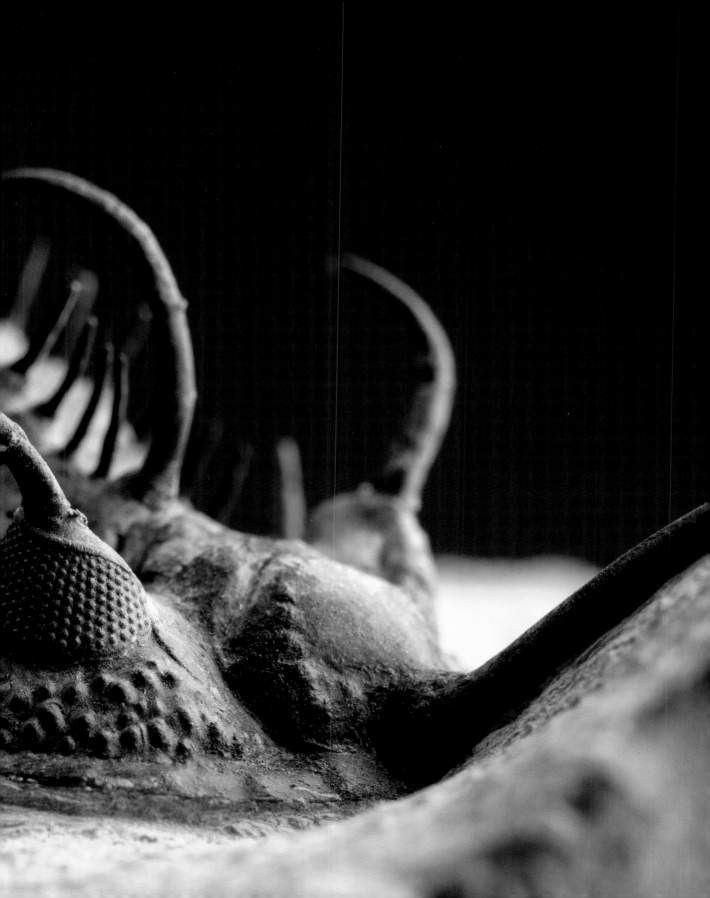

‹‹ Trilobite

The oldest trilobite fossils date back 521 million years to the start of the Cambrian period. At that time life on Earth was undergoing profound change, and it is here that we find the evolution of the first multicellular complex organisms, such as molluscs, worms and sponges. Trilobite fossils extend well beyond the Cambrian period, with the most recent examples being found in rocks that are a 'mere' 252 million years old. This makes trilobites one of the most successful of Earth's early animal species.

However, while this group of creatures survived tremendous environmental change, they were ultimately unable to withstand the greatest mass extinction event life on Earth has ever experienced. More than 90 per cent of all marine species died out during a mass extinction event that happened 252 million years ago. Dubbed 'the Great Dying', it is thought that in a period lasting as little as 60,000 years, half a million cubic miles of lava spewed out to form what is now the Siberian Traps, while vast amounts of carbon dioxide were released, leading to extreme climate change. Global temperatures rose as much as 10°C, while oceans became markedly acidic as they absorbed extra carbon dioxide. This delivered a one-two punch that knocked out the base of most marine ecosystems, including the trilobites, marking the end of their near 300-million-year history on Earth.

Fossilized Palm

This exquisitely fossilized palm tree grew in the Green River Basin, which covers parts of Wyoming, Utah and Colorado in the USA. Today, these states have semi-arid climates, with hot, dry summers and cold winters, which are not the conditions in which palms trees thrive, but all the evidence suggests this region had a sub-tropical climate 55 million years ago. As well as being warmer, sea levels were also higher, and the formation of sedimentary rocks indicates that much of the Green River Basin was close to sea level at that time. These warmer conditions arose from a climate phenomenon that has come to be called the Paleocene-Eocene Thermal Maximum (PETM), when, for around 200,000 years, temperatures increased by 5–8°C. Fossils of sub-tropical vegetation from that time have been found across the Arctic Circle, which tells us that the PETM was a global event.

As well as indicating the broad type of climate that the plants grew in, the fossilized leaves of plants also provide a remarkable amount of information about past conditions. Fossilized leaves with smaller and fewer stomata – the tiny holes through which carbon dioxide is absorbed into the leaf as a part of photosynthesis – indicate that the plant grew in an atmosphere with relatively high carbon dioxide concentrations. Leaf fossils with larger and more stomata tell us that plants had to make more effort to capture carbon dioxide at a time when the atmosphere had lower concentrations. In this way, fossilized plants can paint an incredibly accurate picture of Earth's past climate.

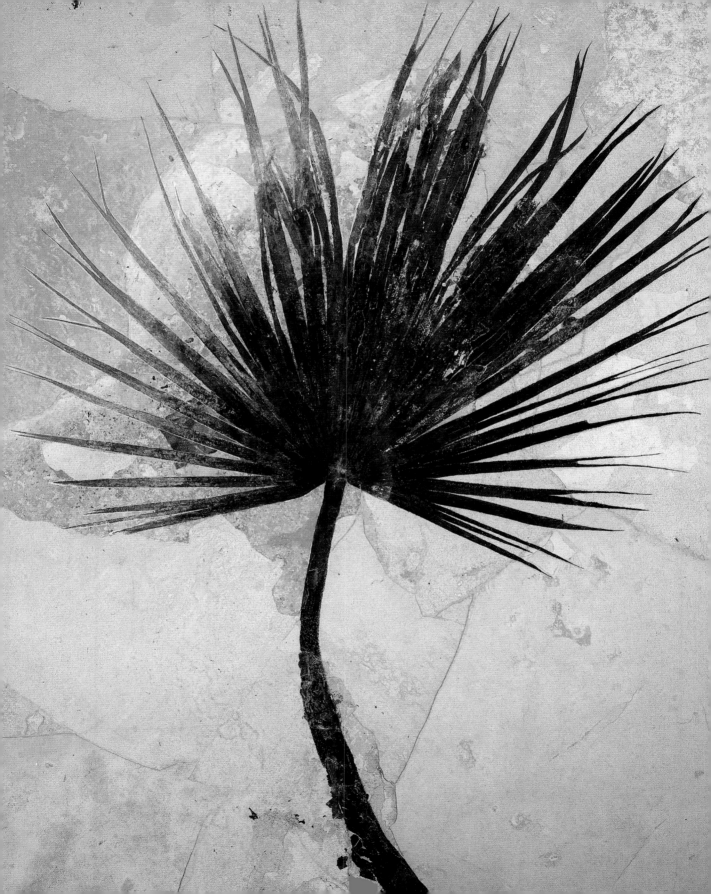

Meteor Crater

Meteor Crater, pictured in this satellite image, was formed 50,000 years ago, when a lump of nickel and iron measuring more than 150 feet across slammed into what is now Arizona, USA, at a speed in excess of 22,000mph. The energy this extra-terrestrial impact generated was over 600 times more destructive than the atomic bomb that devastated Hiroshima at the end of the Second World War, and produced a crater measuring almost three quarters of a mile across and 560 feet deep. Any organism in the immediate vicinity would have been vaporized and the shockwave would have felled trees for many miles around. At the same time, millions of tons of rock and dust would have been ejected into the air, affecting the regional climate for weeks.

As devastating as this event was to life in the vicinity, it is dwarfed by the destruction that was wrought by a meteor impact that happened 66 million years earlier. Erosion and rising sea levels have largely hidden the damage, but with careful measurements and satellite images we can still discern the outline of the 93-mile-wide Chicxulub crater off the coast of the Yucatan peninsula in Mexico. This was caused by a meteorite measuring more than six miles across, which struck Earth at a velocity of almost 45,000mph. The impact caused an explosion equivalent to 1 billion tons of TNT, vaporizing vast amounts of Earth's crust, which was ejected high up into the atmosphere. For several years the airborne debris significantly reduced the amount of sunlight reaching the surface of the planet, not only producing a sudden global-cooling event, but also starving a large portion of the biosphere as photosynthesis in plants and algae plummeted. This led directly to the mass extinction event that ended the 200-million-year reign of the dinosaurs.

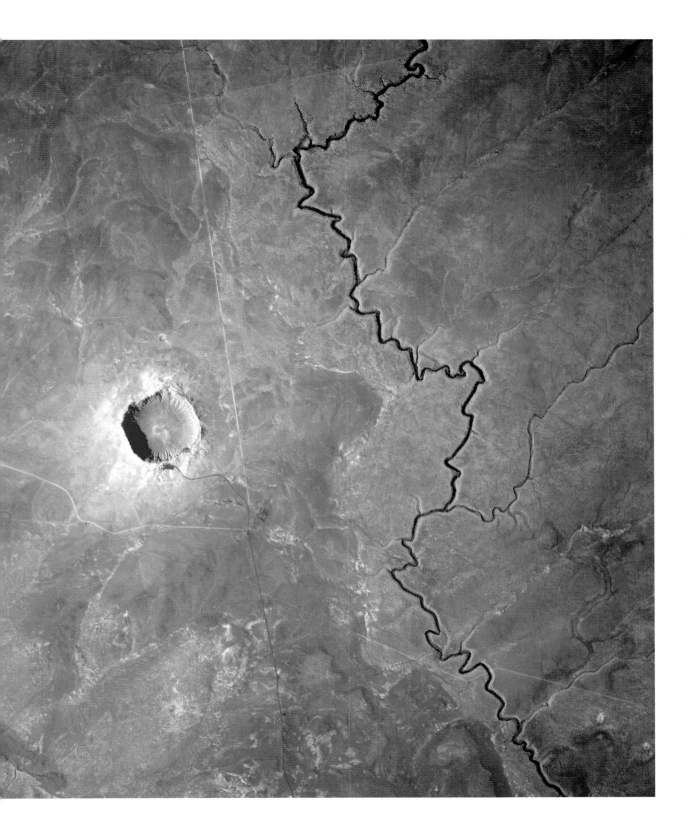

Lake Baikal

Lake Baikal, in the Russian region of Siberia, is the world's deepest freshwater lake. It started to form around 35 million years ago, as Earth's crust started to be pulled apart in this area, creating the Baikal Rift Zone over which the lake formed. This rifting continues to this day, with Lake Baikal increasing in width by just under one inch every year.

From early January through to early June the surface of the lake is covered with thick ice, within which large bubbles of gas can be found. This gas is methane, which is released by decomposing organic matter and mud volcanoes at the bottom of the lake. Under extremely cold conditions, the methane can become trapped in a lattice-like structure of sediment and ice called methane clathrate, which enables large amounts of methane to be stored at the bottom of the lake. Uniquely, Lake Baikal is the only freshwater lake that has such methane deposits, as methane clathrates are usually restricted to the coastal margins of cold oceans.

It is thought that a sudden release of a large amount of methane from similar clathrates led to a period of rapid warming around 55 million years ago. It is not clear what the trigger for this event was, but evidence points to a period of intense volcanic activity under the sea floor. As well as rapidly thawing out the methane clathrates, this activity could have destabilized the sediments that covered them. As these sediments slid off into the deeper oceans, this would have reduced the pressure on the clathrates, which would have released methane in a similar way to a bottle of carbonated water releasing bubbles when it's opened. As large amounts of methane entered Earth's atmosphere, air and sea temperatures would have risen, further accelerating methane clathrate melting. The result was runaway climate change that raised global temperatures by between 5°C and 8°C within a few thousand years.

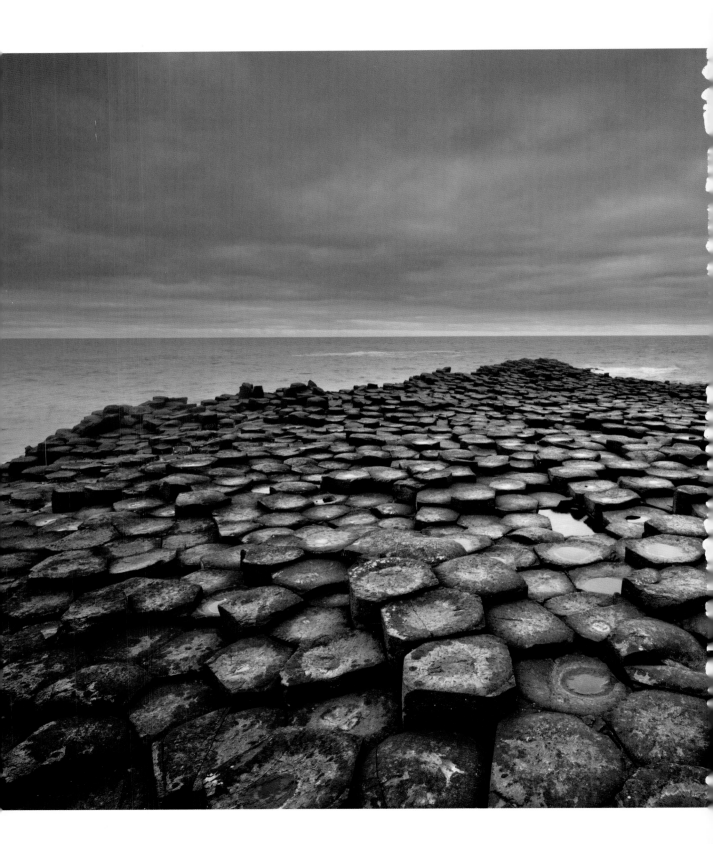

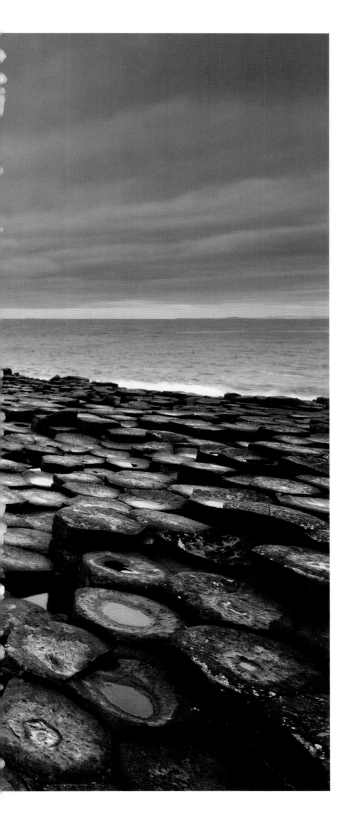

The Giant's Causeway

The 40,000 interlocking hexagonal columns of the Giant's Causeway World Heritage Site in Northern Ireland provide us with a unique insight into a particularly violent period of Earth's past. This geological wonder was formed some 60 million years ago by a massive rifting of Earth's crust, which led to the formation of the Atlantic Ocean. As the tectonic plates under which current-day Europe and North America began to move apart, volcanic activity increased markedly. During a series of lava outpouring and cooling events, these complex geological structures were formed by the cooling of highly fluid molten basalt intruding through chalk beds. Just like mud that dries and cracks, the basalt contracted horizontally, with the cracks propagating down to form regular, hexagonal pillars, some of which are 40 feet high.

Over geological timescales, volcanism has been one of the biggest drivers of Earth's climate, releasing vast quantities of carbon dioxide into the atmosphere. At the same time, carbon dioxide is removed from the atmosphere via chemical reactions with water and bare rocks, producing carbonate rocks such as limestone. This natural carbon cycle effectively regulates concentrations of carbon dioxide in Earth's atmosphere.

The Ice Ages

With large deserts and tropical forests, it can be hard to appreciate that Earth is currently deep in an ice age. To most people, the term ice age summons up pictures of vast frozen regions and woolly mammoths roaming across much of the northern hemisphere; scientists call these periods 'glacial maximums'. During the last glacial maximum, ice sheets some 2½-miles thick extended into Europe, Asia, North America and much of southern South America. So much water was locked up on land as ice that global sea levels were almost 400 feet lower than they are today.

The last glacial maximum ended 11,000 years ago. Since then, the planet has had a warmer interglacial climate, in which most ice is limited to the far north and south, or high up on mountains. We are still in an ice age, though, because this is the geological term that describes the climate when there are permanent regions of ice on the surface of the planet. We are used to seeing pictures of Antarctica as a vast white region of snow and ice, but if you were to travel back in time some 40 million years, Antarctica would be largely ice-free.

It is the permanent presence of ice sheets in Antarctica that is used to date the start of the current Late Cenozoic ice age, which began some 34 million years ago. Sea ice at the North Pole and glaciers on Greenland formed around 2.6 million years ago, marking the start of the Quaternary glaciation, during which there was a regular waxing and waning of ice across Earth's surface. Due to a complex play of forces, the climate flips from glacial maximum to interglacial, and over the past 740,000 years there have been eight of these cycles, each accompanied by a global temperature change of around 5°C.

Over longer time scales, we can detect five major ice age episodes in the past 4.6 billion years. These have ranged in duration from a few million, to hundreds of millions of years. Some have been so extreme that nearly the entire earth was frozen. When first proposed, these Snowball Earth events were controversial, as it would have meant ice sheets extending all the way down to the tropics, but as outlandish as this sounds, there is now strong evidence that supports the theory.

56Mya
The Paleocene-Eocene Thermal Maximum (PETM). A period of rapid warming of approximately 5–8°C leads to major extinctions in ocean ecosystems and significant disruption to the distribution of land animal populations.

5–7Mya
The last common ancestor that humans had with chimpanzees. Since then, the evolution of these species has proceeded along seperate branches of life.

2.6Mya
Formation of Greenland ice sheet heralds the start of the Quaternary glaciation, within which the climate oscillates between glacial maximum and interglacial states approximately every 100,000 years.

300Kya (thousands of years ago)
Evolution of *Homo sapiens*.

44Kya
Oldest examples of human cave paintings in Western Europe.

34Mya
Earth enters ice age. Permanent ice sheets are established in Antarctica.

3Mya
Temperatures are 2°C warmer than modern pre-industrial periods. Sea levels at this time are 30–130 feet higher than today.

1.6Mya
Evolution of *Homo erectus*, which rapidly migrates out of Africa to colonize wide areas of Europe and Asia.

70Kya
Humans start to establish stable populations outside of Africa.

22Kya
Peak of last glacial maximum, during which ice sheets 2½-miles thick extend across multiple continents.

Although there remains much uncertainty about how they happened, we are reasonably confident about the circumstances that triggered a Snowball Earth event 700 million years ago. At that time, the configuration of Earth's continents and the formation of large mountain ranges would have decreased the amount of carbon dioxide in the atmosphere. As carbon dioxide levels plunged, so did temperatures, increasing the amount of ice in the polar regions. These expanding ice sheets reflected more of the energy from the sun back into space, which lowered temperatures further, causing a reinforcing feedback loop that only stopped when ice covered almost all of Earth's surface. This was the Cryogenian period, which lasted a little under 100 million years. The planet was released from its deep freeze by volcanic eruptions that poured large amounts of carbon dioxide back into the atmosphere.

Our current ice age is a far less extreme event, but is much more finely balanced. Given the climate of the past 2.6 million years, we can expect the next glacial maximum to start around now – with 'around' being a period of time that may extend a few thousand years into the future. However, there are good reasons to conclude that the next glacial maximum is not coming anytime soon. While the dynamics of Earth's orbit may be well placed to start a period of colder conditions, the planet's greenhouse is much stronger, because humans have increased concentrations of carbon dioxide in the air by destroying forests and burning fossil fuels. In fact, so strong are our impacts that we could have cancelled the next glacial maximum indefinitely. Within a few hundred years, humans may have stopped a climate process that has been running for millions of years. Where we go next is largely up to us.

13Kya
Humans begin to farm and exchange hunter-gatherer roaming for more sedentary lifestyles.

2334 BC
Akkadian Empire founded. The empire reaches its peak 150 years later.

AD 250–900
Height of the Mayan civilization.

AD 900
Collapse of the Classic Period of the Mayan civilization, following prolonged droughts that devastate food production.

11Kya
Glaciers end their retreat, stabilizing at high altitudes, and to the far north and south. The start of the interglacial Holocene epoch.

2300 BC
Prolonged period of drought and potentially devastating dust storms associated with the collapse of the Akkadian civilization.

AD 536
A series of eruptions – possibly from Icelandic volcanoes – plunge Europe into its coldest decade for more than 2,000 years.

AD 900–1300
The Medieval Warm Period brings warm weather to Europe, thanks to an unusually strong North Atlantic Oscillation drawing extra heat to the continent.

The Great Lakes

The Great Lakes – Superior, Michigan, Huron, Erie and Ontario – hold an incredible 21 per cent of Earth's fresh water. They dominate the landscape of North America, but are relatively young geological features, having been carved out of bedrock by the retreat of the vast Laurentide ice sheet during the last glacial maximum. Between 95,000 and 20,000 years ago, the Laurentide ice sheet covered almost all of Canada and large areas of the northern USA. In places, the ice was up to two miles thick, and as this vast frozen sheet crept along the ground, it gouged out entire valleys. However, as global temperatures began to increase, the ice sheet retreated, and by 11,000 years ago it had fallen back to the Arctic Circle. In its wake it left a series of massive depressions that quickly filled with water to become the Great Lakes.

As well as changing the topography, the waxing and waning of ice has profoundly changed the planet's ecosystems. While much of the northern hemisphere was buried under vast ice sheets, the last glacial maximum also saw highly productive and diverse ecosystems. A vast steppe extended across Europe, Asia and via a land bridge to North America, on which prairie lands flourished along with vast herds of bison and other megafauna, such as mammoths.

Although the global climate of the past 11,000 years has been remarkably stable, the Great Lakes can still experience periods of wild weather, as shown opposite. In the satellite photograph from 2011, the light blue areas in Lake Michigan (left) and Lake Huron (centre) show sediment that has been brought to the surface by strong winds, while the green in Lake Erie (bottom) and Lake Huron's Saginaw Bay is algae, which blooms on the lakes' surfaces in strong sunlight and calm conditions. By contrast, in January 2019, Canada and much of the northern USA were plunged into a deep freeze: in the city of Chicago on Lake Michigan, temperatures plummeted to –31°C with a wind chill of –47°C.

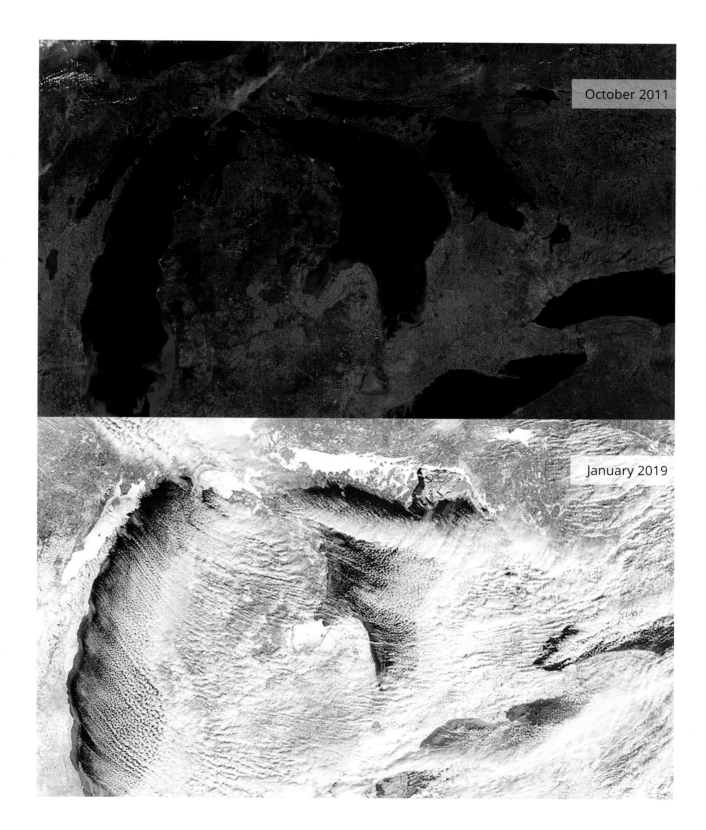

October 2011

January 2019

Glacial Erratics

For many years, glacial erratics were something of a mystery. Ranging in size from large pebbles to mighty monoliths weighing in at more than 10,000 tons, these single rocks can be found far from any mountain or valley, or river system that could have transported them, with a mineral composition that can be entirely different to their surroundings. This, along with their often-unusual perched position, suggested they had been carried and then discarded by some immensely powerful force, leading some eighteenth-century scientific minds to claim they were evidence of ancient floods.

We now know that glacial erratics were not tumbled into place by raging floodwaters, but took a much slower journey in and on glaciers during the last glacial maximum. As ice sheets expanded to their maximum extent some 20,000 years ago, they picked up huge numbers of rocks. Some of these were pushed along beneath the thick ice sheets, as they crept over the ground, with tremendous forces breaking the rocks up into smaller pebbles – gouges and scratch marks on the surface of these pebbles give an indication of the extreme forces they experienced. Much larger boulders were moved by rafting, whereby rockfalls above a glacier could deposit huge lumps of rock onto the icy surface. As the glacier inched forwards, so the rocks were transported upon it.

As conditions started to warm towards the current interglacial period, the edges of glaciers began to retreat rapidly. Eventually, the ice that was previously supporting large boulders melted, depositing the stony sentinels at essentially random locations in the landscape. Glacial erratics have now been collected from across the entire globe, and have been used to increase our understanding of the extent and duration of the last glacial maximum. In some instances they have also provided us with silent witnesses to more intense Snowball Earth cooling events.

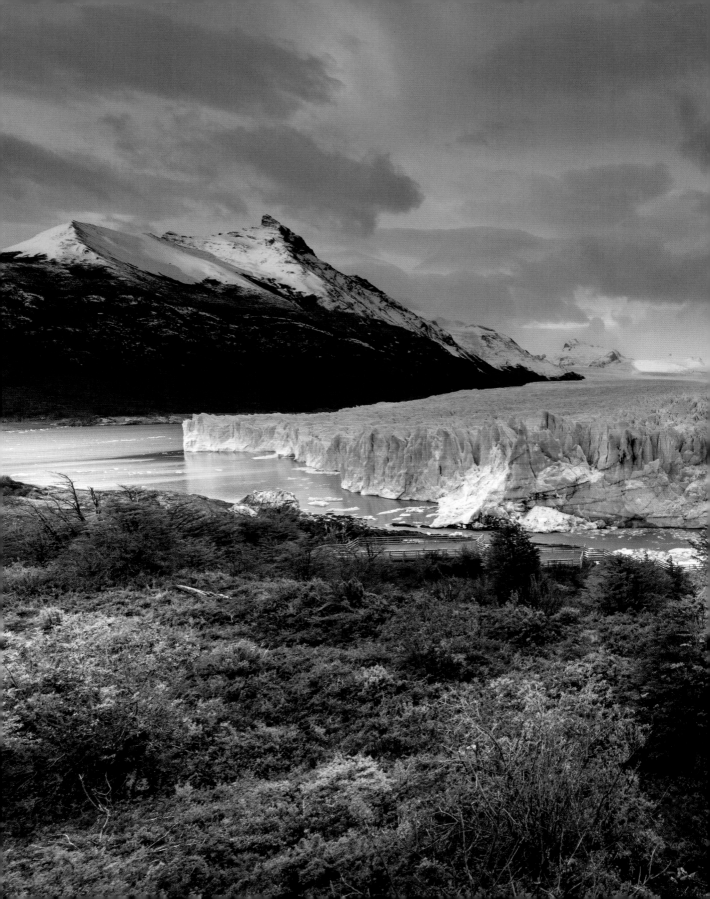

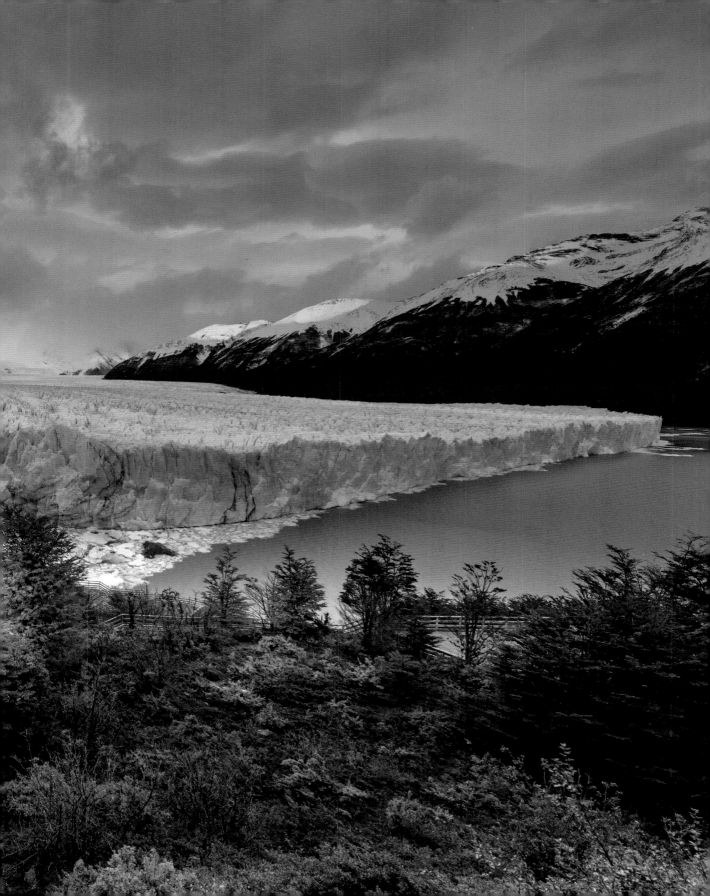

‹‹ Perito Moreno Glacier ›

The Perito Moreno Glacier is part of the vast Southern Patagonian ice field, which covers more than 4,700 square miles of the Andes in South America, making it the third-largest reservoir of fresh water in the world. Today, the glacier is an international tourist destination, thanks to its relatively easy access and beautiful surroundings. Like all glaciers, Perito Moreno is constantly on the move, with ice that is being formed at higher altitudes pushing down on the glacier, which creeps forwards like a vast blue-and-white tongue through the Andean mountains. The edge – or terminus – of the glacier is found on Argentino Lake in Argentina, with an abrupt wall of ice measuring three miles across and 550 feet deep. Ruptures of the terminus occur every two to four years, and these wonders of the natural world draw even more people to the glacier, as cracks and fissures suddenly expand, and entire sections of the glacier fall forwards and crash into the lake below.

Perito Moreno is something of an oddity, though, in that it is slightly increasing in total mass, whereas 90 per cent of the other glaciers in the Andes are melting rapidly as a direct consequence of global warming. This near-universal reduction mirrors the retreat of the vast majority of glaciers around the world, and at current rates it is expected that half of all Alpine glaciers will vanish from valleys over the next thirty years and that most will have disappeared completely by the end of the twenty-first century. Exactly how the Perito Moreno Glacier is bucking this trend is not fully understood, but it may be that global warming is changing precipitation patterns and increasing snowfall high up in the mountainous regions where the glacier is formed. This could be more than offsetting any increased melting at lower altitudes, ensuring that Perito Moreno is safe – at least for now.

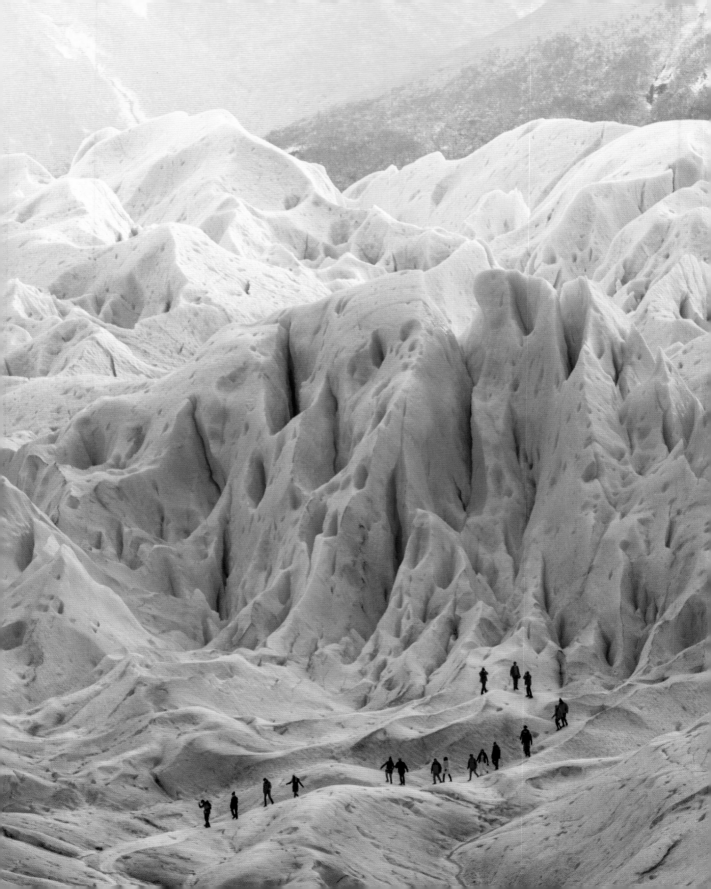

Antarctic Ice Sheet

The scale of the Antarctic ice sheet can only be fully appreciated up close. In this photograph, taken on Ross Island, researchers abseil into a deep crevasse. Yet while this yawning crack descends many storeys into the ice, it barely scratches the surface, as the Antarctic ice sheet is nearly 2½-miles thick in places. In total, the continent is covered by almost 770,000 cubic miles of ice, and if all of this ice were to melt, global sea levels would rise by almost 200 feet. It is the waxing and waning of the Antarctic and Greenland ice sheets during the current ice age that have most strongly affected sea levels over the past 2.6 million years.

Twenty thousand years ago, when ice sheets covered much of northern Europe and North America during the last glacial maximum, the sea was almost 400 feet lower than it is today. In this vastly different climate, global surface temperatures were on average only 5°C cooler than today, but this represents a massive difference in the amount of energy in the climate. Current projections suggest that the warming trajectory that humans have put Earth on will see temperatures increase by up to 5°C compared to pre-industrial periods. This means humans have – within just a few centuries – had an effect on the climate that is similar in scale to an ice age.

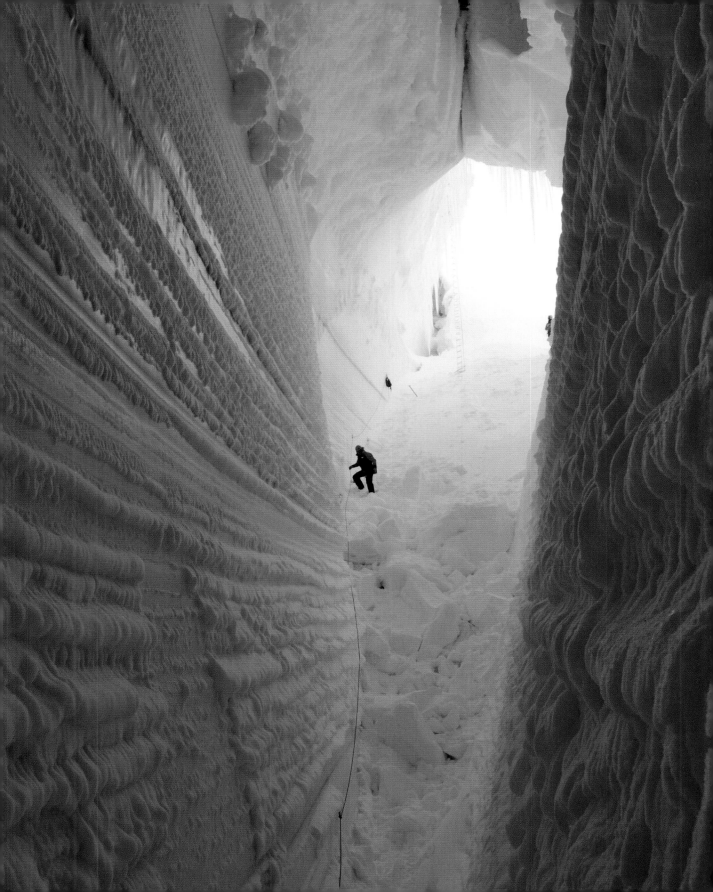

Cave Paintings

This ghostly image of a woolly rhino is one of 600 paintings that have been found in the Lascaux cave complex near Montignac, France. Most of the paintings depict large animals, along with some of the plants that grew in the region during the Upper Palaeolithic period. It is likely that the collection is the result of the work of many generations, made some 17,000 years ago. At that time, the landscapes of northern Europe and Asia saw herds of woolly rhinoceros. Standing 6½ feet high, these heavy animals were covered in thick fur that was perfectly adapted to the bitterly cold conditions. It is reasonable to assume that the period of rapid warming that started some 20,000 years ago would ultimately prove to be their downfall, but while climate change led to their extinction, it did so in surprising ways.

Woolly rhinos were a member species of the Pleistocene megafauna. This group of animals, which included the famous woolly mammoth, thrived for hundreds of thousands of years during the coldest conditions. It has long been thought that as the ice retreated and the landscape changed, these massive animals were no longer capable of surviving in a much warmer world. But there is now abundant evidence of a second climate-driven factor in their extinction: the migration of humans into more northern regions. Neither the woolly mammoth, nor the woolly rhinoceros had evolved in the presence of humans, so had few defences against them. Consequently, these highly efficient human hunters were immortalizing woolly rhinos in cave wall paintings at the same time as they were helping lead them to extinction.

The Nile

The contrast between the green around the Nile river and the surrounding tan of the northern Sahara Desert makes the river easy to see in satellite images such as this one, which was acquired by the Moderate Resolution Imaging Spectroradiometer (MODIS) on board NASA's Terra satellite in July 2004. It is clear how important the Nile is to farming in this region: regular flooding deposits nutrient-rich sediments in which crops thrive, while its constant flow of water provides a source for irrigation that can sustain crops through hot, dry summers.

We now know that farming emerged independently across the Old and New World around 13,000 years ago, before which all humans were largely hunter-gatherers, who would roam across wide areas. Given that modern humans are some 300,000 years old, it is something of a puzzle as to why farming only developed comparatively recently. It is likely that climate change had an important role to play, for the simple reason that environmental conditions were simply too changeable for farming and complex societies to emerge any earlier. It is therefore no coincidence that both civilization and the Holocene epoch began around the same time.

The start of the Holocene is dated some 11,500 years ago, when vast ice sheets completed their retreat back after the end of the last glacial maximum. As well as an absence of ice, the Holocene has been characterized by a very stable climate that has witnessed the establishment of every civilization, from Ancient Egyptians living along the Nile to our current industrialized world.

Cave Paintings

This ghostly image of a woolly rhino is one of 600 paintings that have been found in the Lascaux cave complex near Montignac, France. Most of the paintings depict large animals, along with some of the plants that grew in the region during the Upper Palaeolithic period. It is likely that the collection is the result of the work of many generations, made some 17,000 years ago. At that time, the landscapes of northern Europe and Asia saw herds of woolly rhinoceros. Standing 6½ feet high, these heavy animals were covered in thick fur that was perfectly adapted to the bitterly cold conditions. It is reasonable to assume that the period of rapid warming that started some 20,000 years ago would ultimately prove to be their downfall, but while climate change led to their extinction, it did so in surprising ways.

Woolly rhinos were a member species of the Pleistocene megafauna. This group of animals, which included the famous woolly mammoth, thrived for hundreds of thousands of years during the coldest conditions. It has long been thought that as the ice retreated and the landscape changed, these massive animals were no longer capable of surviving in a much warmer world. But there is now abundant evidence of a second climate-driven factor in their extinction: the migration of humans into more northern regions. Neither the woolly mammoth, nor the woolly rhinoceros had evolved in the presence of humans, so had few defences against them. Consequently, these highly efficient human hunters were immortalizing woolly rhinos in cave wall paintings at the same time as they were helping lead them to extinction.

The Holocene Era

Exactly where and when humans evolved is still a question of intense research. We are able to say with some confidence that the very first human species evolved in Sub-Saharan Africa around 2 million years ago, and over the next million years, multiple human species emerged. Over this period the climate of Africa would have changed as ice sheets advanced and retreated, during glacial maximums and interglacial periods. While large glaciers formed in places such as Mount Kilimanjaro during the coldest periods, Africa was largely spared from the intrusion of vast ice sheets, but there were very large changes in temperature and precipitation that would have profoundly altered African ecosystems. It may be that some of this climate change triggered the migration of *Homo sapiens* out of Africa.

Archaeological finds of stone axes in the Arabian Peninsula have been dated back to 120,000 years, which suggests that the first migrations took place across the Red Sea from the Horn of Africa. It is hard to imagine how such a journey could be undertaken in what must have been very simple boats and rafts, but around that time, a period of climate change meant that the Red Sea in that area was far narrower than it is today.

From a range of archaeological and genetic data, we can trace the movement of *Homo sapiens* from Africa to the rest of the world, but when all the evidence is assembled, it looks as though these first migrants were unable to establish themselves. It was later waves of migration that led to humans establishing themselves on the other continents. This appears to have started around 70,000 years ago, when humans made their way out of North Africa, via what is now Egypt.

Climate change may have been involved here, as it is generally thought that North Africa was a much cooler and wetter place than it is today. This was a period of the 'Green Sahara', during which a continuous belt of vegetation stretched along the north of the continent, providing a corridor within which humans could travel. As well as facilitating the migration, the climate may also have played a part in causing it. Reconstructions of the climate in the Horn of Africa, show that 70,000 years ago the region underwent a profound change in climate,

1350–1850
The Little Ice Age produces bitter winters and cold summers for some regions of the northern hemisphere.

1683–84
The Great Frost is the most severe frost recorded in England. The River Thames freezes completely for two months in winter.

1856
Eunice Newton Foote publishes *Circumstances Affecting the Heat of the Sun's Rays*. She goes on to theorize that changing the proportion of carbon dioxide in the atmosphere would change its temperature.

1871
The Peshtigo wildfire kills an estimated 1,500–2,500 people, making it the deadliest wildfire in the history of the USA – a record it still holds to this day.

1883
Eruption of Krakatau. The volcanic eruption is so violent that it is heard on the island of Rodrigues, near Mauritius, almost 3,000 miles away.

1500–1600
Periods of alternating flooding and drought drive the Khmer Empire to collapse.

1824
In a paper presented to Paris' Académie Royale des Sciences, the French physicist Joseph Fourier describes important properties of the Earth's greenhouse effect.

1861
The Irish physicist John Tyndall carries out research on radiant heat and the absorption of radiation by gases and vapours, demonstrating that carbon dioxide can cause changes in temperature.

1880
Peak of the second Industrial Revolution. Fertilizers and other chemicals, electricity and public health further accelerate growth.

1885
The German automotive engineer, Karl Benz, reveals the first gasoline-powered production motor car.

transitioning from a wet phase to much drier and colder conditions. This could have encouraged humans to head north to seek out a more clement environment.

Through a combination of push-and-pull climate change factors, humans successfully established populations beyond Africa, and Earth would never be the same again. Through rapid cultural evolution, humans adapted to a wide diversity of habitats, from baking deserts to the frozen Arctic, and as they thrived they profoundly altered existing ecosystems.

However, it was the advent of farming and the formation of the first civilizations that saw humans take their first steps towards becoming a planet-altering species. Farming appears to have arisen independently in at least ten different regions of the Old and New Worlds, but may have first begun in the Fertile Crescent, which today covers a region of the Middle East that includes parts of Iran, Iraq, Jordan, Syria, Israel, Palestine and Turkey. It was here, around 13,000 years ago, that humans first began to settle and grow food, and soon after that we see the rise of the first civilizations.

For the emergence of civilizations, a number of evolutionary and cultural adaptations are required, including tools and the intelligence to make them. There also needs to be a system of symbolic thought and language to organize society. It would have taken many generations for such steps to happen, so how can we explain the multiple origins of the first civilizations, which all appeared at around the same time?

Again, the climate may have played a vital role. 13,000 years ago marks not only the foundations of civilization, but the dawn of our current geological epoch: the Holocene. Prior to this, Earth was moving from the last cold glacial maximum to warmer interglacial, and it is hard to imagine how complex human societies could have formed under such extremely challenging environmental conditions. However, with the onset of the relatively stable Holocene climate, the challenges diminished, making it easier for complex societies to grow and thrive.

1896
Swedish chemist Svante Arrhenius proposes the idea of a man-made greenhouse effect.

1920
Coal production peaks in the UK.

1934–40
The Dust Bowl. Three waves of drought in North America produce intense dust storms that destroy large swathes of agriculture and devastate ecology.

1970
22 April: The first Earth Day takes place across the USA. Twenty million people participate in the event.

1908
Oil is struck in Masjid-i-Suleiman, Persia, by the Anglo-Persian Oil Co., now known as BP.

1931
Floods ravage large regions along China's Yangtze and Huai rivers.

1958
Revelle and Suess employ geochemist Charles Keeling to continuously monitor CO_2 levels in the atmosphere. After just two years of measurements a clearly increasing trend could be observed.

1972
Astronauts on Apollo 17 take a photograph of Earth from space. The image, dubbed 'Blue Marble', would go on to be one of the most reproduced photographs of all time.

The Nile

The contrast between the green around the Nile river and the surrounding tan of the northern Sahara Desert makes the river easy to see in satellite images such as this one, which was acquired by the Moderate Resolution Imaging Spectroradiometer (MODIS) on board NASA's Terra satellite in July 2004. It is clear how important the Nile is to farming in this region: regular flooding deposits nutrient-rich sediments in which crops thrive, while its constant flow of water provides a source for irrigation that can sustain crops through hot, dry summers.

We now know that farming emerged independently across the Old and New World around 13,000 years ago, before which all humans were largely hunter-gatherers, who would roam across wide areas. Given that modern humans are some 300,000 years old, it is something of a puzzle as to why farming only developed comparatively recently. It is likely that climate change had an important role to play, for the simple reason that environmental conditions were simply too changeable for farming and complex societies to emerge any earlier. It is therefore no coincidence that both civilization and the Holocene epoch began around the same time.

The start of the Holocene is dated some 11,500 years ago, when vast ice sheets completed their retreat back after the end of the last glacial maximum. As well as an absence of ice, the Holocene has been characterized by a very stable climate that has witnessed the establishment of every civilization, from Ancient Egyptians living along the Nile to our current industrialized world.

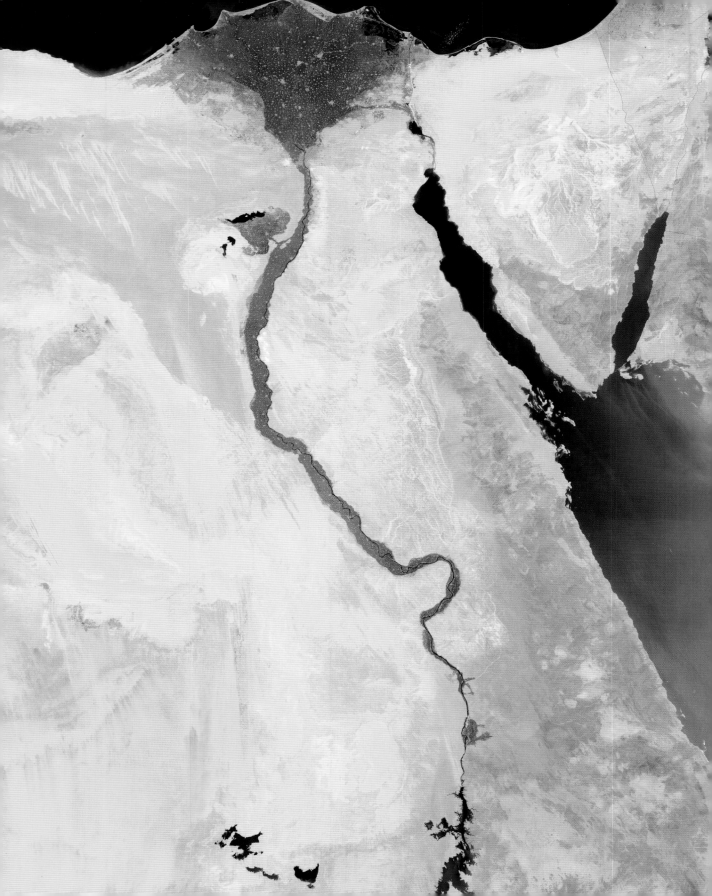

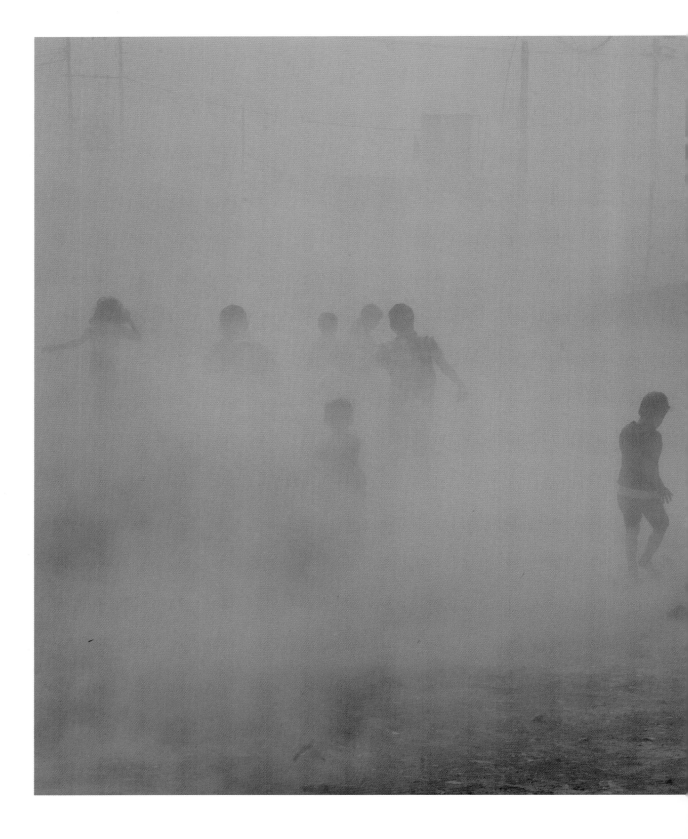

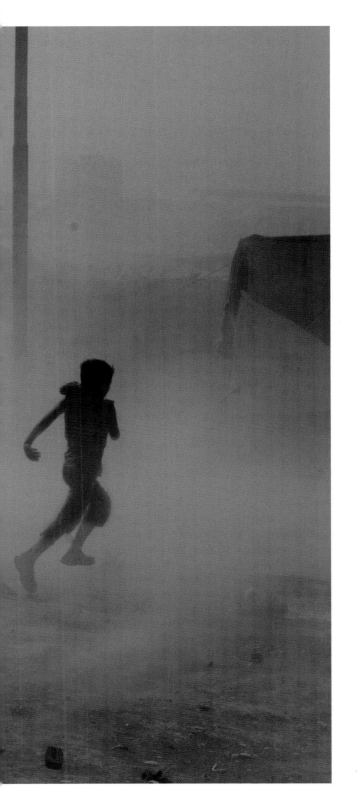

Duhok

These young boys running for cover during a dust storm in the Domiz refugee camp in Iraq's Kurdistan region of Duhok are just a few of the camp's 32,000 residents. Now a place of sanctuary for Kurds displaced by civil war in neighbouring Syria, Duhok has featured prominently in the development of many of the earliest civilizations, having been controlled at one time or another by the Akkadians, Sumerians and Assyrians.

Founded by Sargon of Akkad in 2334 BC, the Akkadian Empire reached its peak some 150 years later, when it ruled Mesopotamia from the sources of the Tigris and Euphrates rivers to the Persian Gulf. However, archaeological evidence shows that around thirty years later, this sophisticated empire collapsed. Although this photograph was taken thousands of years later, it offers a glimpse of what may have caused its downfall. A reconstruction of the climate from that period indicates very dry conditions, in which huge dust storms would have raged. In a short period of time, large regions of Mesopotamia became very arid, with the resulting failure in harvests becoming important drivers of social collapse.

Today, climate change has also been implicated (at least in part) in the collapse of Syrian society and the resulting civil war. The lead-up to the modern conflict started in 2006 with a prolonged and devastating drought in the Fertile Crescent, which evidence now suggests may have been made more severe by human-driven climate change. This drought contributed to the mass migration of rural workers to Syrian cities, increasing social tensions. Although other social and political factors were at work as well, in 2011 these tensions boiled over into a brutal civil war, demonstrating how human civilization is still just as dependent on a stable climate as the Akkadians were, more than 4,000 years earlier.

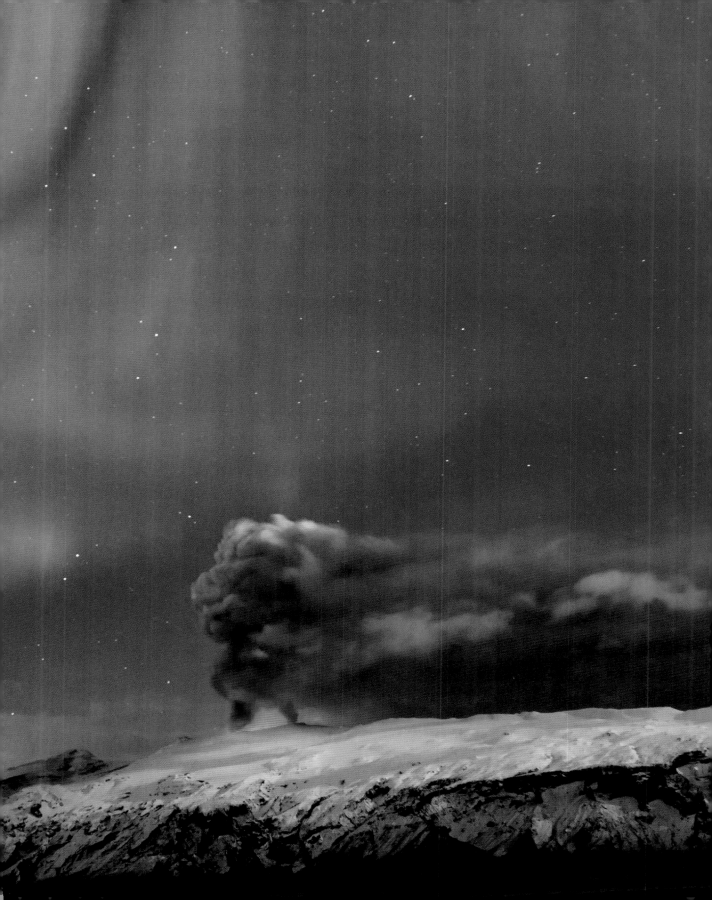

<< Icelandic Eruptions

For many years, Eyjafjallajökull was a fairly unremarkable Icelandic volcano, but it gained international attention in April 2010 when a series of eruptions belched out vast clouds of dust and ash. The ash cloud rose high into the atmosphere and was transported east by strong jet stream winds. As volcanic ash can lead to catastrophic failure in modern jet engines, the cloud had a huge impact on air travel across Northern and Western Europe. At the height of the volcanic activity, most European airspace was closed to commercial aircraft, creating the highest level of air travel disruption since the Second World War.

Yet while these eruptions led to significant economic damage, they pale in comparison to the impact that Icelandic volcanism had in AD 536. Dubbed 'the worst year to be alive', a mysterious fog plunged much of Europe, the Middle East and parts of Asia into darkness. Europe experienced its coldest decade in more than 2,000 years, snow fell during the Chinese summer and crops failed everywhere from Ireland and Scandinavia, to Mesopotamia, producing mass starvation and social unrest. The Byzantine historian, Procopius, wrote at the time how 'the sun gave forth its light without brightness, like the moon, during the whole year'.

The analysis of the rings of Irish oak trees shows very low growth occurred that year, with similar patterns seen in trees in Sweden, Finland and California, while ice cores taken from Greenland reveal there were large amounts of dust in the air. There is now strong evidence that the cause of this calamity was the eruption of an Icelandic volcano that produced so much ash that it dimmed the Sun for up to eighteen months, altering the climate and the affairs of humans for many years to follow.

The Mayans

The heavily weathered carvings in this photograph show some of the many artefacts that have been excavated from the ruins of Copán in Honduras, a centre of the Mayan civilization that for more than 3,000 years controlled regions of what are now Honduras, Mexico, Guatemala, Belize and El Salvador. The golden age of Mayan culture is known as the Classic Period. This period spanned AD 250–900 and is characterized by a complex web of trade and political connections covering thousands of square miles. During this time, the population of the city of Teotihuacán reached 125,000.

However, this highly sophisticated civilization ended abruptly during the early tenth century when Teotihuacán, Copán and other Mayan cities were abandoned suddenly. Early theories about the end of the Classic Period explored the role of invasion from hostile cultures, but more recent evidence suggests that the civilization disintegrated from within. Climate change has become a prime suspect for this calamity, as reconstruction of the period's climate shows prolonged droughts that would have significantly reduced harvests. As different regions started to face food scarcity, trading in food would have collapsed, leaving some large cities with dangerously low supplies, and perhaps triggering a sharp increase in internal conflict. Further droughts occurred during this time of population collapse, and it was not long before the great Mayan cities stood silent, waiting for the jungle to reclaim them.

Fall of the Khmer Empire

The roots of a tetrameles plant flow over the roof of an abandoned temple at Ta Prohm, less than one mile east of the world-famous Angkor Wat complex in Cambodia. Both sites were constructed in the early twelfth century, at the peak of the Khmer Empire, but while Angkor Wat has been restored over many decades, Ta Prohm has been left largely as it was found by French explorers in the middle of the nineteenth century. As such, it stands as an evocative symbol of the collapse of the Khmer Empire.

At its peak, this Hindu-Buddhist empire ruled over most of mainland south-east Asia and parts of southern China. A central part of the empire's expansion was the Khmer's elaborate system of canals and reservoirs, which were used for transport, trade and irrigation. So extensive were the waterworks of Angkor Wat that it has come to be known as the 'Hydraulic City'.

By the fourteenth century, a rapidly expanding population was placing increasing pressure on these water systems and the scene was set for the sudden demise of the empire. The analysis of tree rings shows that decades-long droughts, punctuated by intense floods, battered much of the Khmer Empire during the fourteenth and fifteenth centuries. The droughts would undoubtedly have led to failed harvests, while the floods would have destroyed some of the reservoirs and canals that were needed to irrigate the crops. Although famine and war ultimately brought down the empire, it was a change in the climate that initiated its downfall.

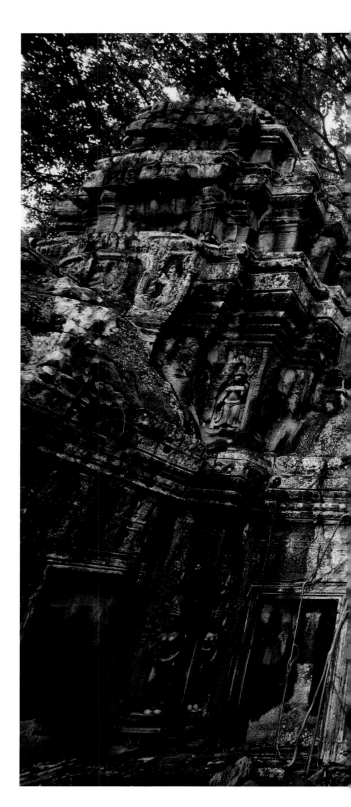

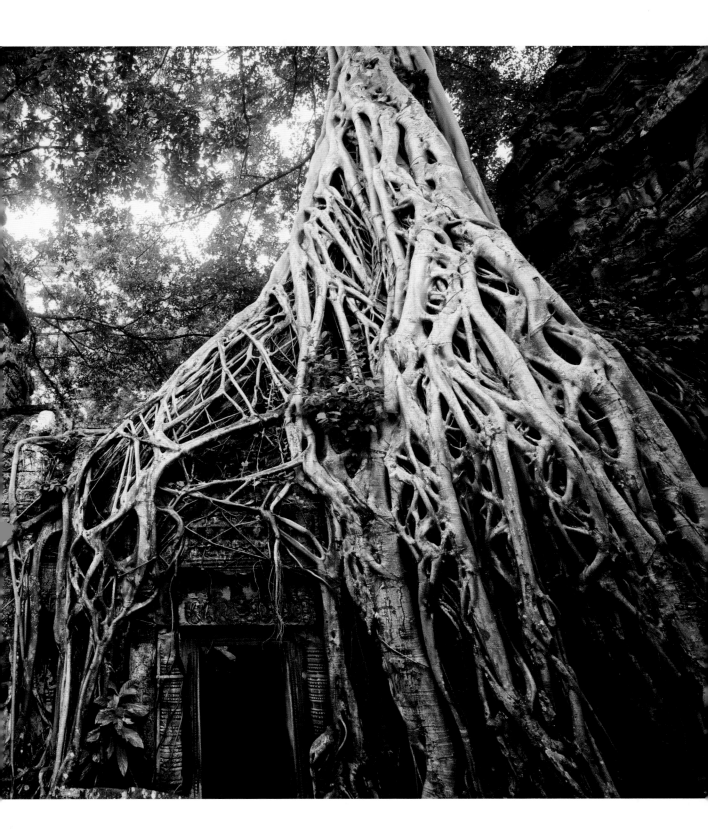

Plague

Masks like these – with the addition of glass lenses – were a fundamental part of the plague doctor's costume in the seventeenth century, and would typically be worn with an ankle-length overcoat, boots, gloves and a wide-brimmed hat. The mask was made of oil cloth and its bird-like beak would be filled with strong-smelling substances such as lavender, which were mistakenly believed to keep the doctor safe from the 'miasma' that was thought to transmit plague.

It is hardly surprising that plague doctors went to such lengths to protect themselves, as Europe had been ravaged by bubonic plague for centuries. Indeed, the fourteenth century Black Death remains the deadliest pandemic recorded in human history, with anywhere between 25 million and 200 million people dying in Eurasia and North Africa in the space of around five years.

Today, we know that bubonic plague is caused by *Yersinia pestis*, a bacteria carried by the Oriental rat flea, and that plague first came to Europe from Asia in the sixth century. It had long been assumed that European rodents served as a reservoir for the disease, with outbreaks occurring on a regular basis until improved medicine and public health managed to effectively eradicate plague in the nineteenth century. However, recent research suggests that regional climate change also had an important part to play in the spread of the disease. Periods of hotter and drier conditions in central Asia led to the collapse of large rodent populations, forcing fleas to find new hosts, including the livestock and rats that lived in close proximity to humans. These animals then carried the disease along established trade routes – to European ports with the transport of infected black rats, for example – from where it could spread rapidly, decimating human populations as it did.

The Little Ice Age

Joseph Gale's photograph captures the rare sight of a frozen River Thames in central London in the latter half of the nineteenth century. The British Isles usually have a clement climate, as they are bathed in the warm waters of the North Atlantic Current, which is part of the Atlantic Meridional Overturning Circulation (AMOC). The North Atlantic Current transports vast amounts of warm water from tropical regions, and as this water moves past the British Isles it releases its heat. Meanwhile, colder, denser waters from the Arctic generate currents that descend to the bottom of the ocean, turning the North Atlantic Current to the south and west. This cooler water then flows down along the east coast of North America to return back to the tropics. This circulatory system largely explains why London experiences milder winters than other cities that are found at the same latitude.

There have been periods when the AMOC has been unable to shield the British Isles from periods of intense cold, though. The most severe frost ever recorded in England was the Great Frost of 1683–84, during which the Thames froze completely for two months over winter – in places the ice was up to 12 inches thick, allowing a 'frost fair' to take place on the river that featured stalls, competitions and performers.

It is now clear that these bitter winters were due to a regional climate phenomenon known as the Little Ice Age, which extended from the fifteenth to the nineteenth century and saw temperatures drop by around 0.6°C across Europe. However, while the Little Ice Age had profound impacts on Europe, it was not a global phenomenon, and it is not clear what caused such a sustained decrease in temperatures. There is evidence that the North Atlantic Current was weaker during this period, and there are indications that increased volcanic activity may be partly to blame, but no conclusive reason has been determined.

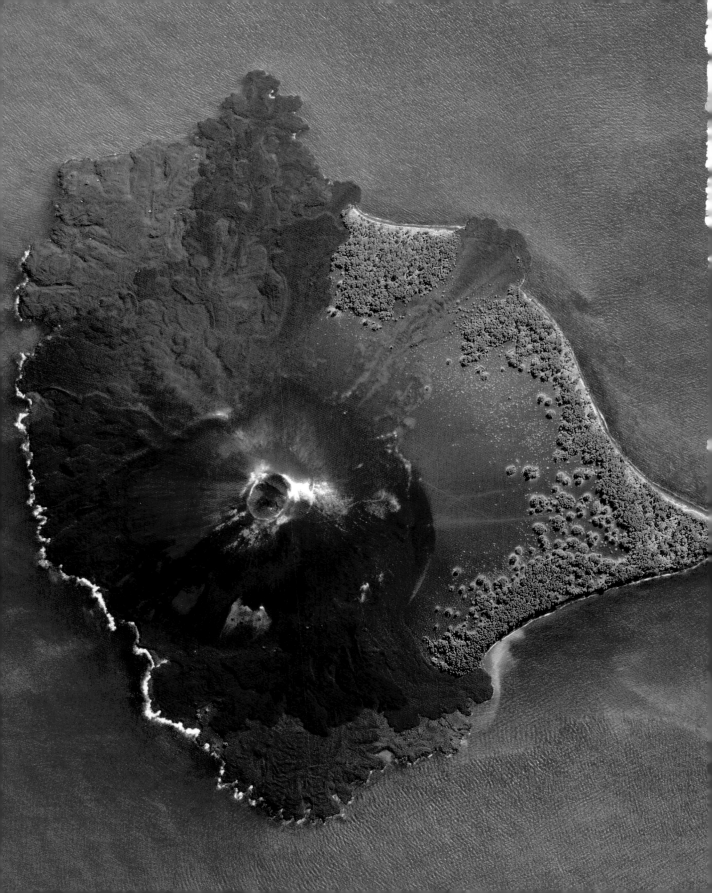

Like many volcanoes in the 25,000-mile-long Ring of
Fire, Krakatau would erupt periodically, but nothing
matched the violence of the events of 27 August 1883.
Following several months of relatively minor activity,
Krakatau exploded with such ferocity that it was heard
almost 3,000 miles away and produced a shockwave
that circled the globe three and a half times. Krakatau's
eruption emitted so much gas and ash that red-glowing
sunsets were witnessed around the world for several years
to follow.

Although this was the most noticeable impact of
the eruption, volcanoes can produce even more marked
changes in the climate. Along with dust and rocks they
emit millions of tons of sulphur dioxide. This can be
carried up into the stratosphere where it reacts with water
vapour to form tiny droplets of sulphuric acid, which
can then be dispersed around the globe by high-speed
winds. This can have a strong effect on the climate, as
these droplets are highly reflective and bounce back some
of the energy from the Sun before it has a chance to
warm the surface of the planet, producing a detectable
change in global temperatures – the 1991 eruption of
Mount Luzon in the Philippines ejected so much sulphur
dioxide into the atmosphere that the average global
temperature over the next 15 months dropped by 0.6°C.

Even though most of Krakatau was obliterated by the
explosions, this wasn't the end, as a new volcano emerged
from its caldera in 1927. Named Anak Krakatau, which
translates from Indonesian as 'Child of Krakatau', it too
has increased in size, as seen opposite, and has become a
prominent and active addition to this geologically violent
region, as demonstrated on the following page.

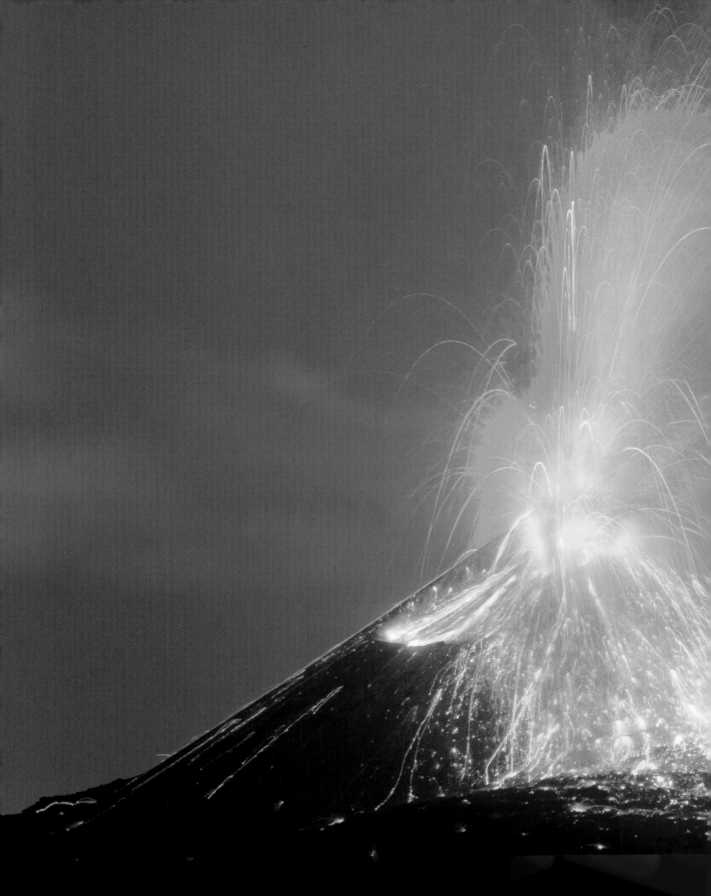

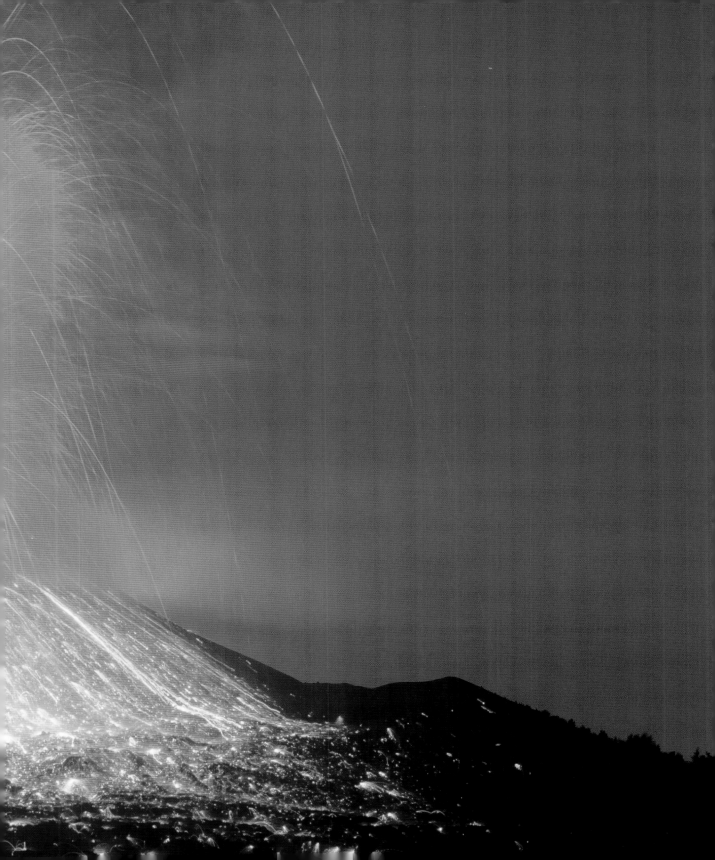

Human-Driven Climate Change

After hundreds of thousands of gradually increasing populations, the Industrial Revolution transformed both humanity and the planet. Our meteoric rise over the past few centuries means we now burn fossil fuels on an epic scale, releasing so much carbon dioxide into the atmosphere that it is rapidly warming the climate, producing heatwaves, extreme drought and severe flooding..

>>>

The Human Fingerprint

As humans migrated out of Africa some 70,000 years ago, the global population slowly increased, and by 45,000 years ago the Earth was home to approximately 1.5 million people. The widespread adoption of farming lit the touchpaper for an explosive increase in human numbers, which grew from a global population of around 6 million people 10,000 years ago, to 250 million people by the start of the Common Era, some 2,000 years ago.

An even greater population increase started from around the early eighteenth century, as a series of scientific, economic and social changes led to the transformation of industry in the UK. There were several centres and waves of the Industrial Revolution, but in general terms we can see that change spread rapidly across the UK, then Europe and then almost all other countries.

This revolution transformed the planet. The large increases in production meant increases in wealth and prosperity. While this was by no means distributed equally, it did lead to significant improvements in public health. As a result, death rates – particularly among young children – decreased markedly over the course of the nineteenth century in developing nations, while birth rates continued to remain high for several decades. This meant that as industrialization expanded, populations continued to grow. This growth accelerated during the twentieth century: by 1920 the global population was 2 billion; by 1974 it was 4 billion; by 1999 it was 6 billion; and today it stands at 7.8 billion.

The sheer number of people has transformed ecosystems and landscapes around the world, but it is the secondary effects of the spectacular rise of humans that may prove to be even more profound. Although humans had been using coal for several thousands of years prior to the Industrial Revolution, it was not until the first British deep coal mines in the eighteenth century that significant amounts of coal started to be burnt, as steam engines replaced windmills, water wheels, and the horse and cart. By the start of the twentieth century the UK was consuming more than 230 million tons of coal a year, with the rapidly industrializing USA burning even

1973
First global energy crisis, as OPEC (the Organization of the Petroleum Exporting Countries) limits the supply of oil to the USA, Western Europe and Japan during the Yom Kippur War.

1976
UK experiences its hottest summer for more than 350 years.

1987
15–16 October: The Great Storm hits the UK.

19–30 November: Typhoon Nina devastates the Philippines.

Montreal Protocol of the Vienna Convention imposes international restrictions on the emission of ozone-destroying gases.

Warmest year ever recorded.

1988
23 June: James Hansen testifies before the United States Senate Committee on Energy and Natural Resources, raising public awareness of global warming and climate change.

Intergovernmental Panel on Climate Change (IPCC) is established by the United Nations Environment Program (UNEP) and World Meteorological Organization (WMO).

1990
The 1980s are confirmed as the warmest decade for the past 1,000 years.

1991
2 April–2 September: Mount Pinatubo erupts in the Philippines, injecting huge amounts of aerosols into the stratosphere and lowering temperatures around the world for several years.

more. But if coal powered the first stage of the Industrial Revolution, it was oil that transformed it into a planet-wide phenomena. In 2019, our industrialized civilization consumed more than 100 million barrels of oil every single day.

Coal, oil and gas are all fossil fuels, created over millions of years by geological processes that transform the organic carbon in the cells of plants, algae and animals into hydrocarbons. The problem is, burning them releases carbon dioxide into the atmosphere that was previously trapped in Earth's crust.

Carbon dioxide is continually being added to and removed from the atmosphere through a range of natural biogeochemical processes. Volcanic eruptions are a significant source of carbon dioxide, for example, while sea water continually dissolves carbon dioxide in the air, making the oceans the main route for its removal. Over hundreds and thousands of years, these two processes largely cancel each other out, so the concentration of carbon dioxide in the atmosphere remains constant.

However, our burning of fossil fuels has been so large and sustained that we are putting more carbon dioxide into Earth's atmosphere than natural processes can remove. This is increasing concentrations of carbon dioxide in the atmosphere and increasing the strength of the greenhouse effect.

Yet while human-caused climate change is now one of the most studied phenomena in the history of science, it is not new. The scientific understanding of the role of carbon dioxide in Earth's climate dates back more than 150 years; direct measurements of carbon dioxide in the atmosphere started in the late 1950s; and the very first climate models that produced estimates for temperature increases from the burning of fossil fuels were developed in the 1960s. But despite various findings and warnings, this science has so far had no impact on the rates of global fossil fuel use.

1992
3–14 June: The United Nations Conference on Environment and Development – better known as the Earth Summit – takes place in Rio de Janeiro. It is attended by 172 countries and is the first unified effort to get to grips with global warming.

1998
Replaces 1995 as the warmest year ever recorded.

2001
The third IPCC report highlights how human activities are responsible for the majority of global warming since the 1950s.

2005
Replaces 1998 as the warmest year ever recorded.

1995
Replaces 1987 as the warmest year ever recorded.

1997
Following the Earth Summit in 1992, industrialized countries sign up to the Kyoto Protocol, agreeing to cut their emissions of six key greenhouse gases by an average of 5.2 per cent.

2000
The 1990s replace the 1980s as the warmest decade in the past 1,000 years.

2003
Europe suffers a heatwave and widespread drought; more than 70,000 people lose their life as a direct result.

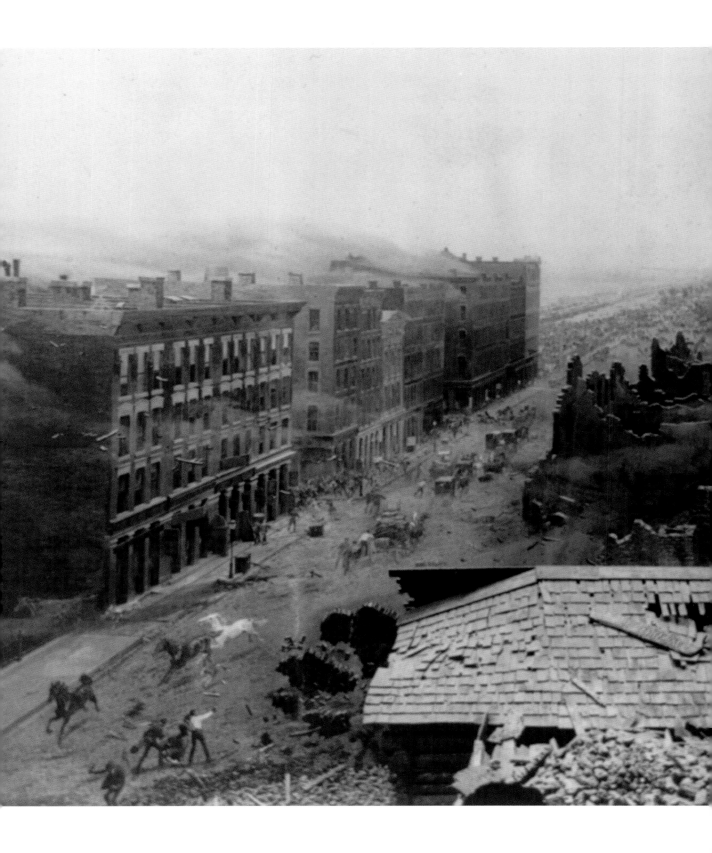

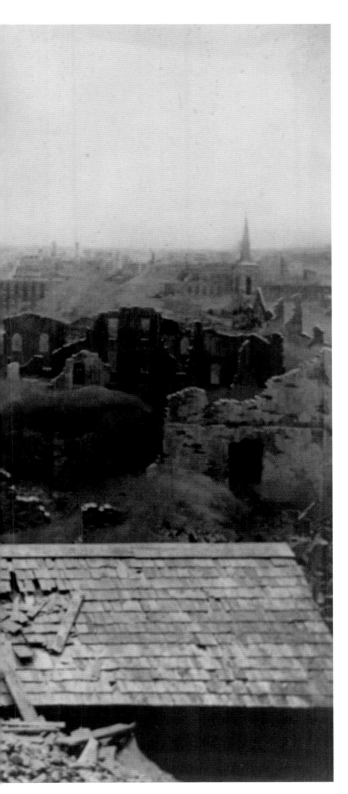

< The Great Chicago Fire

The Great Chicago Fire raged for three days from
8 October 1871, during which time the blazing inferno
devastated more than three square miles of the North
American city, killing approximately 300 people and
leaving more than 100,000 homeless. These photographs
give some sense of the scale of the destruction, which
mobilized international help. European governments
contributed funds to the rebuilding of the city,
including a donation from the UK that helped establish
the Chicago Public Library, replacing the previously
exclusively private libraries in the city.

But while the Great Chicago Fire has entered the
public consciousness as one of the most destructive fires
ever suffered by the USA, another fire that occurred on
the same day was far more deadly. In fact, the Peshtigo
fire in north-east Wisconsin, 250 miles from Chicago,
came to be the deadliest fire in the history of the USA.

The precursor was a prolonged period of very hot
and dry weather that had produced tinderbox conditions.
A small series of fires, started accidentally or caused
by lightning strikes, broke out in Wisconsin in early
October. Strong winds on 8 October quickly whipped
these small fires up into a firestorm, which eventually
consumed more than 2,300 square miles of land, killing
somewhere between 1,500 and 2,000 people. Some
survivors said the fire moved so fast that it was 'like a
tornado', and this was perhaps an incredibly accurate
description. Very large and intense wildfires can create
their own weather, as columns of rapidly rising hot
gases suck air into the base of the fire, producing vast
differences in air pressure measuring several miles across.
This can develop into a true tornado, and although they
are extremely rare, the size and intensity of the Peshtigo
blaze makes it possible that fire tornadoes were generated
during the conflagration.

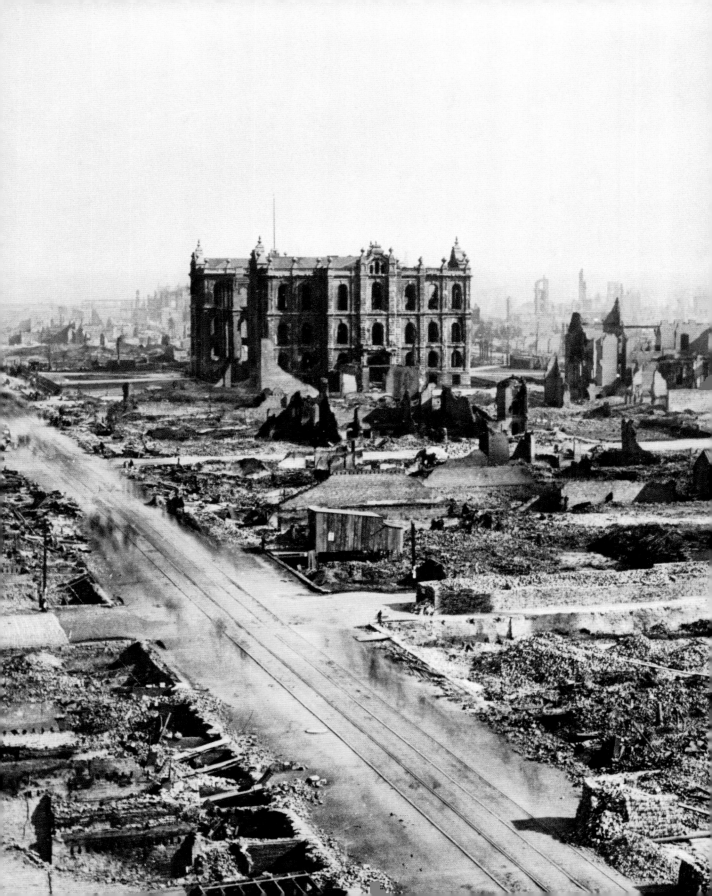

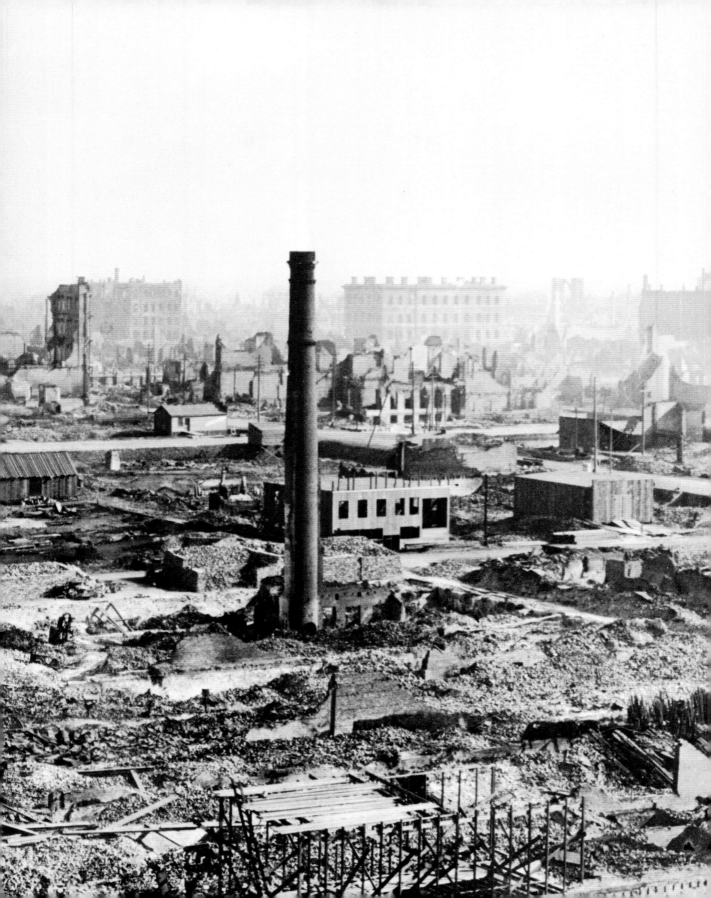

Industrialization

For much of history, the power that humans have had at their disposal has come from the muscles of animals, such as the oxen and horses that pulled carts and ploughs, and the stored sunlight in wood and other biomass that has been burnt. However, the first Industrial Revolution that began in the north of England in the eighteenth century changed everything.

The revolution spread quickly across the rest of Europe and on to North America, with industrialization starting in earnest in the USA towards the end of the eighteenth century. Pioneering industrialists were able to exploit the very large coal reserves located around the nation, and over the course of the next hundred years, factories multiplied across the country. Nowhere was this more noticeable than in the city of Pittsburgh, which had developed as an important centre for the production of iron, brass, tin and glass at the start of the nineteenth century. Steel production, which required large amounts of coal to heat blast furnaces, rapidly increased, and by 1911 – twenty years after this picture was taken – Pittsburgh was producing half the steel in the USA.

The impact this had on air pollution was disastrous, and many wealthy Pittsburgh citizens moved to exclusive neighbourhoods, miles from the downtown factories. Yet despite the clear environmental and health impacts that burning coal produced, coal mining and consumption increased exponentially. By 1920 the USA was consuming more than 500 million tons of coal a year and was well on its way to becoming the predominant industrial power of the twentieth century.

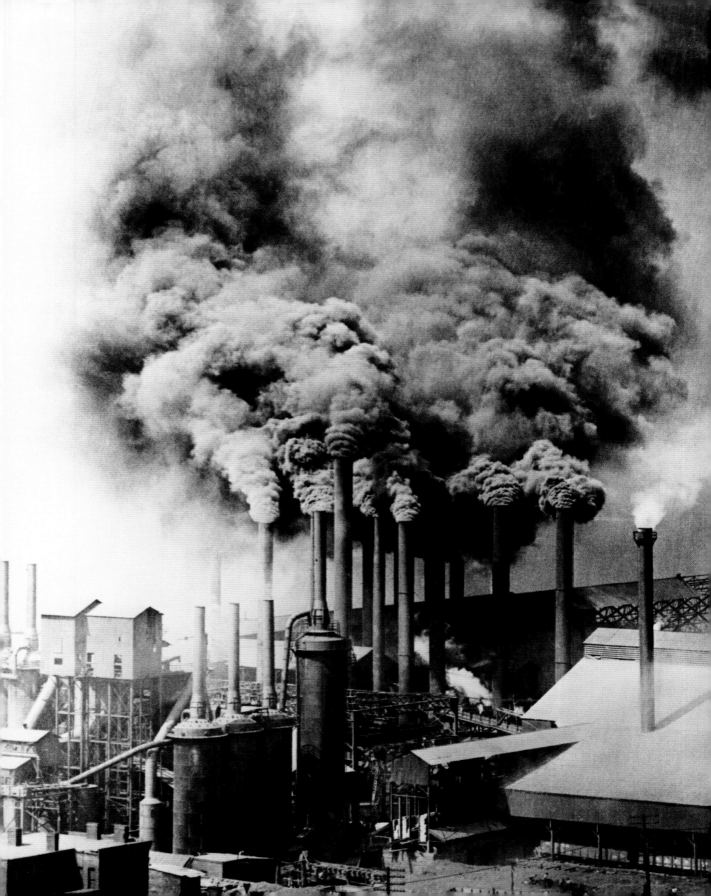

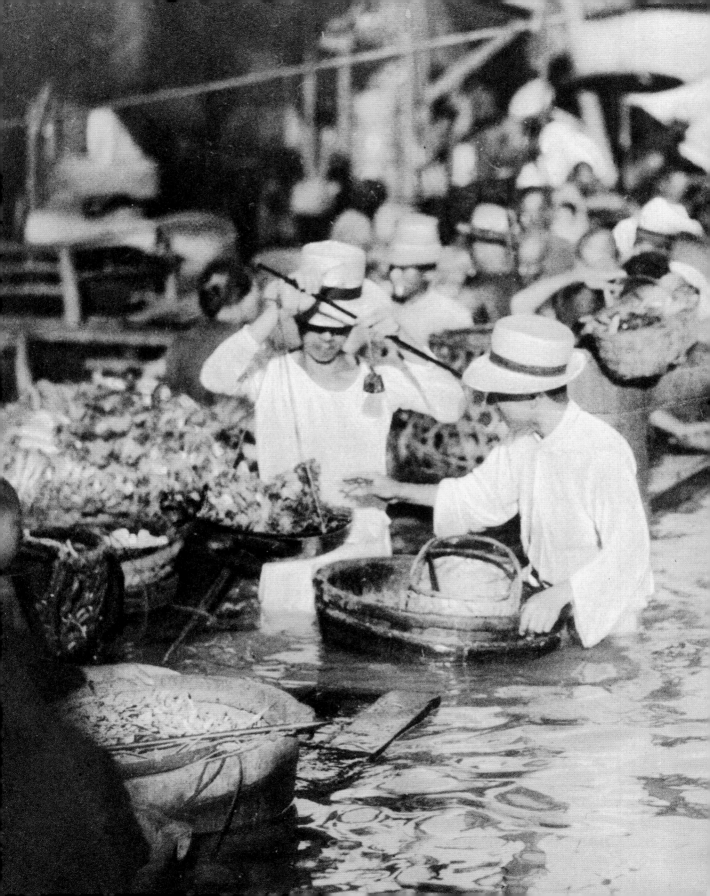

China Floods

A particularly harsh winter in 1930–31 deposited large amounts of snow and ice on China. Consequently, as the spring thaw set in, a greater volume of meltwater than usual entered the Yangtze river, which was already swollen by a protracted period of very heavy rainfall. This set the scene for what would become perhaps the deadliest flooding of the twentieth century.

Covering one fifth of China, in 1931 the Yangtze drainage basin was home to tens of millions of people, who lived next to the river or on its surrounding flood plain. Consequently, when the Yangtze and Huai rivers started to flood in June of that year, millions of people were forced to flee the rising waters. As rain continued to fall, nine cyclones dumped vast amounts of additional water on to the region in July, with weather stations along the Yangtze recording two feet of rainfall in a single month. Tens of thousands of square miles were ravaged by the flooding, and at its peak in August, water gauges in the city of Wuhan were recording water levels 53 feet higher than average. While some of the flooding happened gradually, allowing people to escape, this was punctuated by catastrophic events that greatly increased the loss of life. On 25 August, floodwater washed away a series of dykes near Gaoyou Lake: in this area alone it is estimated that 18,000 people drowned.

This photograph was taken at Hankou, Wuhan, towards the end of September, after the peak of the flooding. However, while life continued as best as it could, the full impact of the catastrophe was not felt until the following year, when malnutrition and disease swept through the affected regions. The final death toll is estimated to be somewhere between 450,000 and tens of millions of people.

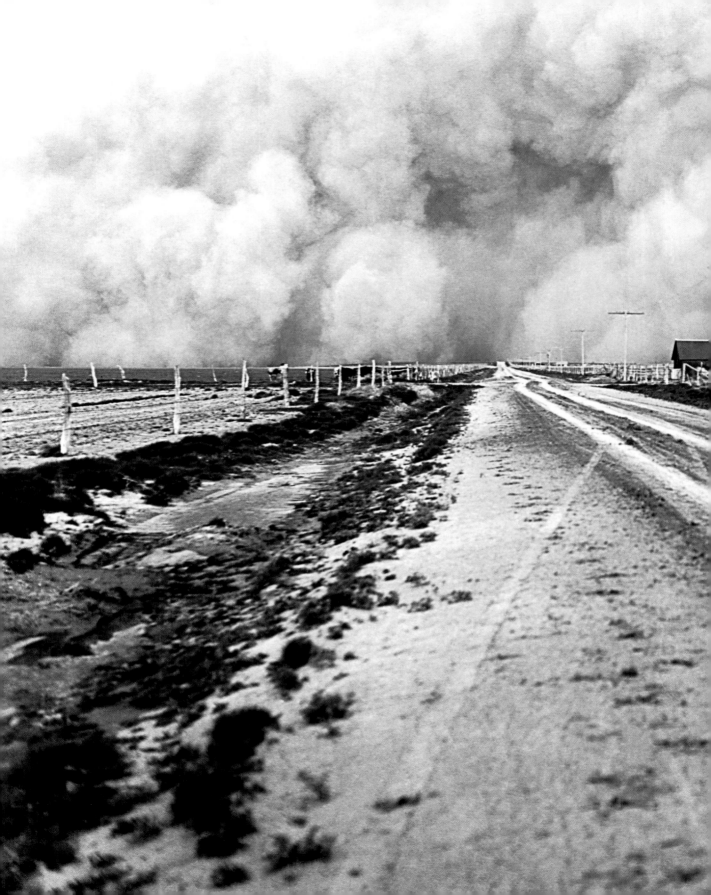

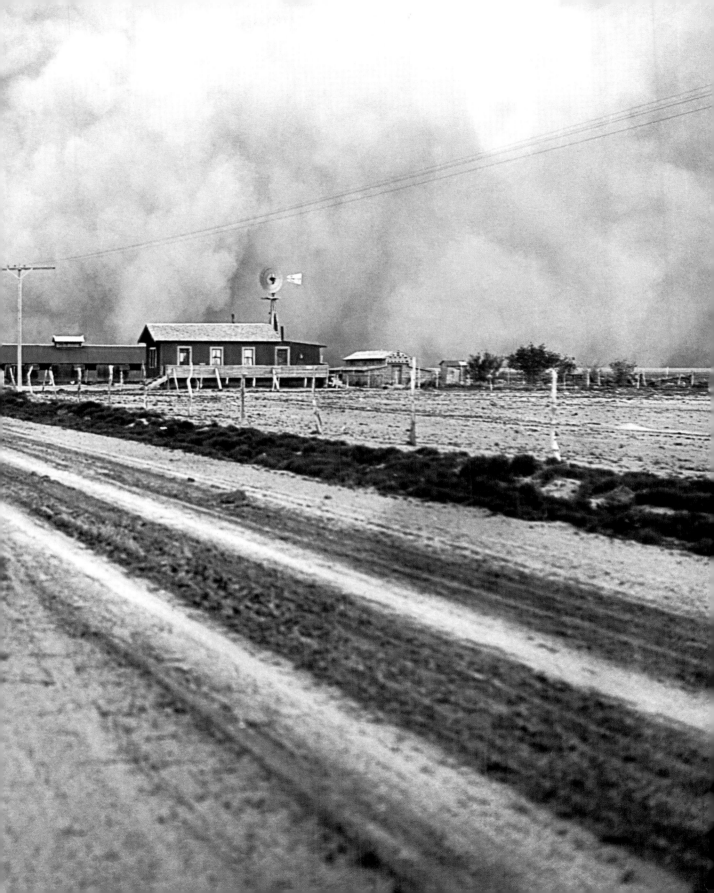

‹‹ The Dust Bowl ›

During the 1930s intense dust storms destroyed large
swathes of agriculture and devastated the ecology of the
American and Canadian prairies. Although three waves
of drought (in 1934, 1936 and 1939–40) had left the
soil parched, poorly adapted farming methods were
probably more important catalysts of what would become
known as the Dust Bowl. In the previous decade, settlers
to the area had brought with them the practice of deep
ploughing. Combined with increased mechanization
in the form of tractors, this enabled farmers to convert
large areas of grassland into initially productive fields.
However, in doing so they tore up the deep-rooted grasses
that were playing a vital role in maintaining the structure
of the soil and its moisture content during periods of
high wind and low rainfall. At the onset of drought, these
fields quickly desiccated, leaving the top soil exposed to
wind erosion. Gusts turned the soil to dust, which was
carried high up into the sky where it formed vast clouds
that locals referred to as 'black rollers' or 'black blizzards',
such were the clouds' effectiveness at blocking out the
sun. One of the worse dust storms of that (or any) period
in American history occurred on 14 April 1935, when it
is estimated that a single storm removed 300 million tons
of topsoil from farmland.

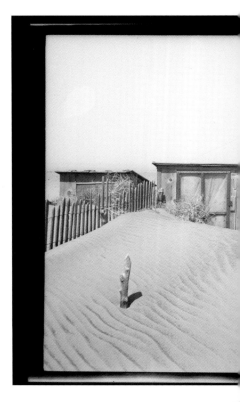

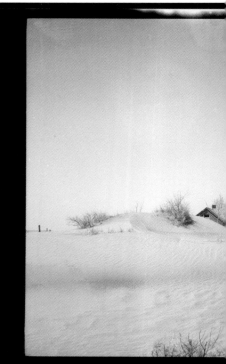

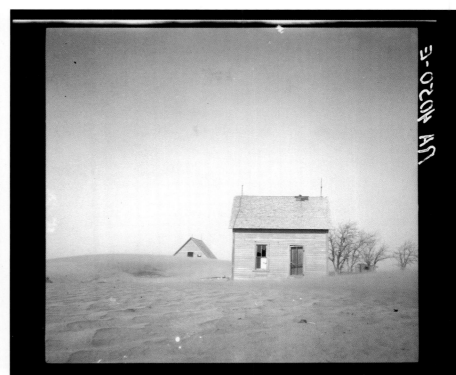

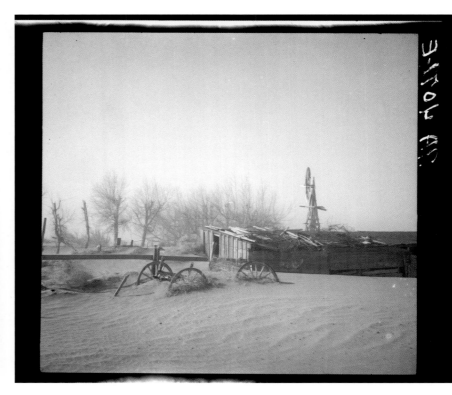

Burning Coal

Taken by the renowned American photojournalist
W. Eugene Smith on 1 January 1950, this photograph
captures a typical scene in a Welsh mining village, at a
time when quarter of a million people worked in the UK's
coal mines. The UK has a long history of being one of the
largest miners and consumers of coal. At the start of the
eighteenth century, 2 million tons of coal was mined in
Britain, representing more than 80 per cent of the global
total. One hundred years later, coal mining had increased
five-fold to 10 million tons a year, and by 1900 the UK's
mines were delivering more than 200 million tons a year,
with production reaching its peak a few decades before
this photograph was taken.

However, from that point, a set of interacting
factors led to a sustained decline. The Clean Air Act of
1956 reduced the amount of coal burnt in UK homes;
mainline steam trains were being replaced by diesel
locomotives; and more people were travelling in petrol-
powered motor cars. In the 1980s, coal-fired power
stations started to be replaced by gas, which was being
produced in large quantities from gas fields in the North
Sea, while acid rain (a product of burning high-sulphur
coal) and greenhouse gas emissions became headline-
grabbing environmental factors that further reduced
coal's popularity. The decline has been so rapid that for
two months during the summer of 2020, the UK did not
burn any coal to generate electricity, marking the longest
coal-free period in the country since the world's first coal-
fired power station opened in London in 1882.

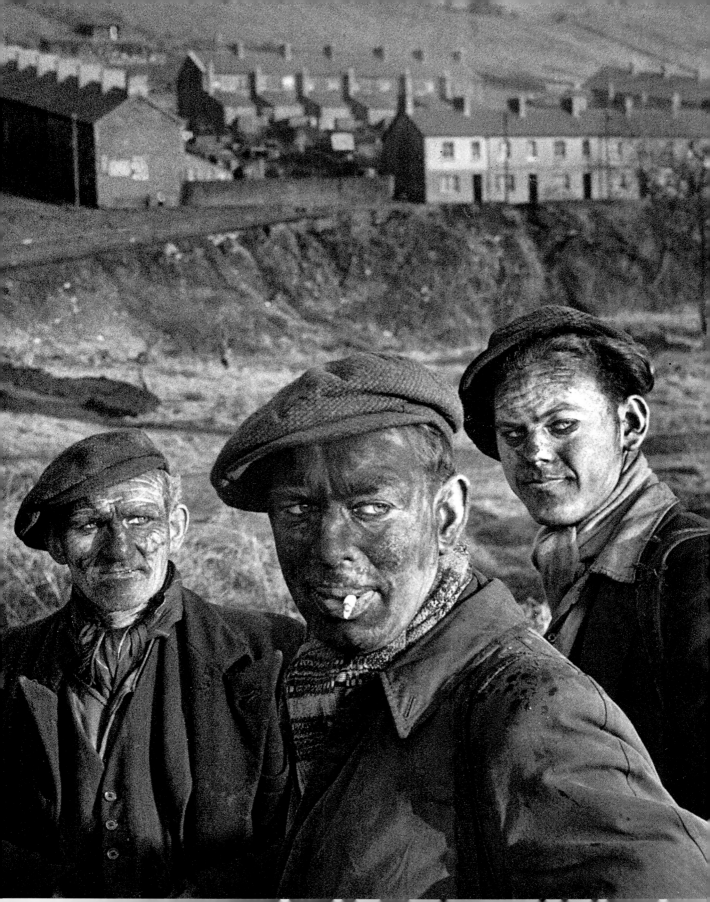

Hurricane Camille

Hurricane Camille was the most powerful hurricane of 1969, and the second-most intense hurricane ever to make landfall in the USA. With sustained wind speeds of 175mph and gusts exceeding 220mph, Camille devastated wide swathes of the Deep South, including the city of Biloxi, Mississippi, shown here.

The genesis of the hurricane was a low-pressure system that formed off the west coast of Africa. As it travelled across the Atlantic, the pressure system deepened, producing a series of large thunderstorms. By the time it reached the Bahamas it had developed into a large tropical storm with winds in excess of 60mph, and the conditions were ripe for it to expand into a full-blown hurricane. When Camille crossed over Cuba it was already a small hurricane, and it picked up further energy in the Gulf of Mexico, where its eye narrowed, air-pressure dropped and winds increased.

Hurricane Camille barrelled into the city of Bay St. Louis, Mississippi, at 11.30 a.m. on 17 August. It travelled across to the eastern seaboard and then north until it dissipated over the course of 20 August. By then, more than 250 people were dead and damage totalling $1.42 billion (in 1969) had been sustained across Louisiana, Mississippi, Alabama, Florida, Ohio, West Virginia and Virginia. Virginia was hit particularly hard, as even though the wind speed had dropped considerably by the time the hurricane reached the state, Camille was still producing intense rain storms. These caused a series of lethal landslides that were directly responsible for the deaths of 153 people in the state. Of these, 123 deaths – including twenty-one members of the Huffman family – were in Nelson County.

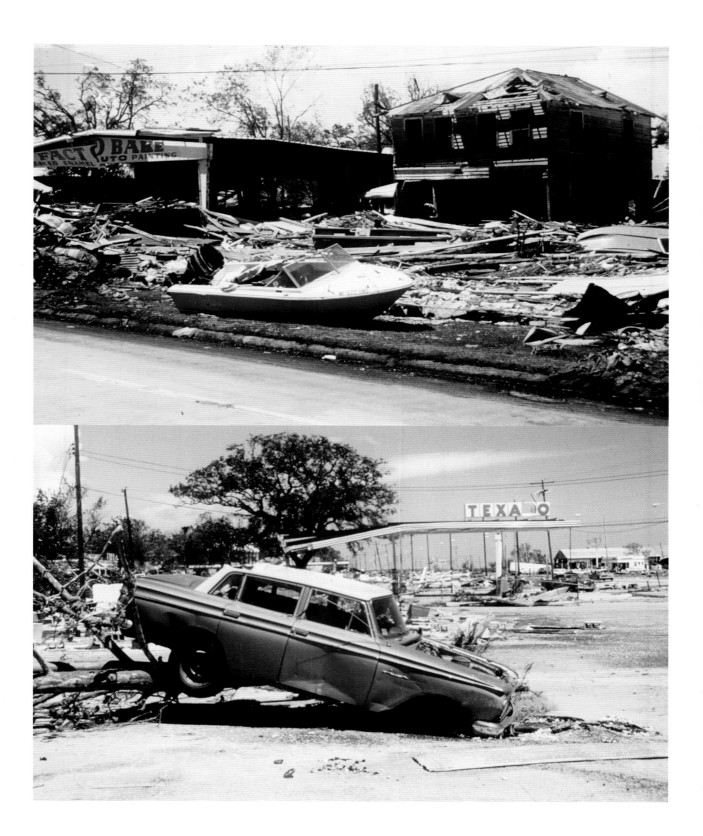

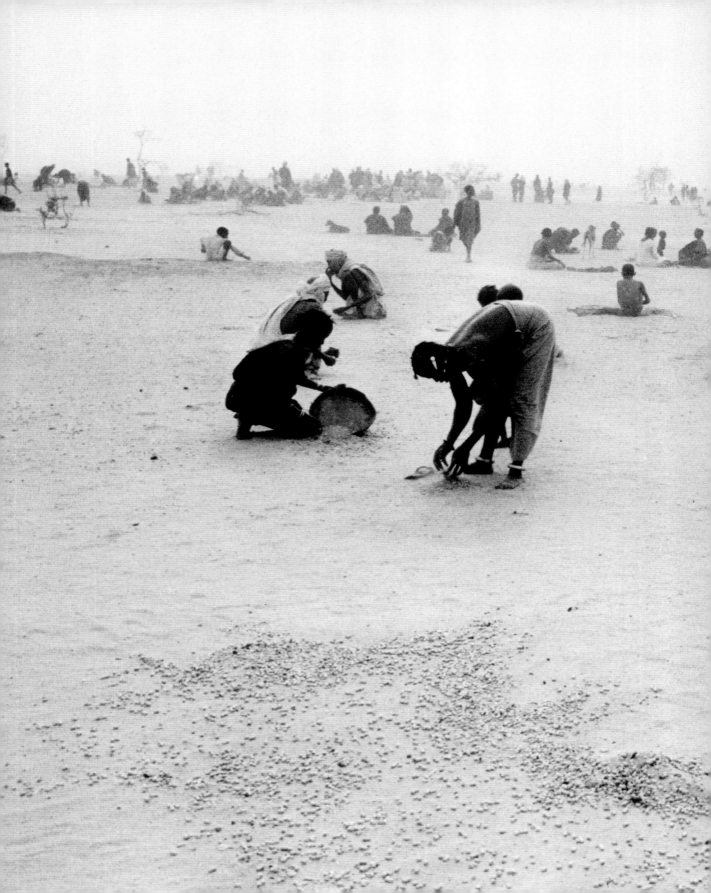

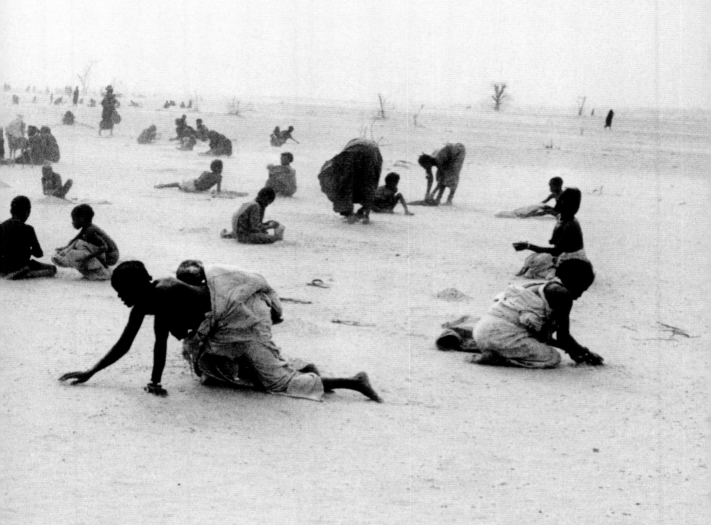

<< Sahel Drought >>

Taken in 1973, the image on the previous page shows
nomads picking up bran sticks from sacks dropped by
plane by the French Army, as drought gripped the Sahel.
Despite receiving international aid, by the early 1980s
it is estimated that 100,000 people died due to food
shortages and disease, with 750,000 more needing food
aid to survive.

Over time the Sahel has witnessed profound climate
change. Around 6,000 years ago, this semi-arid belt,
which stretches across the width of Africa, received far
more rainfall than it does today and was comparatively
lush. But bands of rain have since moved south, leaving
this area of more than 1 million square miles much
drier. Despite this there have been multi-year periods of
wetter conditions that have produced a more hospitable
environment. One such period began in the 1950s when
increased rainfall supported the expansion of agriculture
to feed growing populations. However, these clement
conditions ended abruptly with the onset of a crippling
drought in the early 1970s, which saw rainfall decrease
by a third. A possible explanation for the drought is
that increased farming and cattle ranching intensified
desertification, which led to the land surface becoming
darker. This would not only increase temperatures by
absorbing more energy from the sun, but also reduce the
amount of cloud cover by lowering the soil's capacity to
hold the water from which the clouds are formed.

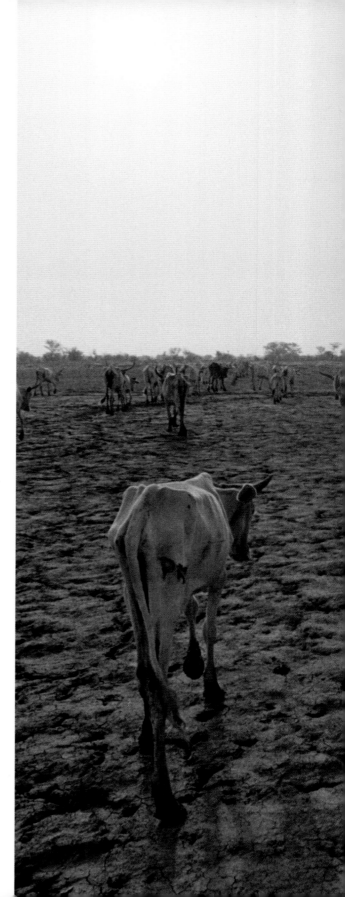

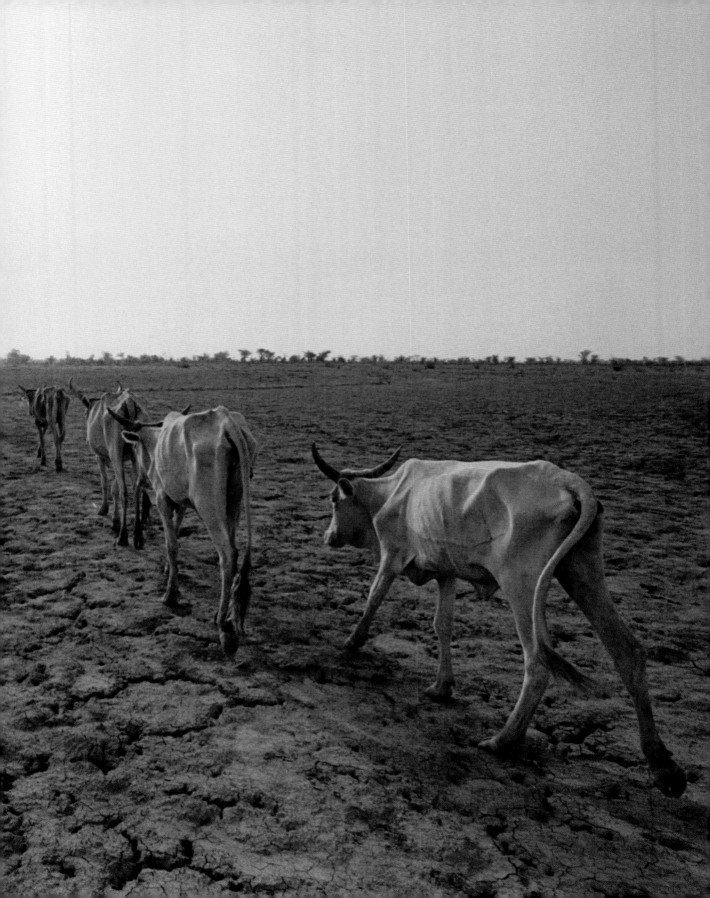

UK Heatwave

By August 1976, some regions in south-west England had not seen rain for forty-five days. This was the culmination of the driest summer the British Isles had experienced since 1772, and the second hottest summer ever recorded in the UK. The drought had started the previous summer with significantly lower-than-average rainfall and this trend continued all the way through to spring 1976. By May of that year a hosepipe ban was invoked in an attempt to protect dwindling water reserves, but as temperatures continued to increase, reservoirs dropped further and some rivers ran completely dry for the first time in living memory. By July, water restrictions were forcing some companies to shorten their working week and wildfires were breaking out in southern England.

As desperate farmers watched crops wither in their fields, the UK government responded by implementing the Drought Act, which gave local governments the power to ration water to homes and businesses. Public water standpipes – such as this one in the town of Northam, North Devon – became a common sight across much of England and Wales, and for a while were the only source of fresh water for large sections of the population. The extreme weather seared itself into the country's psyche and future hot summers were always compared to 1976. It was not until 1995 that the UK experienced a summer that was comparably hot and dry.

Glacier Retreat

Located in north-west Montana, Glacier National Park spans two ranges of the Rocky Mountains and was once home to more than 100 glaciers. However, as this pair of photographs of the Grinnell Glacier show, climate change has led to their precipitous decline. From the mid-nineteenth century, glaciers in the national park have gradually retreated as northern hemisphere temperatures have increased. This melting accelerated between the First and Second World Wars, slowed during cooler conditions up to the 1980s, but has since increased again.

The dynamics of glaciers involve some fairly complex processes, but the degree by which they advance or retreat is simple: if the amount of melting at lower, warmer elevations exceeds the amount of snow that is being deposited at higher, colder elevations, then the glacier will retreat. Therefore, the increase in global temperatures – and subsequent increased melting – is producing a global shift in the mass balance of glaciers. At the current rate of retreat it is estimated that nearly all of Glacier National Park's glaciers will be gone by 2030.

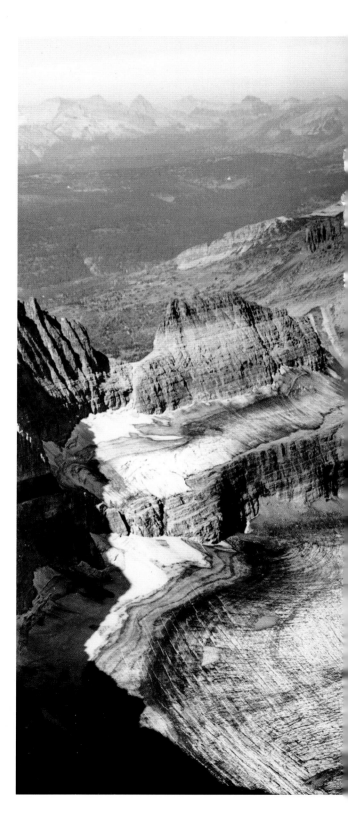

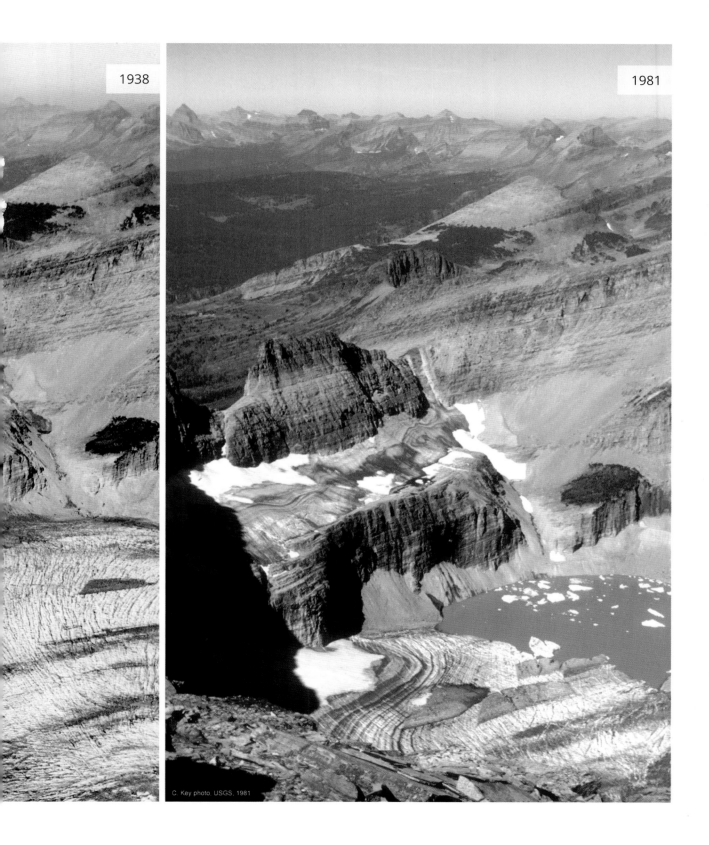

1938

1981

C. Key photo, USGS, 1981

Watching the Weather

Modern meteorologists have a vast array of data from which they can build their forecasts. In Europe alone there are 4,500 weather stations providing near real-time information on a range of environmental variables, while a constellation of weather satellites orbits the planet continuously, beaming back observations. However, despite today's technological advances, a crucial tool in the meteorologist's arsenal continues to be the relatively simple weather balloon.

First used at the end of the nineteenth century by the French meteorologist Léon Philippe Teisserenc de Bort, weather balloons are now launched frequently from 800 locations across the globe. Most are made of latex and filled with hydrogen, and as they ascend, the decreasing air pressure allows the balloon to expand – balloons regularly reach an altitude of 18 miles above sea level, at which point they may be 100 times larger than they were at launch. They carry with them an array of instruments, contained within a small box called a 'radiosonde', which measure temperature, pressure, atmospheric gases and a range of other variables. Most radiosondes transmit this data back to ground stations while they are in the air, but others are released from the balloon to return to the ground via parachute, providing scientists with incredibly accurate information about atmospheric conditions.

The Great Storm

Crushed by a fallen tree, this pair of telephone boxes in Brighton, UK, were just two of the victims of the Great Storm of 1987. Between the evening of 14 October and the morning of 15 October, large swathes of southern England, France and the Channel Islands were battered by hurricane-strength winds, as a powerful extratropical cyclone rolled in from the Atlantic Ocean. This type of weather system is characterized by very large regions of spiralling clouds rotating around an area of low pressure. It can increase rapidly in intensity – which is known as 'explosive cyclogenesis', or more commonly, a 'weather bomb' – and is notoriously difficult to forecast.

On the days leading up to 14 October, a region of low pressure had caught the interest of meteorologists across Europe. The air pressure at the centre of the developing storm dropped precipitously in the space of twenty-four hours as it headed east along the Atlantic, but on the morning of 14 October, the UK's Meteorological Office forecast that the storm would pass south of the English Channel, largely avoiding the British Isles.

However, due to gaps in land and ocean weather monitoring, the Met Office was unaware that the storm had veered north and was on a collision course with the south of England. By the evening of 14 October, winds in the south-west of the country had reached gale force, and over the course of the night they increased to peak at speeds of 140mph. A day later, around 15 million trees had been felled by the storm and the cost of the damage to homes and businesses was an estimated £2 billion. Nineteen people had also lost their lives, but as the storm had peaked overnight – when most people were indoors – the number of casualties was considered far lower than it could have been had the weather bomb landed during the day.

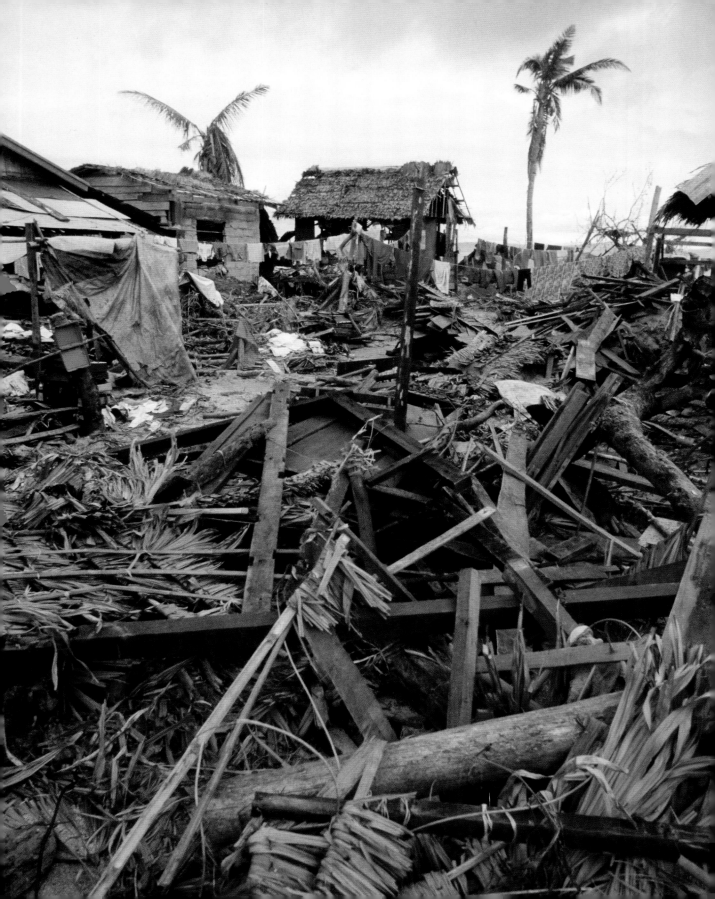

< Typhoon Nina >>

Although The Great Storm caused significant damage to southern England in October 1987, it pales in comparison to the tragedy that befell the residents of Luzon in the Philippines when Typhoon Nina tore through the island the following month. Photographs of houses reduced to matchwood starkly demonstrate the terrifying destructive power of the storm, which destroyed 90,000 homes, leaving 150,000 people homeless and killing 812. Such was the intensity of the typhoon that in some areas of the island virtually every structure was damaged extensively or destroyed entirely.

The scale of the devastation was a product of three factors that came together: Firstly, Typhoon Nina was a very powerful storm. As it approached the north of the Philippines it intensified rapidly, producing sustained wind speeds of 165mph as it made landfall on Luzon. Secondly, Luzon is the most populous island of the Philippines, with around 30 million people living there in 1987. Thirdly, most of the island's population was vulnerable to extreme winds and flooding. While people in the south of England the previous month had been largely sheltered from hurricane-strength winds in brick-and-mortar houses, most of those seeking shelter from Typhoon Nina did so within lightweight shacks constructed from timber and corrugated metal. Neither of these could resist the typhoon's wrath for long.

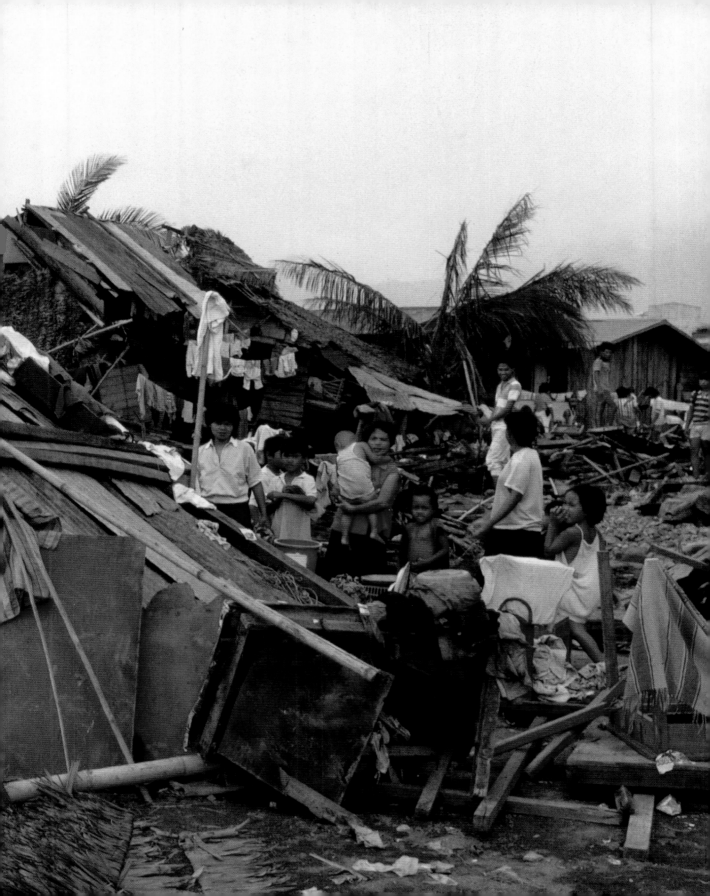

European Heatwave

Photographs of young Parisians cooling down in the fountains of Parc André Citroën in July 2003 may suggest an idyllic childhood summer, but the city was in the grip of the hottest summer Europe had experienced for at least 450 years. While Mediterranean regions also contended with abnormally high temperatures, the impact of the heatwave was most severe in more northerly areas, with France being particularly badly hit. A typical summer in northern France is mild, as cooling weather systems from the North Atlantic roll in from the west, but during July and August 2003, hot and dry weather moved further north than usual. As a result, the city of Rennes in north-west France recorded temperatures in excess of 40°C, compared to an average July high of 22°C.

It was not only the extremes of heat that proved lethal, but also the duration. Early August saw a week of consecutively high temperatures and the region's housing was simply not designed to withstand such prolonged hot periods: air conditioning was not widespread and older houses built with solid stone walls held on to the heat throughout the night, giving their occupants no respite. This was exacerbated by the urban heat island effect, which arises from the extensive use of dark surfaces, such as asphalt, that absorb far more heat than the natural landscape. Combined with other factors, a humanitarian disaster stretched across Europe. Although the final death toll can never be established accurately, some studies estimate that the number of excess deaths attributed to the heatwave exceeds 70,000, of which almost 15,000 were in France.

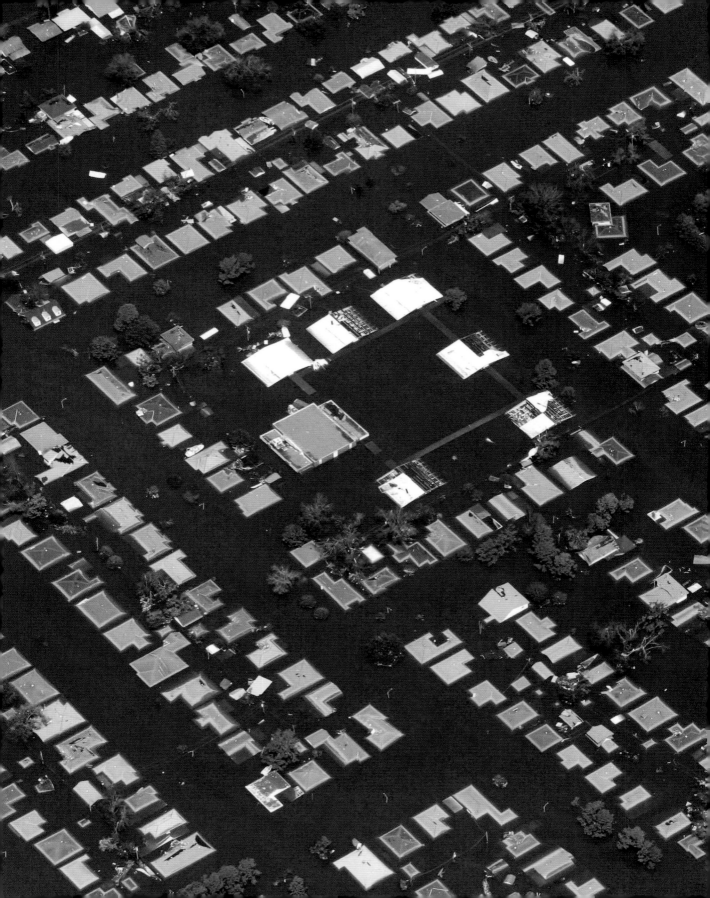

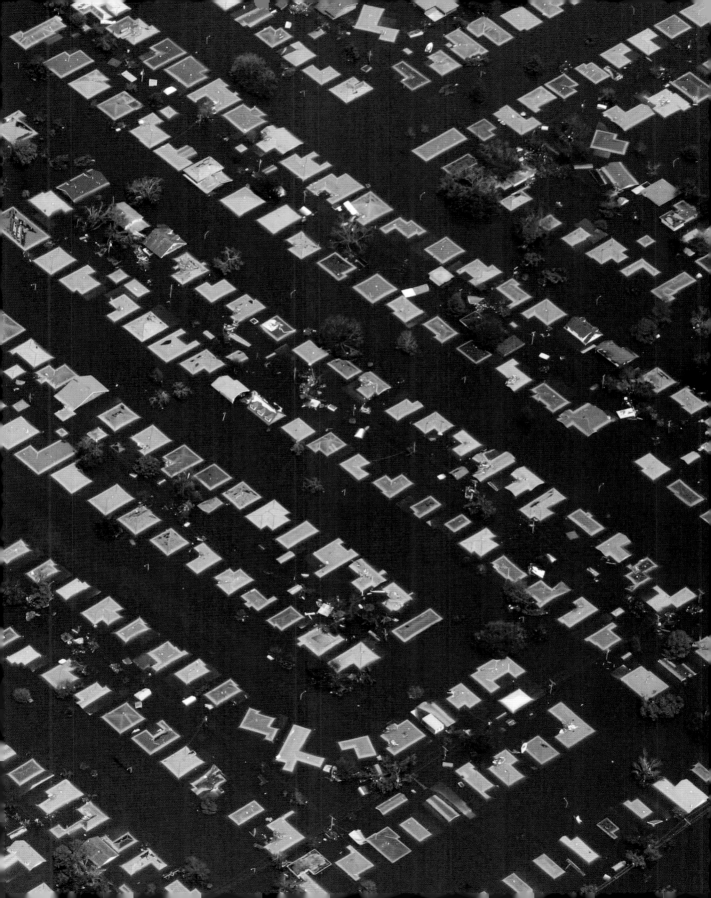

« Hurricane Katrina (I)

Over the course of 23 August 2005 a period of intense low pressure deepened over the south-western Atlantic Ocean to produce a tropical storm. The storm made landfall in Florida on 25 August before continuing back out to sea, where, fed by the warm waters of the Gulf of Mexico, it intensified rapidly. By the end of the day a hurricane was born.

Hurricane Katrina continued to grow until 28 August, at which point it was producing sustained winds of 175mph. Although the wind speed had decreased to 120mph by the following day, it still wreaked havoc when it crossed Buras-Triumph, Louisiana, before making its final landfall near the Louisiana–Mississippi border. In places, Katrina dumped more than 12 inches of rain within the space of a few hours, while intense winds and low atmospheric pressure produced a bulge in the sea that formed a storm surge measuring more than 13 feet high. It was this sheer volume of water that led to the catastrophic failure of the levee system that was designed to protect the metropolitan area from flood. By the time Hurricane Katrina dissipated, 80 per cent of New Orleans was underwater and more than 1,800 people were dead.

Hurricane Katrina (II)

New Orleans is surrounded by water: to the north by Lake Pontchartrain, to the east by wetlands and Lake Borgne, to the west by further wetlands and to the south by the Mississippi river. Most of the city is also lower than its surroundings, which means it is kept dry by an extensive levee and water-pumping system that has grown up with the city. Built and maintained by the US Army Corps, the levees were designed to protect the city from the sort of extreme rainfall produced by a hurricane, and in places they stood 30 feet high. However, the tremendous forces produced by Katrina were simply too much for the levees to take. Twenty-seven points on the flood-defence system either leaked or disintegrated completely, and although heavy lift helicopters were called upon in a desperate attempt to plug some of the breaches, the city was submerged.

A review of the disaster found numerous faults with the levees, including the use in their construction of steel piles that were too short. Although this had reduced the initial cost of building the levees, it was far outweighed by the rescue, recovery and rebuild operation, which is estimated to have cost $125 billion. Not only did this make Hurricane Katrina one of the most expensive extreme weather events in human history, but it also made the levees one of the most expensive and lethal engineering failures the USA has ever seen.

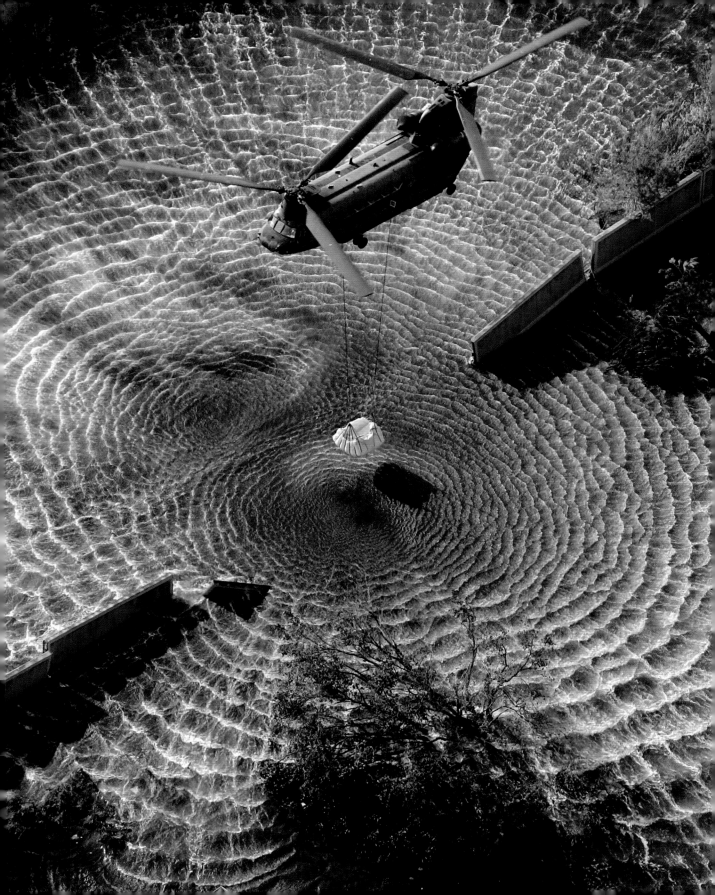

The Thar Desert

Straddling India and Pakistan, and covering 77,000 square miles, temperatures in the Thar Desert range widely over the year, from sub-zero in winter to over 50°C in summer. The amount of rainfall varies, too; the desert receives anywhere between 4 inches and 18 inches of rain a year, with 90 per cent of this falling between July and September in monsoon season.

Yet despite having such an inhospitable climate, the Thar is one of the most heavily populated desert areas in the world. This is despite its inhabitants having to travel to wells that can be several miles away to collect water, with a need to make multiple trips in some areas. It is unsurprising that prolonged disruption of the monsoon that replenishes the Thar's meagre water supplies would have a devastating impact on the farmers of the region, and would mean some people need to make ever more arduous journeys to collect water.

A wide range of other animals also inhabits the desert, including more than forty reptile species among the dunes and scrub, and 140 species of bird. Like all desert organisms, most of these creatures are highly adapted to the harsh environment and live at the limit of temperature tolerances, making them as vulnerable to climate change as polar bears. We are already witnessing a reduction in the diversity and abundance of animals and plants in deserts across the globe as a consequence of human-caused climate change, and with further rises in temperature the physiological limits of all desert animal species – humans included – will be tested to the limit. The more pessimistic climate change scenarios would see the Thar Desert largely uninhabited by the end of the twenty-first century.

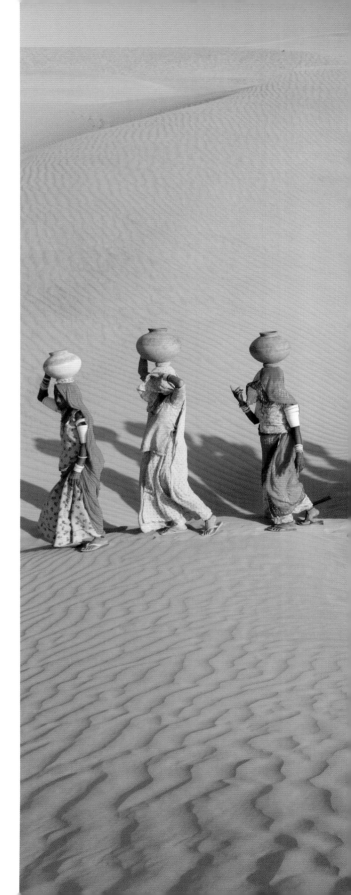

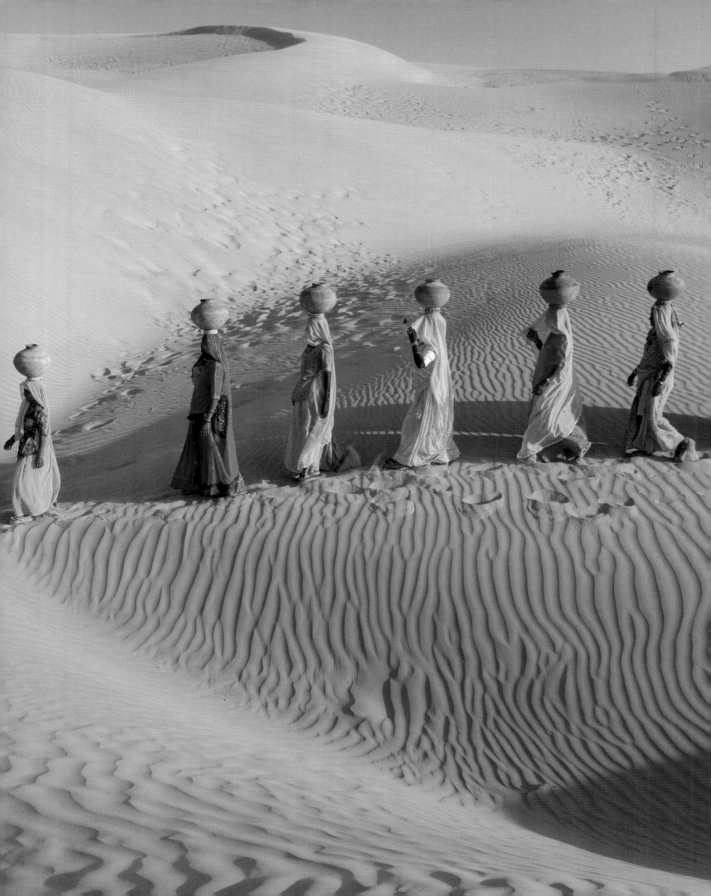

Mediterranean Wildfires (I)

The Mediterranean summer of 2009 was very hot and very dry. With temperatures reaching 44°C in Spain, and only half the average rainfall for that time of year, it might have been ideal for tourists seeking the summer sun, but the high temperatures that lasted throughout May and June had dried out the region's soil and vegetation. With such tinder-dry conditions it was perhaps only a matter of time before parts of Spain, Greece and France ignited, creating a series of wildfires that raged across the region.

This aerial view of the outskirts of the French city of Marseilles, taken on 23 July, shows a fragment of land spared from intense burning that started when practice firing by the French army set fire to dry vegetation. The blaze eventually consumed almost four square miles, leading to the evacuation of a retirement home and scores of other residents of the Trois Ponts suburb, and making it one of the worst fires to hit the area in recent years.

With more hotter and drier summers predicted, climate change is expected to increase the risk of wildfires throughout southern Europe. However, over the past few decades better land management has successfully produced a steady decline in the number of wildfires being started. Although the 2009 fires burnt a total area of 1,250 square miles across southern Europe – almost double the area that was burnt in the previous year – this was still below the average for the previous 30 years, demonstrating that at least some of the expected impacts of climate change can be mitigated against.

Mediterranean Wildfires (II) »

France was not the only country hit by wildfires in the summer of 2009. On the Greek mainland, wildfires swept through fourteen towns over the course of three days, including the suburbs of Athens, as shown in this photograph from 23 August.

Wildfires are a natural occurrence, and in some ecosystems regular and limited fires are associated with increased biodiversity and ecosystem resilience. Mature trees can survive wildfires that clear out understory vegetation, which allows the seeding of new plants that can provide diverse habitats for more animal species.

However, the rate of wildfires in Europe and other continents continues to be many times higher than the natural rate. The primary reason for this is human ignition, and while this can be accidental – a discarded cigarette, for example – the majority of these fires are started intentionally. There is good evidence that most of the fires that raged across Greece in 2009 were started initially to clear land for farming, or to burn agricultural waste, but strong winds carried embers and set new fires, leading many of them to spread out of control.

‹‹ Australian Dust Storms

Dust storms are common in Australia, which is hardly surprising given that it is the world's driest inhabited continent. However, the eastern dust storms of 2009 were unprecedented, and remain the largest dust storms (in terms of visibility reduction) to pass over Sydney since records began in 1940. Between 22 and 24 September, a plume of dust almost two miles long swept east across the country, enveloping the cities of Canberra, Sydney and Brisbane in a choking red haze. The dust was so thick in places that it triggered smoke alarms, while flights into Sydney airport were diverted and scores of people were hospitalized with breathing difficulties.

Beyond the immediate health impacts and disruption, the greatest danger that dust storms present to Australia is the loss of vital topsoil from farmland. This is yet another challenge for farmers who are increasingly having to battle water scarcity due to multi-year droughts. As well as drying out soil through a combination of higher temperatures and more variable rainfall, climate change will also reduce the amount of vegetation in the driest areas, and as vegetation is lost, so the soil is robbed of its stabilizing roots. To compound matters, climate change may also increase the intensity of storms and winds, which would more easily liberate the soil from the ground and hold it aloft for longer, carrying it across greater distances.

California Drought

In 2011, California found itself at the start of a drought that would last for six years. These two photographs of the Enterprise Bridge, which spans a section of Lake Oroville, were taken in 2014 and 2017 respectively. The earlier image reveals the severity of the crippling drought after three years, during which time it had killed 102 million trees, devastated farming communities and led to the introduction of emergency drought measures. However, record rainfall and snow in the mountains in early 2017 meant that by April the region's reservoirs had been replenished to levels that allowed all but four counties to lift the emergency measures.

The long period of extremely low rainfall was largely the result of a persistent zone of high pressure located off the coast of California. Dubbed the 'Ridiculously Resilient Ridge' by meteorologists, the high pressure system effectively blocked the winter storms that would otherwise pass over California and deposit large amounts of rain and snow. Given the prolonged nature of the drought, scientists explored the extent to which climate change may have affected it. Their studies concluded that while the multi-year drought period was largely driven by natural variability in the climate system, human-caused climate change had increased its intensity by 15 to 20 per cent. This was mainly as a consequence of higher temperatures that dry out soil and more rapidly evaporate water from streams, rivers and reservoirs.

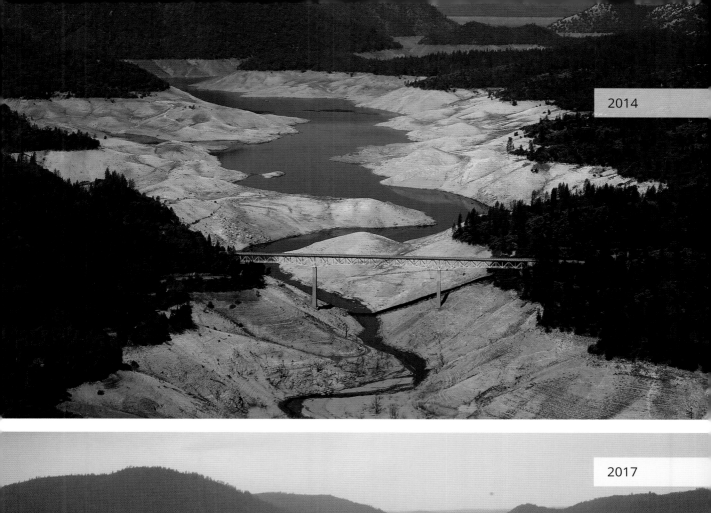

2014

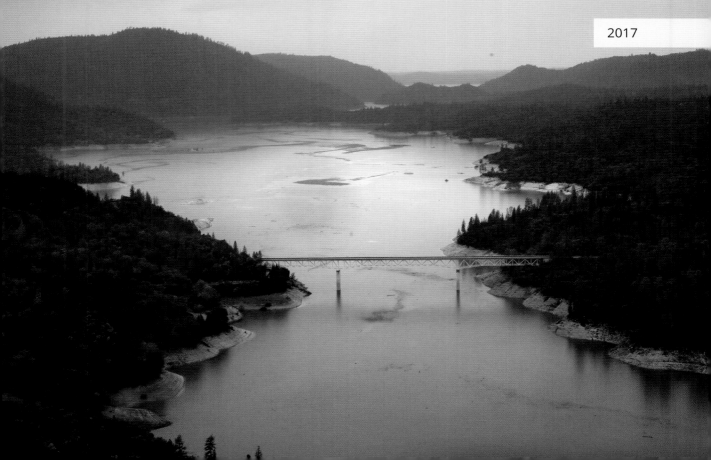

2017

East African Drought

Civil war has ravaged Somalia for decades, displacing
millions of people in the process. The origins of the
current crisis can be traced back to the mid-1980s and the
armed uprising against the country's military dictatorship.
The Somali government fell in 1991, and into that
vacuum a spectrum of different factions have continually
fought for overall control.

By 2011 the civil war was concentrated in the
southern and central regions of the country, along with
areas of north-east Kenya. During that year government
forces launched a series of major offensives against the
militant group al-Shabaab, which led to intense fighting
in the capital city, Mogadishu. The timing could not
have been worse, as people fleeing the violence were also
subjected to a severe drought that was affecting the East
African region. From July 2011, through to the middle of
2012, rainfall was well below average, with failed harvests
and a spiralling food crisis experienced across Somalia,
Kenya and Ethiopia. Many of the refugees fleeing to
the Dadaab camp in Kenya (seen here) had to make the
journey on foot and in baking hot conditions, with many
child fatalities recorded due to a lack of shelter, food
and – most importantly – water along the way. Over
the summer of 2011, Dadaab became the largest refugee
camp in the world, with a population approaching
440,000. Malnutrition and unsanitary conditions led
to huge numbers of fatalities.

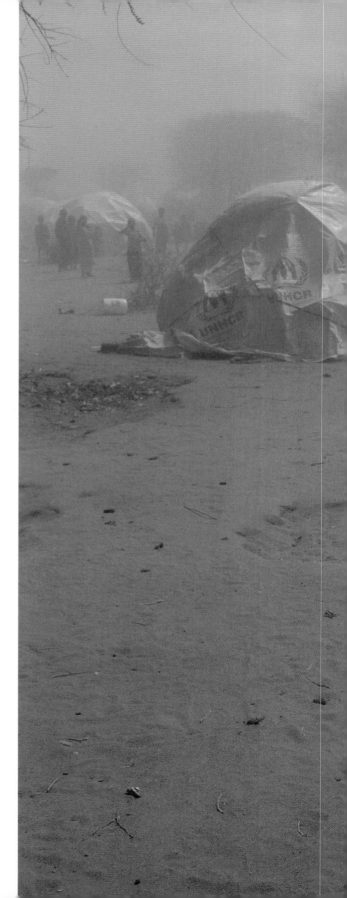

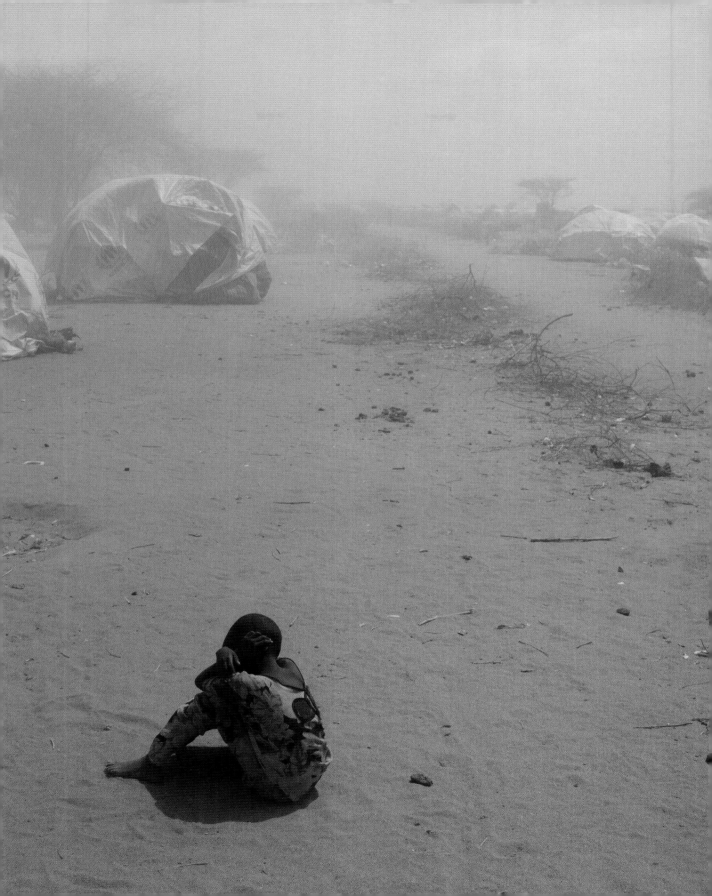

Warning Signals

Standing 13,677 feet above sea level, Mauna Loa forms part of the island of Hawaii and is Earth's largest volcano on land. Located on its flank, at an altitude of 11,145 feet, the Mauna Loa Observatory is ideally placed to monitor the concentrations of carbon dioxide (CO_2) in Earth's atmosphere, as it is far from major cities and high enough to sample well-mixed air. The first direct measurements of carbon dioxide in the atmosphere were taken at Mauna Loa by the American scientist Charles Keeling in 1958. Keeling soon discovered that the amount of carbon dioxide in the atmosphere underwent noticeable changes over the course of the year, with CO_2 levels lower in May than they were in October.

The reason for this is most of Earth's landmass is north of the equator. That means that most of Earth's vegetation is also north of the equator. During summer in the northern hemisphere, plants and trees grow, and as they do they suck in millions of tons of carbon dioxide. Then, in autumn and winter, as the vegetation dies back and decays, this carbon is released back into the atmosphere. What Keeling had observed was the first measurements of our biosphere breathing.

By 1960 Keeling had noticed another trend: carbon dioxide levels were increasing each year. In May 1958 he measured concentrations at 317 parts per million (ppm), and in May 1959 this had risen to 318ppm. This annual increase continued throughout the 1960s and began to generate serious scientific attention by the early 1970s. It was becoming clear that burning fossil fuels was swamping Earth's natural carbon sinks and that CO_2 was increasing in the atmosphere. By estimating how much carbon was being released into the atmosphere, and how much CO_2 concentrations were increasing by, scientists were able to calculate that 57 per cent of human-derived carbon emissions remained in the air. Scientists could now compare changes in CO_2 levels in the atmosphere with changes in temperatures being recorded around the world, and there was a clear match: higher concentrations of CO_2 were increasing the strength of the greenhouse effect and warming the air, land and sea.

2006
Al Gore, former Vice President of the USA, releases his environmental documentary feature, *An Inconvenient Truth*.

2009
July: France, Spain, Greece, Italy and Turkey plagued by a series of wildfires.

2011
Earthquakes and a tsunami lead to the catastrophic failure of the Fukushima Daiichi nuclear reactor in Japan. Shortly after, Germany moves to close down all of its nuclear power stations.

2014
Replaces 2010 as the warmest year ever recorded.

2008
More than 150 square miles of the Wilkins Shelf breaks away from the Antarctic coast. Scientists are concerned that climate change may be happening faster than previously thought.

2010
Replaces 2005 as the warmest year ever recorded.

2000–2010 replaces the 1990s as the warmest decade ever recorded.

2012
Hurricane Sandy hits North America, affecting twenty-four states in the USA and causing damage from the Caribbean to Canada.

But how much warmer could things get? In order to answer that vital question, scientists would need to go back further into Earth's past. If measurements of atmospheric carbon dioxide could be compared to global temperatures over hundreds and thousands of years, then it would be possible to produce a clear link between the two. This would then allow accurate predictions for future warming to be produced.

While people had been making accurate temperature records for a couple of centuries, scientists were limited to Keeling's direct measurements for CO_2, which only began in the late 1950s. Fortunately, there was another accurate record available of both temperature and carbon dioxide levels, which stretched back hundreds of thousands of years. These records were not made by humans, but by ice.

In places, the ice sheets in Greenland and Antarctica are around 2½-miles thick, and some of this ice is made from snow that fell more than 2 million years ago. As the snow fell and was compacted by further snow, it trapped tiny bubbles of air. Using a corkscrew-like drill, long cores of ice can be extracted from deep within the ice sheets and the tiny air bubbles can be used to reconstruct past CO_2 concentrations and temperatures. From this we can see that before the start of the Industrial Revolution, 300 years ago, global concentrations were around 280ppm. This had risen to 317ppm by 1958, and in May 2020, the Mauna Loa Observatory recorded concentrations of carbon dioxide of 417ppm – an increase of 100ppm in just 62 years, and a higher value than at any time during the previous 3 million years.

We are already beginning to experience the impacts that a warmer climate is having on extreme weather events. These are a foretaste of what is to come over the rest of this century

2015–16
Storm Desmond batters the UK over the New Year holiday period.

2017
June: Twenty-four hours of torrential rain leads to extensive flooding of the German capital, Berlin.

July: A series of around 9,000 wildfires burn 2,000 square miles of California, killing forty-seven people.

2015
Replaces 2014 as the warmest year ever recorded.

Paris Agreement sees 195 countries commit to limiting warming to below 2°C.

2016
Replaces 2015 as the warmest year ever recorded.

Research reveals that sea-level rise in the twentieth century was faster than in any of the previous twenty-seven centuries.

2017
August: Heatwave and drought strikes central Western Europe, contributing to a series of wildfires and the loss of 127 lives.

September: A discarded firework starts the Eagle Creek fire, just one of a succession of wildfires that burns more than 670 square miles in Oregon.

Hurricane Sandy (I)

Hurricane Sandy was a vast weather system that measured more than 1,000 miles across when it tore through Haiti in late October 2012. The country was still reeling from a catastrophic earthquake that had struck the previous year, destroying or damaging quarter of a million homes and causing an estimated 100,000 to 300,000 deaths. As a result of this earlier disaster, millions of people had been relocated to refugee camps, so when the high winds and heavy rains of Hurricane Sandy started to lash the country they were striking an already extremely vulnerable population. The hurricane left tens of thousands more destroyed houses in its wake, making a further 200,000 people homeless and killing at least fifty-four. Roads and bridges were damaged, and it is estimated that $750 million of devastation was caused in the space of just two days.

The weather system didn't just have an immediate impact, either. Almost half of Haitians are reliant on the agriculture sector and the ravaged landscape saw 350 square miles of crops lost, bringing further misery to farmers who had been battling drought earlier in the year. It is a cruel irony that as one of the world's least industrialized nations, Haiti has had little impact on the climate, but it is this lack of industrialization – as well as its location – that makes it vulnerable to climate change.

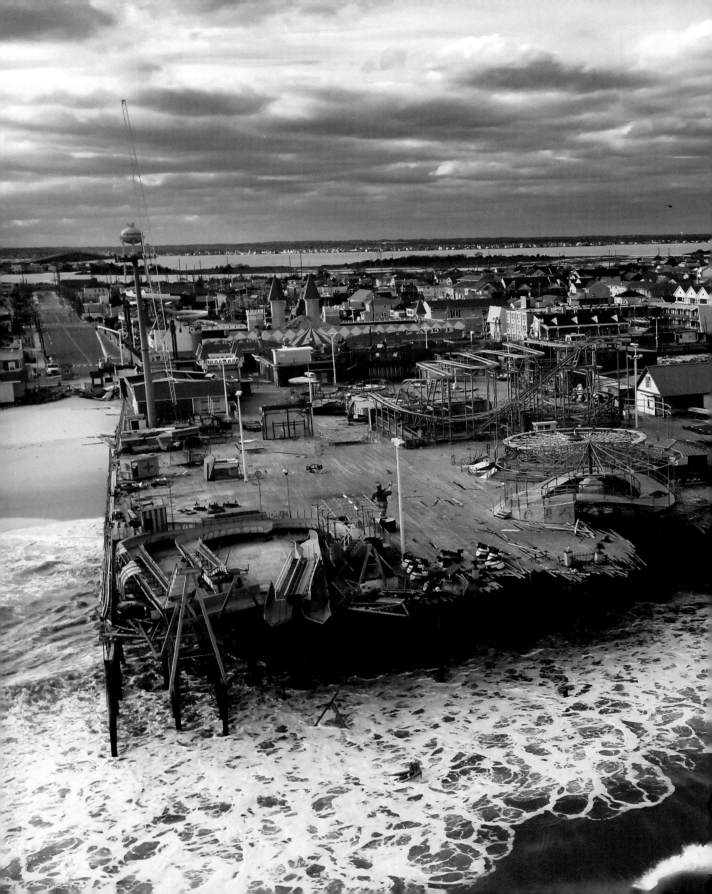

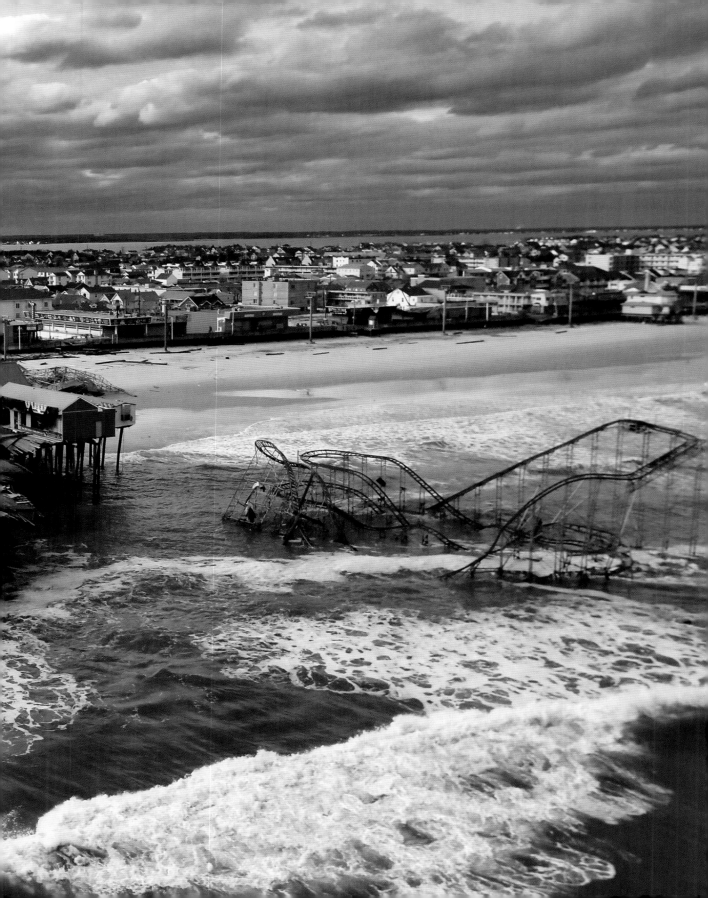

◄◄ Hurricane Sandy (II)

Waves break in front of the remains of Casino Pier, Seaside Heights, New Jersey on 31 October 2012, two days after the region had been battered by Hurricane Sandy. Although far more powerful storms had made landfall in the continental USA in the past, Hurricane Sandy was one of the costliest, due to its long journey through twenty-four states. From Florida to Maine, Sandy killed 150 people and caused nearly $70 billion in damage. Across the country at least 8 million people experienced power outages, with some areas disconnected for several weeks.

A particular feature of the storm was its interaction with other weather systems. As Hurricane Sandy moved past New Jersey it collided with a cold front, while an existing storm to the north effectively kept Sandy and this new weather system pressed close to the coast. The resulting 'Frankenstorm' produced strong winds that could be felt more than 1,000 miles off the eastern seaboard, and at its greatest extent one quarter of mainland USA was covered by the Hurricane Sandy storm system. The combination of rain and strong storm surges resulted in unprecedented flooding in New York City, putting subways and roads beneath several feet of water. In doing so, the storm brutally exposed the vulnerability of northern states to extreme weather that had previously been assumed to only affect southern parts of the country.

Hurricane Sandy (III)

Cut almost in half, Princess Cottage became an icon of the damage inflicted on the Union Beach community by Hurricane Sandy. Although the construction of many of these New Jersey homes was sturdy enough to weather gusts of over 100mph, they couldn't hold out against the large storm surge that washed away their foundations. Governor Chris Christie's assessment at the time, that 'the devastation on the Jersey Shore is probably going to be the worst we've ever seen', proved entirely accurate: more than 340,000 homes were destroyed or damaged, many of them by the coast. At one point, more than 2 million homes were without power, and over the course of two days the hurricane claimed thirty-seven lives and produced a $30 billion storm-damage bill for the state. By the end of October the storm's destructive power began to wane as it moved inland, before dissipating on 31 October. Sandy didn't disappear completely – its associated weather systems continued to produce storm surges and flooding in the state of New York during the first few days of November.

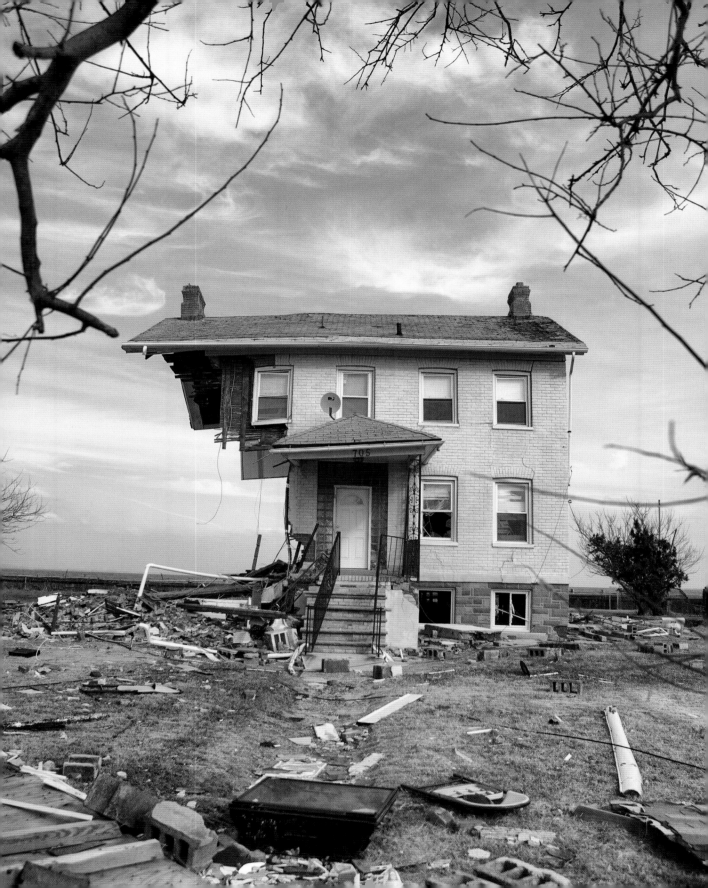

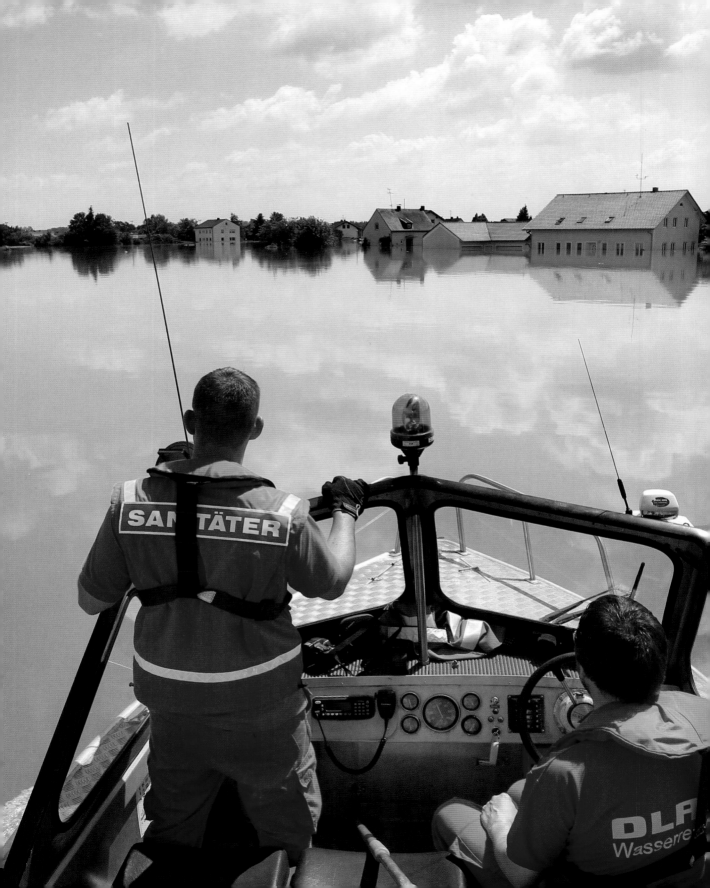

Central European Flooding

Over the three days between 30 May and 1 June 2013, central Europe experienced some of the worst flooding on record. It followed a particularly wet May, which had seen record levels of moisture in the soil in Germany and twice the average amount of rainfall in Austria, so when exceptionally heavy rain started at the end of the month, the saturated land was ripe for flooding. Unable to absorb any further rainfall, the water travelled across the land as runoff, with hills and valleys acting as vast funnels that concentrated the water into streams and rivers. More rain fell in parts of Austria than would normally be seen in 2½ months, while the border city of Passau, where the Danube, Inn and Ilz rivers converge, recorded its highest water level since 1501. In this photograph, members of the German Life Saving Association (DLRG), patrol the flooded streets of the town of Deggendorf, Bavaria, four days after the rain had ceased.

Following the flooding, research revealed that the preceding three decades had been one of the most flood-rich periods in Europe for 500 years. It also revealed that the present-day floods were importantly different from historical events. Whereas earlier flooding was associated with cooler-than-usual periods and was more evenly spread across the year, the recent floods were more closely related to warm weather over the summer months, making them far more seasonal. This trend is likely to continue as climate change continues, so floods that might once have been expected to occur once every 100 years will become more frequent, increasing the risk to both property and life.

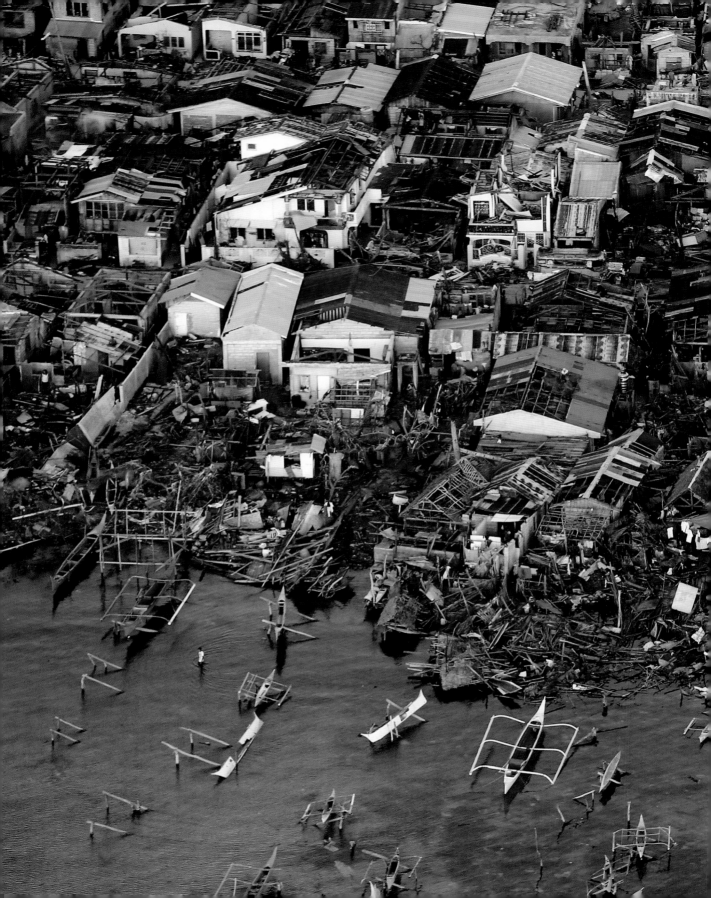

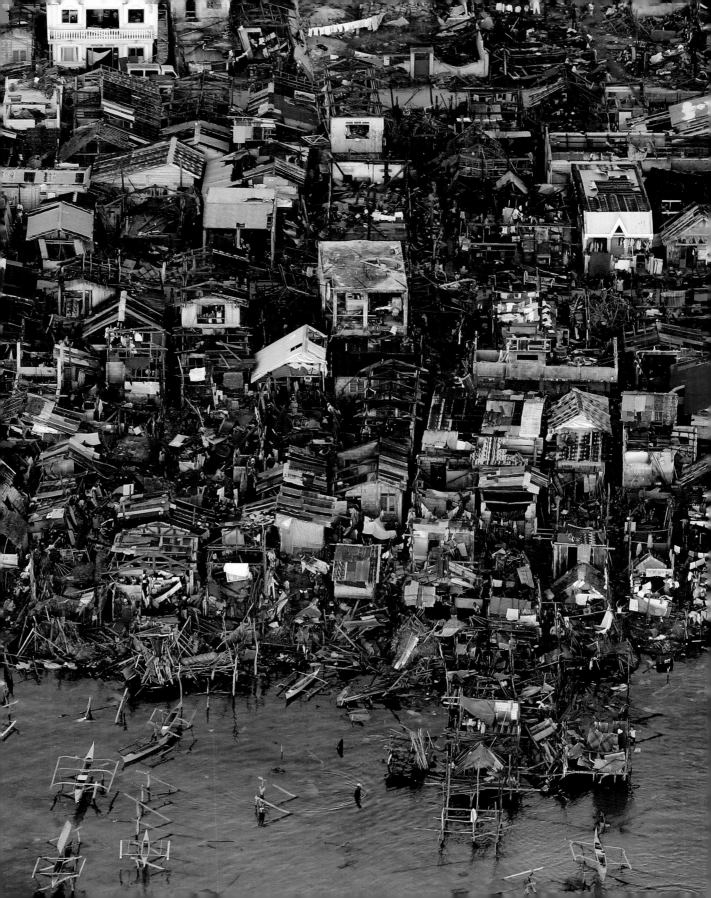

‹‹ Typhoon Haiyan (I)

The Philippines is no stranger to typhoons: every year, around ten of them threaten the archipelago, with approximately half proving to be dangerously destructive. Typhoon Haiyan was not only the most destructive to date, causing more than $2 billion in damage, but also the deadliest in decades, with 6,300 lives lost. These staggering losses were a direct result of the intensity of the storm, which remains one of the most powerful typhoons ever recorded – at its peak, sustained wind speeds of 195mph were recorded, with gusts exceeding 230mph.

Like Atlantic hurricanes, typhoons derive their energy from hot surface waters, which drive enormous convection systems that translate heat into kinetic energy. The island of Samar was the first to feel Haiyan's wrath, when it struck at 8.40 p.m. on 7 November 2013. As this photograph shows, the typhoon's winds effectively erased entire towns, and while concrete structures in the regional capital of Tacloban were more resilient, most buildings in the city were damaged in some way. The water was just as damaging as the wind, with storm surges producing 20-foot waves. As a result, the terminal building at Tacloban airport was submerged up to its second storey, with damage to the rest of the airport and the island's roads severely limiting the rescue and clean-up operations.

Typhoon Haiyan (II)

Tanauan is a small town on the Philippine island of Leyte, which had the misfortune of lying directly in the path of Typhoon Haiyan. The scale of devastation is hard to imagine: 1,380 of the town's population were killed, many thousands were seriously injured and it is estimated that more than 90 per cent of the city's buildings were damaged or destroyed. The amount of debris on roads into and out of the city left survivors cut off from help for days, so the town hall was rapidly repurposed into an emergency centre where the homeless and wounded gathered. Although people's vulnerability to typhoons can be reduced significantly with improved early warning systems and evacuation orders, the absence of large flood-protection schemes and poorly enforced building codes means catastrophic damage is likely to continue in the Philippines under any climate change scenario.

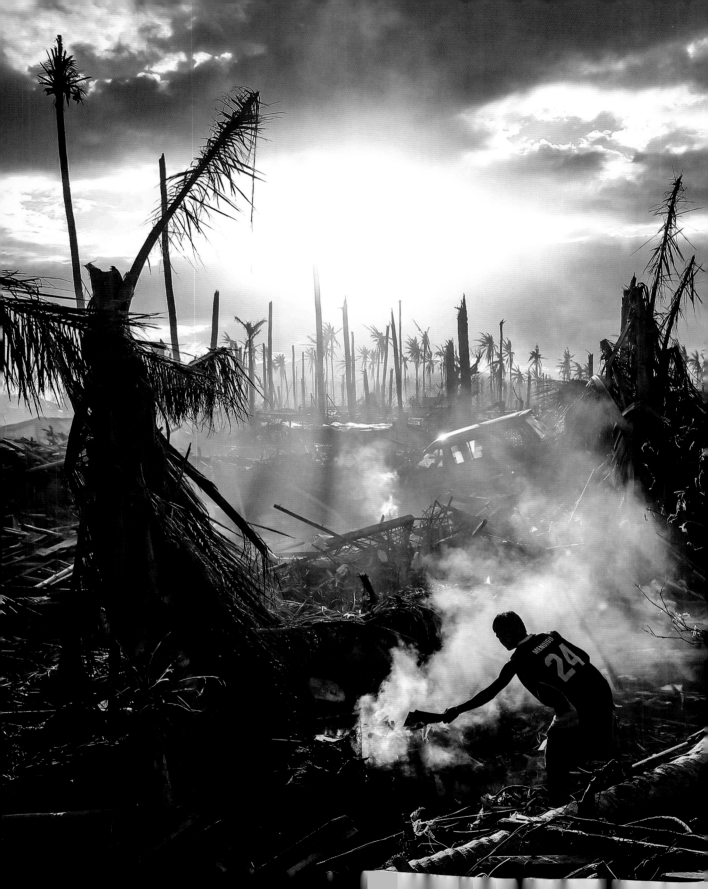

Fracking

First discovered in 1911, the Belridge Oil Field in Kern County, California, shown here, had produced more than 1.5 billion barrels of oil by 2009. But by then the oil fields were becoming depleted and the volume of the USA's oil production was roughly half that of its 1970 peak, when the nation pumped 9.6 million barrels a day.

However, the fortunes of the oil companies were to be transformed by the widespread application of hydraulic fracking. First employed in the 1950s, fracking uses pressurized water and other fluids to break rock formations in order to allow the oil trapped within them to be more easily pumped to the surface. Working in this way allowed a sustained increase in oil production from 2008, and by 2013 fracking was responsible for more than 43 per cent of all oil produced: the USA – the world's largest oil producer – was pumping 19.5 million barrels a day. The increase in fracked oil is mirrored by an increase in fracked gas, which has transformed the country's electricity generation sector.

The USA also continues to be the world's largest user of oil. Consuming 19.7 million barrels a day, it is the country's long history of fossil fuel use that explains how and why it still leads the world in terms of cumulative emissions of carbon dioxide. Carbon that was emitted centuries ago is still in the atmosphere and is still having a warming effect. Consequently, countries that industrialized early – such as the USA and the UK – were for many decades the largest producers of carbon dioxide. This 'head start' in emissions means that the USA remains firmly in the number one spot, with the UK in a surprising third place considering its size.

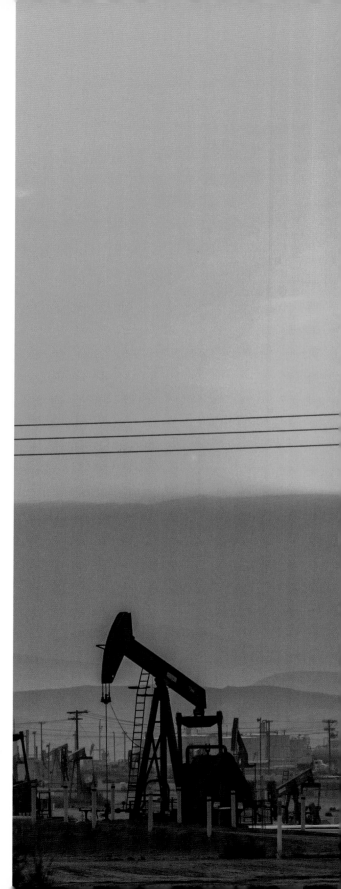

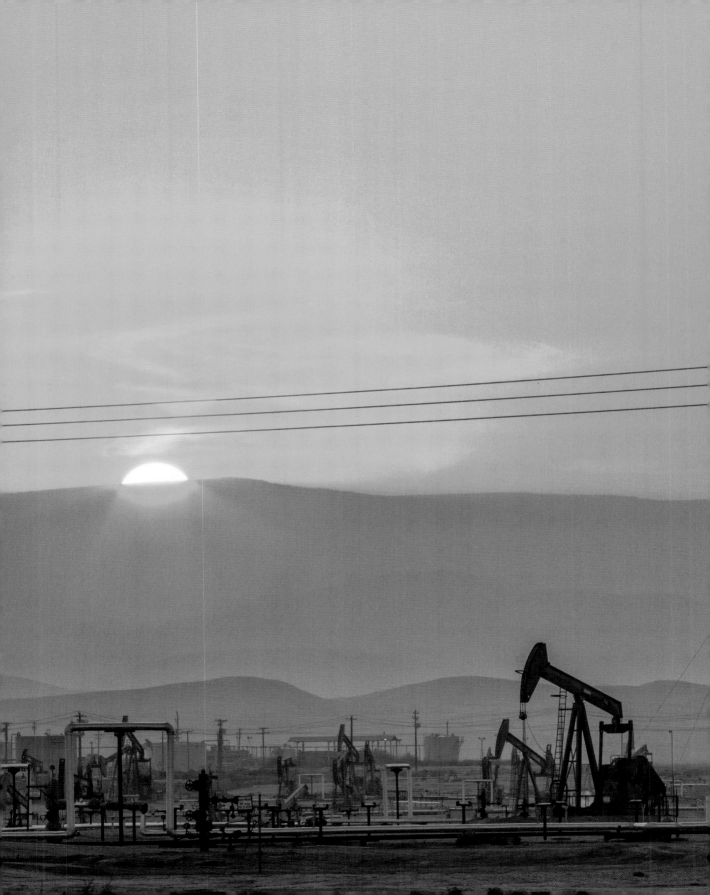

The Bramble Cay Melomy

Lying 34 miles south-east of Papua New Guinea, at the northern end of the Great Barrier Reef, the diminutive island of Bramble Cay appears as a tiny point on most maps, if indeed it appears at all. But this 10-acre island is notable for two reasons: it is the most northerly point of Australia, and was once home to the Bramble Cay melomy (*Melomys rubicola*).

The Bramble Cay melomy was a large rat-like rodent, and when it was first encountered by British sailors from HMS *Bramble* in April 1845, it was estimated that the island was home to many hundreds of Bramble Cay melomys. A survey in 1978 found a similarly large population, but just two decades later the population was less than 100, with researchers unable to find any at all in surveys conducted in 2011, 2014 and 2015. Consequently, the Bramble Cay melomy was officially declared extinct by the International Union for Conservation of Nature (IUCN) in 2015, and by the Australian government in 2019.

As the highest point of Bramble Cay is less than 10 feet above sea level, the melomy's habitat was always vulnerable to climate change and extreme weather, so it is very likely that flooding brought about the demise of this little animal. This makes the Bramble Cay melomy the first mammal species to have its extinction categorized as being the direct consequence of climate change.

Storm Desmond

Storm Desmond was the fourth named storm of the UK's 2015–16 storm season, which was to be the most active storm period that the British Isles had ever recorded. In total, eleven storm systems battered the region, although Desmond was by far the most destructive, thanks to the tremendous amount of rain it unleashed. Storm Desmond was also a severe example of an 'atmospheric river', which is a weather phenomenon where bands of very moist air transport vast quantities of water through the atmosphere. These bands are usually around a couple of thousand miles long and several hundred miles wide, and move more water than the Amazon river.

Originating in the warm waters of the Caribbean, Storm Desmond snaked its way north-east across the Atlantic. As it met the hills and mountains of the British Isles it was forced upwards, which condensed water vapour into rain droplets. This rain began to fall on the west coast of Ireland, Wales and, in particular, the north of England – on 5 December 2015, Honister Pass in Cumbria received more than 13 inches of rain in the space of twenty-four hours. This intense deluge produced widespread flooding, with 5,200 homes in the region inundated, and thousands of people being evacuated.

In this photograph, a woman cleans the windows of her wine bar in York, North Yorkshire, as floodwaters rose following the rivers Foss and Ouse bursting their banks. The unprecedented scale of the flooding also led to water cascading over Malham Cove in North Yorkshire – an event not witnessed for more than 200 years, and which momentarily turned the 260-foot cliff into England's highest waterfall.

Athabasca Oil Sands

This aerial photograph, taken in 2015, gives a sense of the scale of the tar sands mining operations in Athabasca. Located to the north and east of the city of Edmonton, in Alberta, Canada, these deposits of tarry fossil fuels cover an area that is approximately the same size as the state of Florida. The oil can be extracted from around 1,800 square miles of the tar sands, using a process known as surface mining. This involves stripping away the covering forests or peat bogs to expose the tar sands, which are removed and processed to produce a liquid oil product.

However, surface mining is a resource-intensive operation, and for every barrel of oil that is produced, three barrels of fresh water are needed, which generates vast amounts of polluted waste water that is held in tailings ponds along the Athabasca river. In 2018, the tar sands operation yielded approximately 3 million barrels of oil a day, producing enough waste water to fill more than half a million Olympic-sized swimming pools.

Processing the tar sands also consumes huge amounts of electricity. In total, 13 per cent of Canada's electricity is generated in Alberta, and 95 per cent of that is produced by burning coal and gas. The net result is that if Alberta was a country it would be the fifth largest oil-producing nation in the world, with per capita carbon emissions three times larger than those of the USA.

Fort McMurray Wildfire

Taken on 6 May 2016, less than one year after the image on the previous page, this aerial photograph shows a vast wall of smoke arcing over Fort McMurray in the centre of the Athabasca oil fields. First spotted on 1 May, the fire started in a remote area, but strong winds soon began to drive it towards Fort McMurray. This led to the largest evacuation in the state of Alberta's history, with more than 80,000 people forced to flee the area, and some 2,400 homes being destroyed. The wildfire was eventually contained two months later, on 5 July, but by then it had consumed more than 2,000 square miles, devastating extensive regions of boreal forest and forcing the Athabasca oil sands to scale back operations.

The blaze followed an exceptionally dry and warm winter, which may be indicative of things to come. Research shows that temperatures in Canada are increasing twice as fast as the global average and it is becoming clear that climate change is having a significant impact on Canadian wildfires. Not only is the fire season now lasting an average of seventy-eight days longer than it was in 1970, but the area of land destroyed by forest fires each year has doubled since 1990. As climate change continues, hotter and drier conditions will only increase the destruction brought about by wildfires, and by 2050 the area of land they destroy may double again. It is also expected that there will be an increase in the frequency and severity of heatwaves: just two years after the Fort McMurray fire, a period of intense heat and humidity claimed the lives of fifty-four people in Quebec.

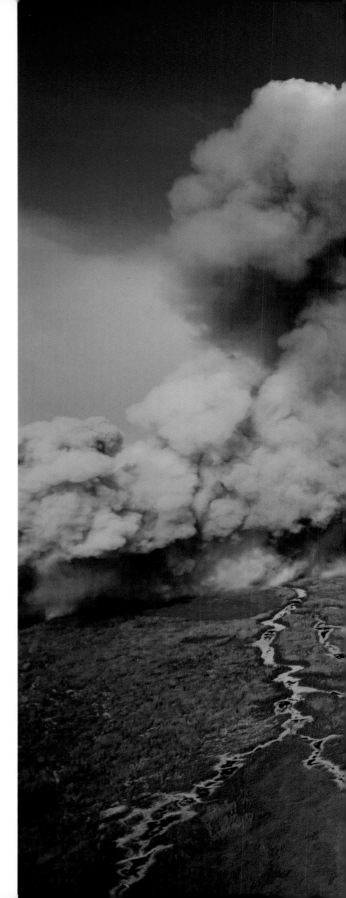

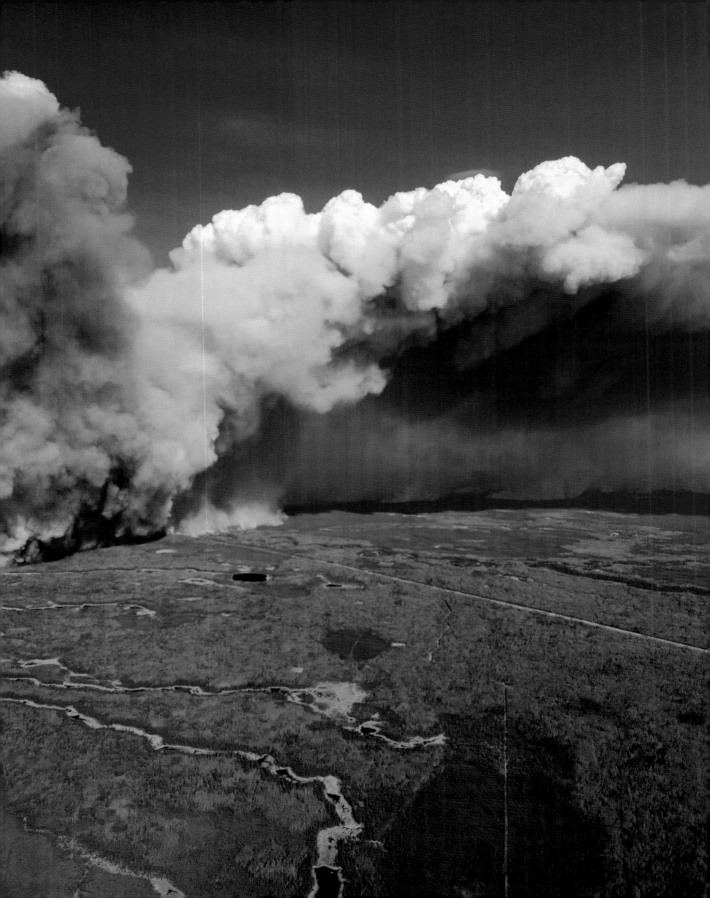

Berlin Flood

Rain started to fall on Berlin around noon on 29 June 2017. Those first drops quickly turned into an extraordinary downpour that saw more than six inches of rain fall in less than twenty-four hours – more than twice the monthly average. Water soon swamped the city's drainage system and Berlin started to flood. Aircraft on route to Berlin's Tegel Airport were diverted as the flooded runway made landings impossible, and western portions of the U-Bahn – the city's underground railway – were submerged, along with many of the city's streets. This photograph shows the Brandenburg Gate reflected in a flooded park on 30 June, after the rain had ceased.

Precipitation has increased in Germany by 10 per cent since the 1880s, and this trend is likely to continue into the future. As climate change progresses over the course of the twenty-first century it is also expected that European summers and winters will become much warmer. The maximum summer temperature in Berlin is currently on course to increase by over 6°C by 2050. This would make its future climate similar to the current climate of Canberra in Australia, which can experience summer temperatures in excess of 42°C. Exacerbating this warming trend will be the urban heat island effect, which explains why temperatures in German cities can already be over 10°C warmer than the surrounding rural areas.

Bangladesh Floods (I)

In early July 2017, following heavy seasonal rains and an onrush of water from hills in the state of Meghalaya in India, rivers in the north of Bangladesh started to rise. By 20 July nearly all of those rivers – including the Brahmaputra river – had started to flow over the danger level. As the water rose, fields and homes were inundated, and hundreds of thousands of people were left homeless.

The town of Sariakandi, which sits on the banks of the Brahmaputra, is no stranger to flooding, but it was particularly badly affected – this boy was photographed sitting inside his flooded home on 15 August, more than a month after the river started to rise. The combination of floods and cyclones, and their increased severity due to climate change, is directly threatening the lives of more than 19 million children in Bangladesh, as families in the poorest communities struggle to keep their children properly housed, fed, healthy and educated. Flooding of the Brahmaputra river region in 2017 impacted more than 480 community health clinics and damaged around 50,000 tube wells, which for many communities are the only source of safe water. The fragility of such vital infrastructure can be reduced through the construction of flood defence systems, but when budgets are already stretched by the rebuild costs from previous flooding events, such systems are often unaffordable. It is likely this damaging cycle will continue for years to come.

Bangladesh Floods (II) 〉〉

Bangladesh is one of the countries most vulnerable to climate change, as much of it lies less than 13 feet above sea level and hundreds of rivers criss-cross the land. This includes two mighty Asian waterways – the Ganges and Brahmaputra – which flow through the nation and terminate in a vast delta region that dominates the south of the country. With a subtropical monsoon climate, Bangladesh experiences large seasonal variations in rainfall, temperature and humidity. Annually, around 80 per cent of its rain falls during the monsoon season, which typically runs from June to November, and it is during this period that heavy rains can lead to rivers bursting their banks and widespread flooding.

The country is also hit regularly by powerful tropical storms, which can dump vast amounts of water within hours and produce large storm surges that can penetrate many miles into the interior: Super Cyclonic Storm BOB 01 hit Bangladesh on the evening of 29 April 1991 and thrust a 20-foot high storm surge across the coastline. While climate change is not expected to increase the number of tropical cyclones that affect Bangladesh, it is expected that warmer ocean waters will make them more intense, leading to a significant increase in the damage caused by wind and storm surges.

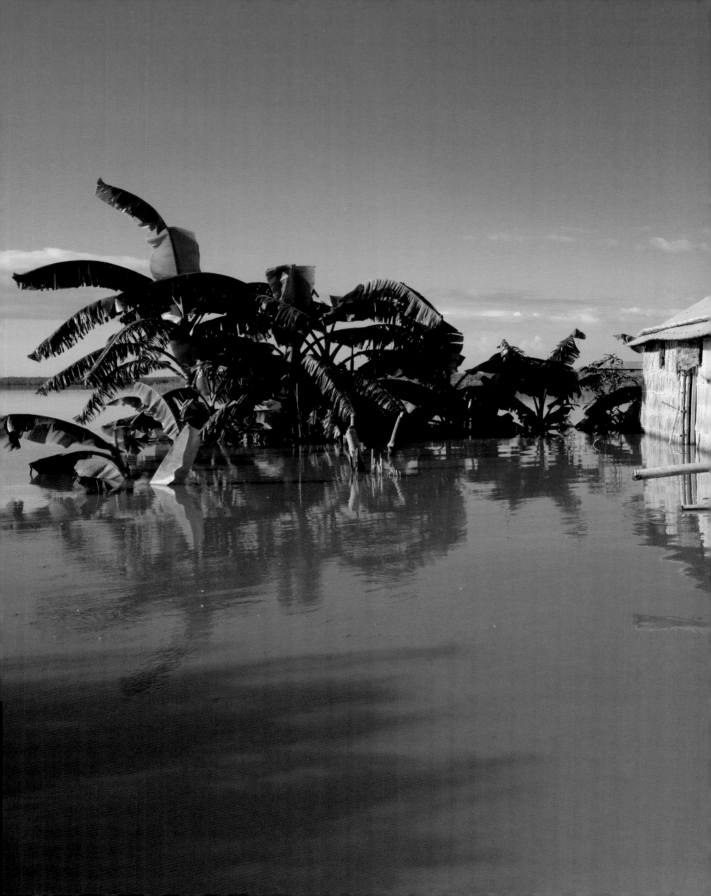

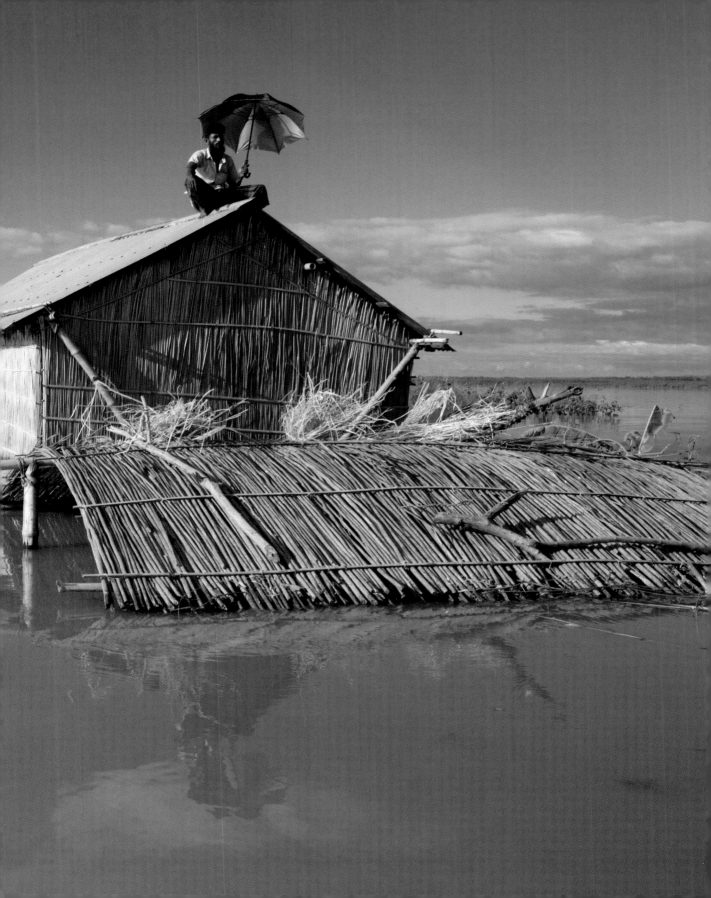

European Drought

Although Berlin experienced unprecedented rainfall in June 2017, August saw much of Europe gripped by an intense heatwave. More than 90 per cent of central Western Europe faced drought conditions, making it the most severe dry spell to hit the region since at least 1979. In Italy, temperatures exceeded 40°C across most of the country, which went on to record its fourth warmest year ever. It was also one of the country's driest, with rainfall some 80 per cent below average for the first six months of the year.

In this photograph, a young man shelters from the sun on the dried-out banks of the Po river in Linarolo, northern Italy. However, while the north of the country suffered, it was southern and central parts of Italy that were affected most. There, the drought persisted for almost one year, by which time water reservoirs were very low. Two thirds of Italian farmland was impacted, with entire crops lost in the most hard-hit regions.

The intense heat also dried out soil and vegetation, and this contributed directly to the outbreak of a series of deadly wildfires that burnt more than 4,500 square miles of land and killed 127 people. It is expected that wildfire damage in this region will increase as a consequence of climate change, resulting in long-term ecological, economic, health and social impacts. The past thirty years already show an increase in the length of the European wildfire season, and this is largely the result of higher land temperatures and an increased frequency of intense hot and dry periods. Although southern European countries are typically those most affected by wildfires, it is notable that parts of northern Europe have also experienced unprecedented forest fires in recent years.

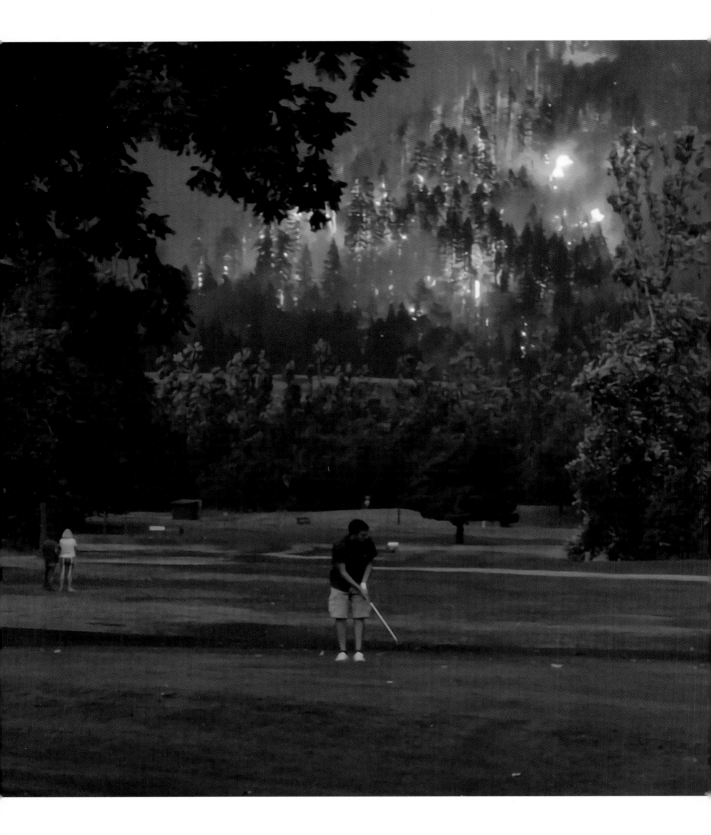

Taken by an amateur photographer, Krisit McCluer, this image went viral when it was posted on social media in 2017. It shows golfers at Beacon Rock Golf Course in the USA playing in front of Eagle Creek fire, which started when a fifteen-year-old boy threw a firework into Eagle Creek on 2 September. As shown in the infrared aerial photograph overleaf, which records live foliage as red and burnt areas as black/grey, the wildfire devastated almost 80 square miles in the Columbia River Gorge over a three-month period.

The Eagle Creek fire was just one of multiple fires that burnt more than 670 square miles across Oregon. Although this particular wildfire was ignited deliberately, exceptionally hot and dry weather had turned much of the country into a tinderbox, enabling electrical storms to start fires elsewhere. Consequently, while the number of wildfires can be reduced through improved human behaviour and fire-management practices, if climate change continues, the risk of further catastrophic fires will only rise.

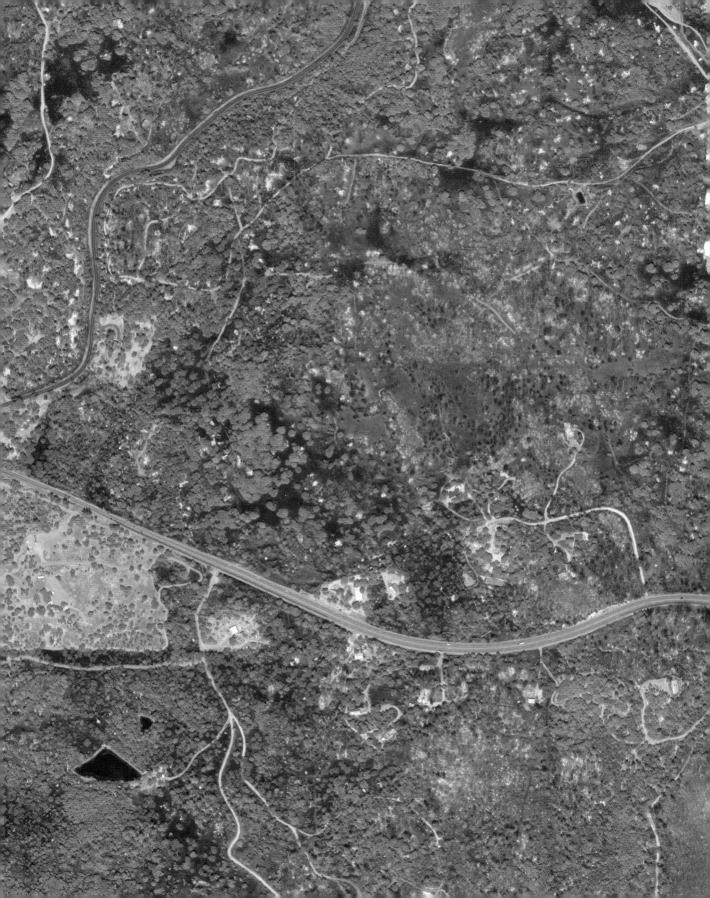

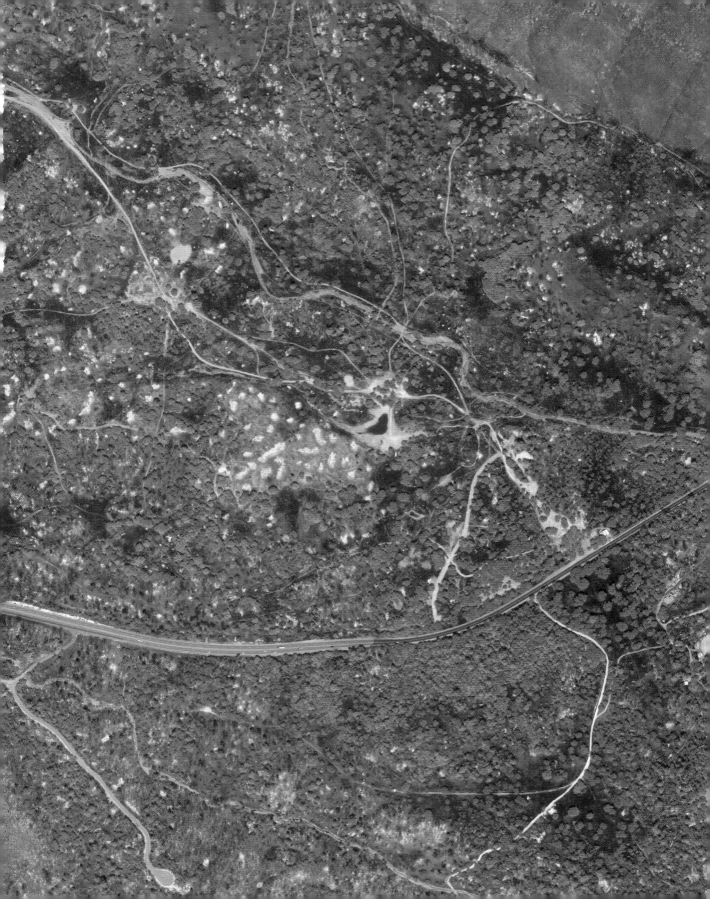

Chinese Heatwave

Much of the northern hemisphere experienced intense heatwaves in 2018, but China was particularly badly affected. As some of the 5.56 million residents of Xiangyang city cooled off in the Han river (pictured), the weather across the nation reached record-breaking temperatures. July saw all-time highs in some areas, and daily highs of more than 35°C were recorded across a region stretching from Gansu province in the north-west to Jilin province in the north-east.

In line with the global rise in prolonged periods of high temperatures, China has seen a significant increase in the number and severity of heatwaves since the 1980s. The country's National Climate Centre is in agreement with all other nations' meteorological organizations that this is a direct result of climate change. As climate change continues, high summer temperatures in China will become more frequent, and in some areas it could potentially make outdoor work impossible. If the current rate of warming stays the same, the 150,000 square mile North China Plain – currently home to 400 million people – could, by 2070, experience conditions that exceed the physiological threshold of humans.

The urban heat island effect would make cities even more dangerous, and stepping outside an air-conditioned building into intense heat for any prolonged period of time could kill a healthy adult. Even if significant cuts in carbon emissions are made now, it is likely that the inhabitants of the mega-city of Shanghai will, by the end of the century, still experience dangerous extremes of temperature multiple times during the summer months.

The Beast from the East

Although it might pale in comparison to the snows that fall elsewhere in the world, the county of Dorset in southern England has a temperate maritime climate and rarely receives snow. But even Bat's Head on the Jurassic Coast was not immune to a sustained period of very cold weather that caused temperatures to plunge across most of northern Asia and almost all of Europe.

Nicknamed 'The Beast from the East' by the British media, the cold weather reached the country on 22 February 2018. It was the result of a large anticyclone centred over Scandinavia that brought frigid winds down from the Arctic. As they travelled over the North Sea they picked up large amounts of moisture, which produced unprecedented snowfall across much of the British Isles and the rest of Europe – snow even fell on the ancient town of Pompeii in southern Italy, and the Mediterranean islands of Corsica and Capri.

To compound matters, this mass of cold air collided with Storm Emma as it rolled in off the Atlantic. Storm Emma's damper and warmer air spilled up over the cold air that had blanketed Western Europe, and as it did, moisture condensed and produced heavy snowfall. Many parts of the UK received more than 18 inches of snow over the course of just a few days. Although this produced beautiful scenes of beaches and cliffs blanketed with snow, it also created widespread disruption, with major roads, businesses and schools forced to close, and sixteen deaths recorded due to weather-related incidents.

Yet while Europe was experiencing intense cold and snow, the Arctic was recording temperatures that in some areas were more than 30°C warmer than average for that time of year. Such record-breaking weather was the result of cold Arctic air spilling southwards over Europe and being replaced by much warmer air from North America.

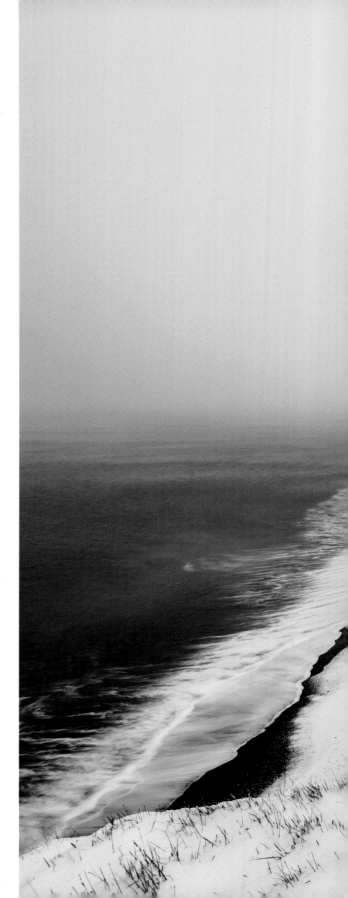

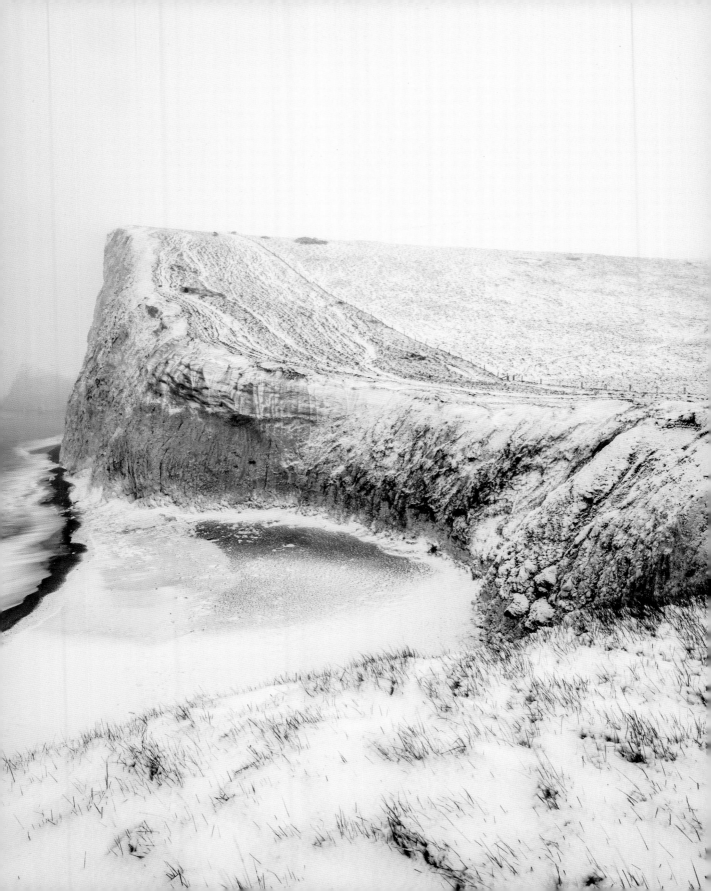

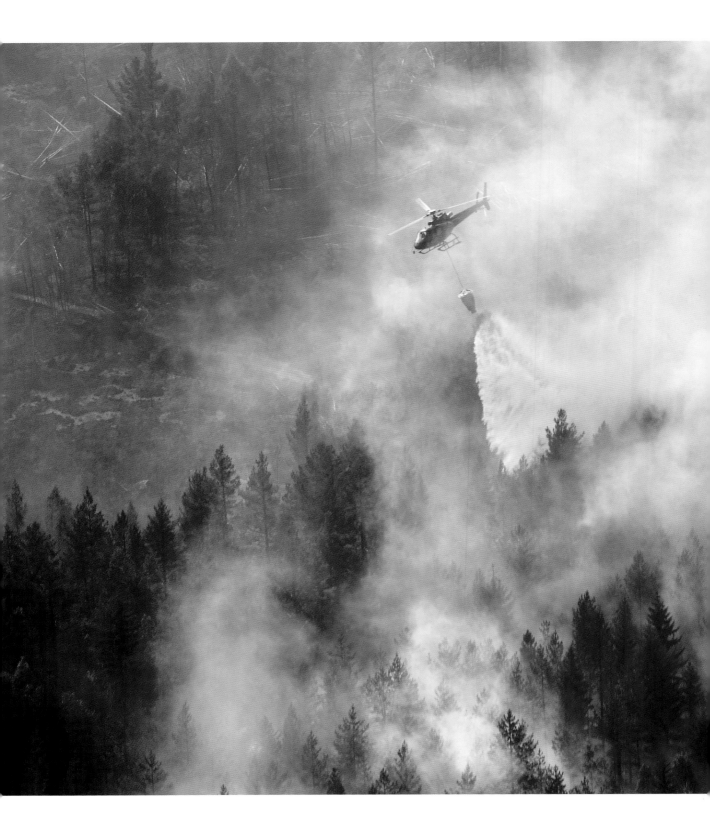

Swedish Wildfires

While 2018 started with a spell of extreme cold weather, summer saw record-breaking high temperatures across much of northern Europe, Asia and North America, as the northern hemisphere sweltered under an intense heatwave. As a result of these hot, dry conditions, Sweden experienced one of its largest wildfires in recent history, when a lightning strike ignited dry vegetation on the afternoon of 14 July. This photograph was taken near Ljusdal on 18 July, as helicopters released water over a large forest to help stem a blaze. By 23 July more than fifty wildfires were burning across Sweden, from the south of the country to the far north.

But as devastating as these were, they were just a small fraction of the fires that were raging across the Arctic. Within Siberia alone, more than 11,500 square miles – an area larger than Belgium – were on fire, producing a plume of smoke that was, for a while at least, larger than the surface area of the European Union. Fires also raged in Alaska, Canada and Greenland, destroying vast tracts of forest and grassland.

Wildfires like these are a large source of carbon dioxide. In June, the combined Arctic wildfires emitted in excess of 50 million tons of carbon dioxide, which is more than the Swedish economy releases in an entire year. What is of more concern is the potential thawing of large areas of permafrost as fires burn across them. Should these melt it would release many millions of tons of the more powerful greenhouse gas, methane. Current research concludes that this could become a major additional driver of further global warming. Although we are still some distance away from any significant release, the risk will increase if warming continues beyond the middle of this century.

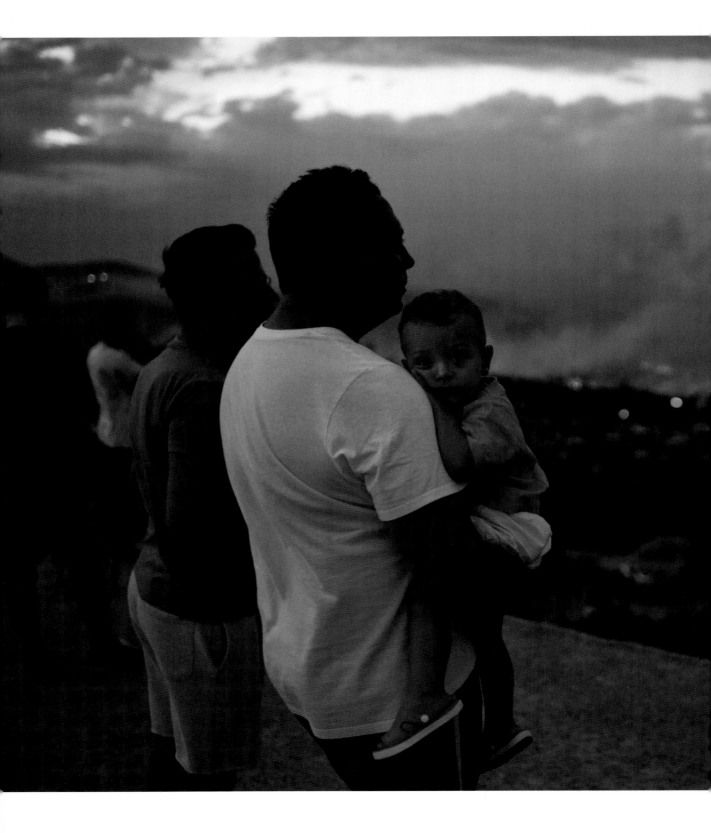

Attica Wildfire (I)

A man holds his son as a wildfire burns in the town of Rafina, near Athens, on 23 July 2018. This was part of a massive set of fires that would become known as the Attica wildfire – the second deadliest wildfire of the twenty-first century. The blaze started at two separate locations: the first, close to the small coastal town of Kineta, west of Athens, began in the early afternoon, followed by another blaze later in the day, which started in the town of Penteli, north-east of the capital. While the region's typically hot and dry summer months mean that wildfires are common, Greece – along with the rest of Europe – was in the grip of an intense heatwave that produced large amounts of fuel in the form of desiccated grasses, shrubs and trees. It was also a very windy day, so both fires grew quickly as gusts of more than 70mph drove the flames across parched land.

As the wind carried embers downwind, starting new spot fires, the fire from Penteli was soon bearing down on the small coastal town of Mati. Popular with tourists due to its seafront location, the fire swept in from the north-west, forcing many people to flee to the sea. The coastguard and private boats rescued around 700 residents and tourists from the beach who had managed to make their way through the burning town, but a group of twenty-six, possibly disorientated by dense smoke, found themselves trapped by a steep cliff. Their bodies were discovered in an open area close to a coastal road, and were just some of the 102 people who lost their life that day.

Attica Wildfire (II)

As the Attica wildfire rapidly approached a number of towns, the Greek government declared a state of emergency. At its peak, hundreds of firefighters, 250 fire trucks, five aircraft and two helicopters were battling back flames. This modified heavy lift Sikorsky S-64 Skycrane was photographed on 23 July dumping thousands of gallons of water over a portion of the fire engulfing the Greek town of Rafina. However, this would prove to be in vain, as the town was devastated.

Part of the problem is that temperatures in large wildfires can exceed 1,000°C, which will quickly dry out wood as the fire front approaches. Consequently, the sheer amount of dry vegetation, combined with strong winds, meant the fire advanced over a very wide front, continually seeding new spot fires that thwarted attempts to contain it.

Due to the severity of the Attica (and other) wildfires, new laws and land-management practices have been introduced in Greece and other European countries. These have led to a decrease in the total number of wildfires that occur, but as climate change continues, hotter and drier conditions are likely to increase the severity of any fires that start. Consequently there is no guarantee that this short-term decline will prove sustainable over the rest of this century.

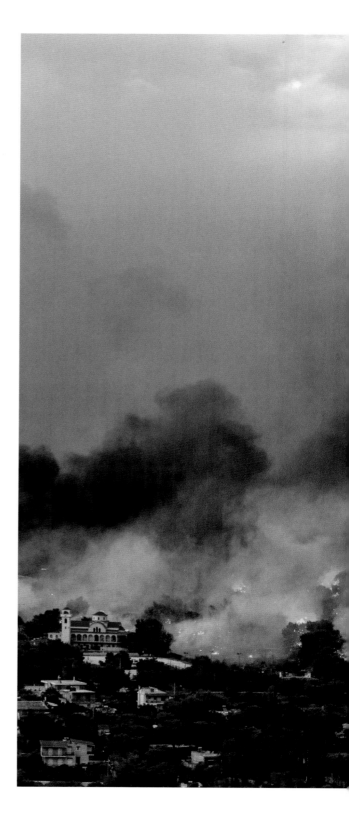

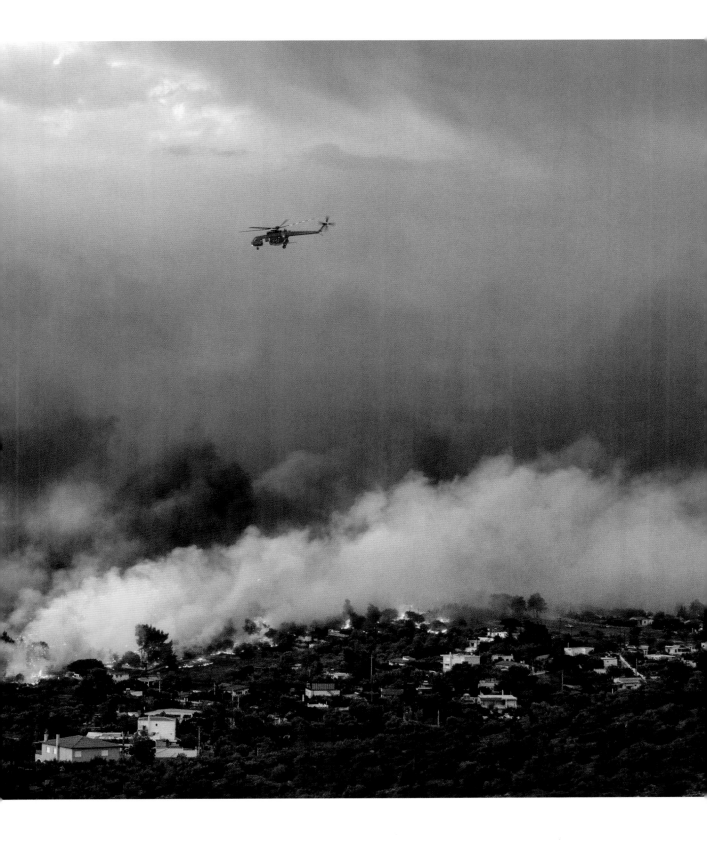

› Polar Bears »

The Arctic is currently warming at more than three times the rate of the global average, through a process called Arctic Amplification. This is the result of a number of reinforcing feedback loops, with the most important being the loss of snow and ice. As this melts, less of the Sun's heat is reflected, leading to warmer land and oceans, and further melting. From October 2017 to September 2018, the average air temperature in the Arctic was the second-highest ever recorded, while the summer of 2020 produced the lowest total extent of sea ice on record.

Polar bears are highly vulnerable to this level of climate change, as they are exquisitely adapted to their frozen homeland. They keep warm thanks to four inches of thick blubber covered by two layers of heat-trapping fur, but while this prevents them from freezing, it also means they start to overheat when the ambient temperature rises by about 10°C. They are also highly dependent on sea ice for hunting seals, and as the ice has reduced, it has affected their hunting grounds. As a result there has been an increase in human-bear conflict as they are forced to look elsewhere for food. The group of polar bears shown overleaf was photographed scavenging for food on a rubbish dump near the remote Arctic settlement of Belushya Guba on 31 October 2018. Earlier in the year a state of emergency was declared in the same area after dozens of bears entered homes and public buildings in search of food.

If warming continues at current rates, research concludes that polar bear numbers will decrease by 80 per cent by the end of the twenty-first century.

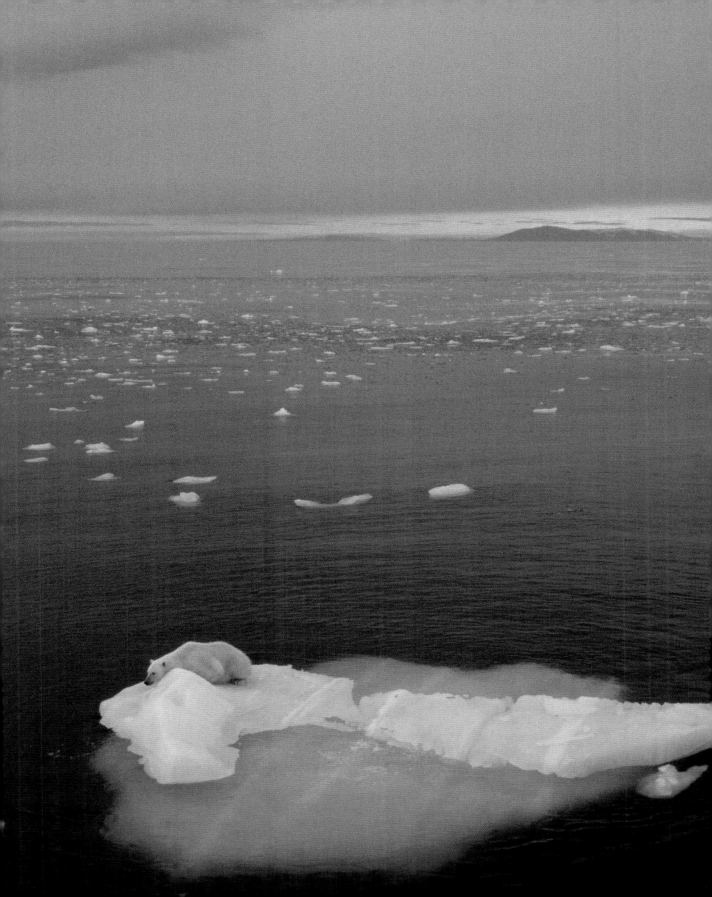

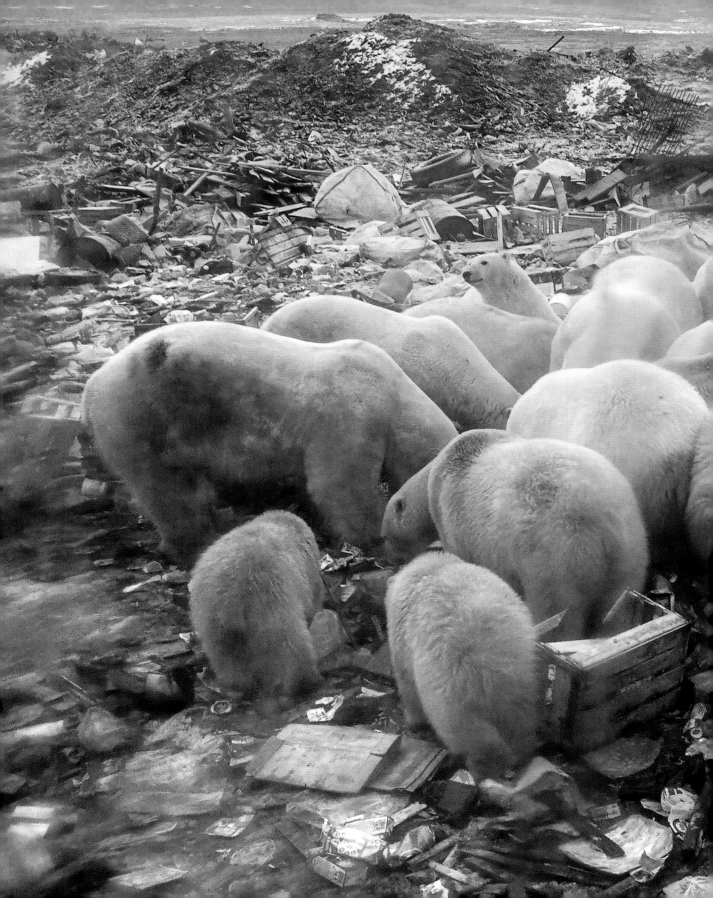

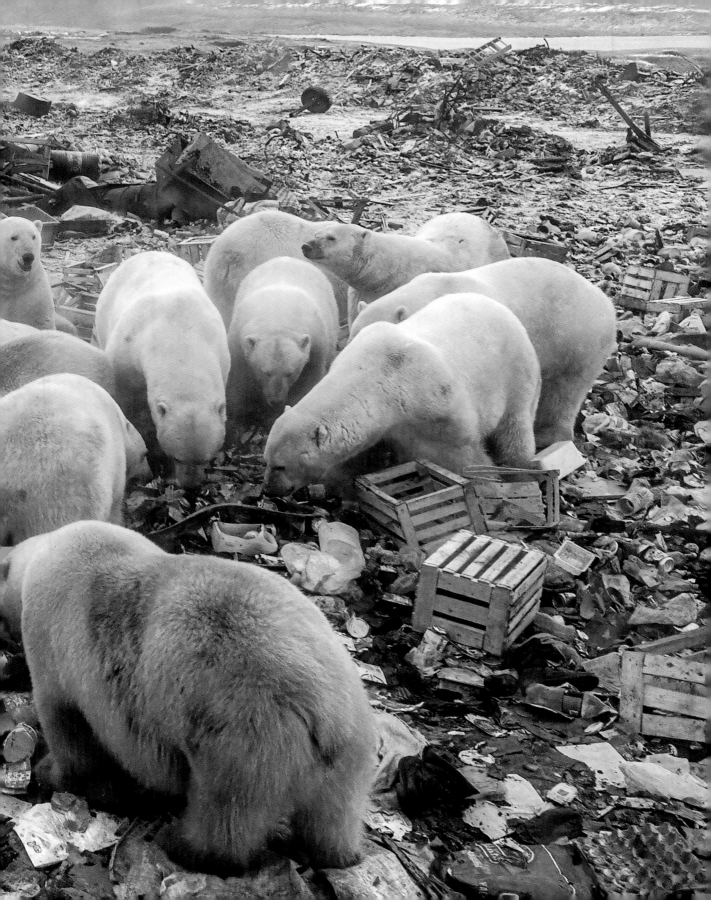

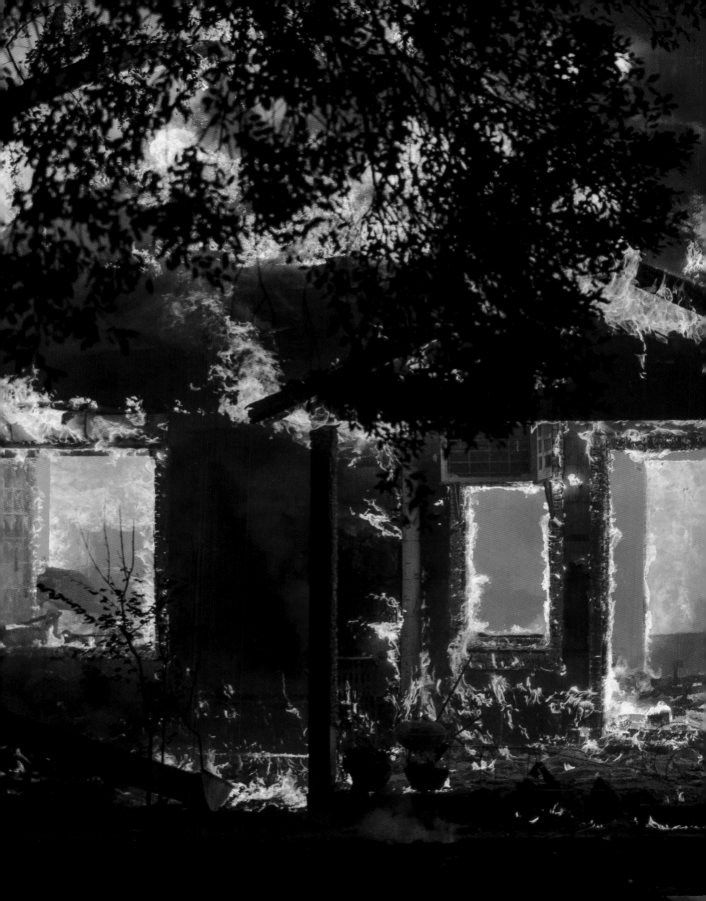

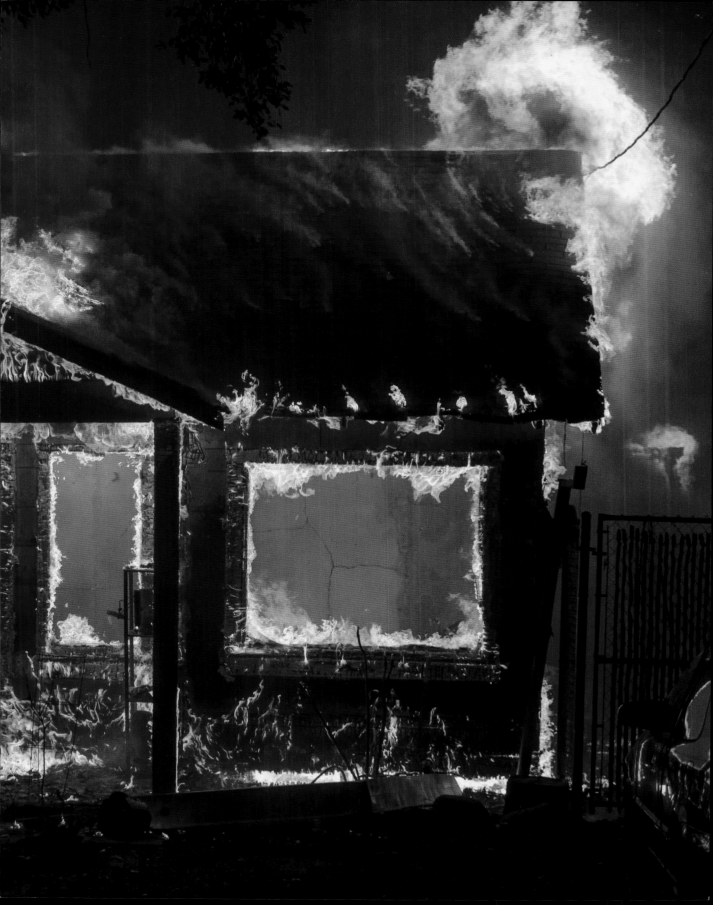

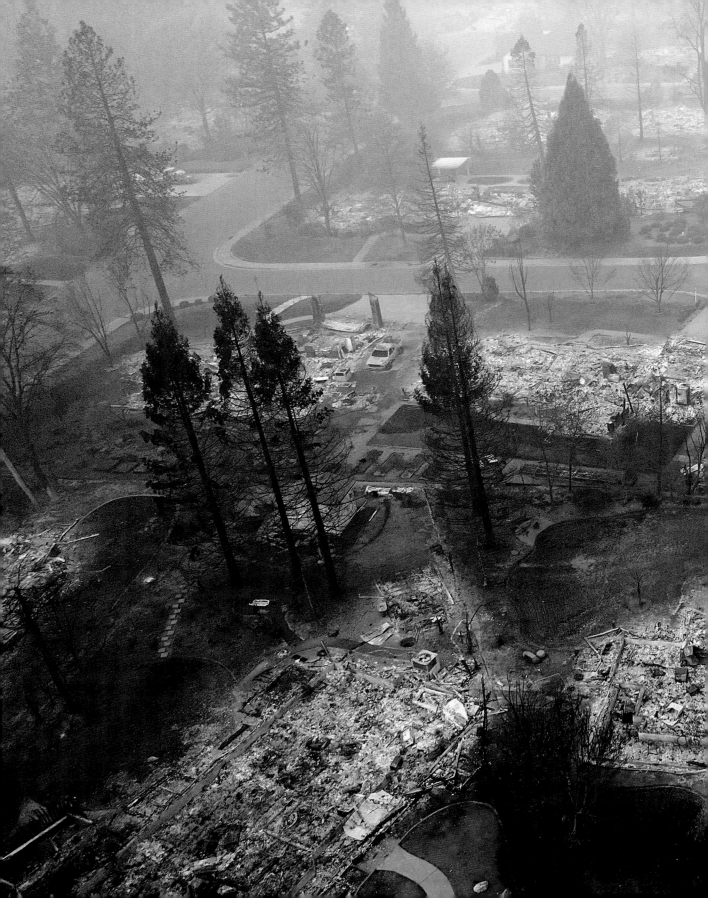

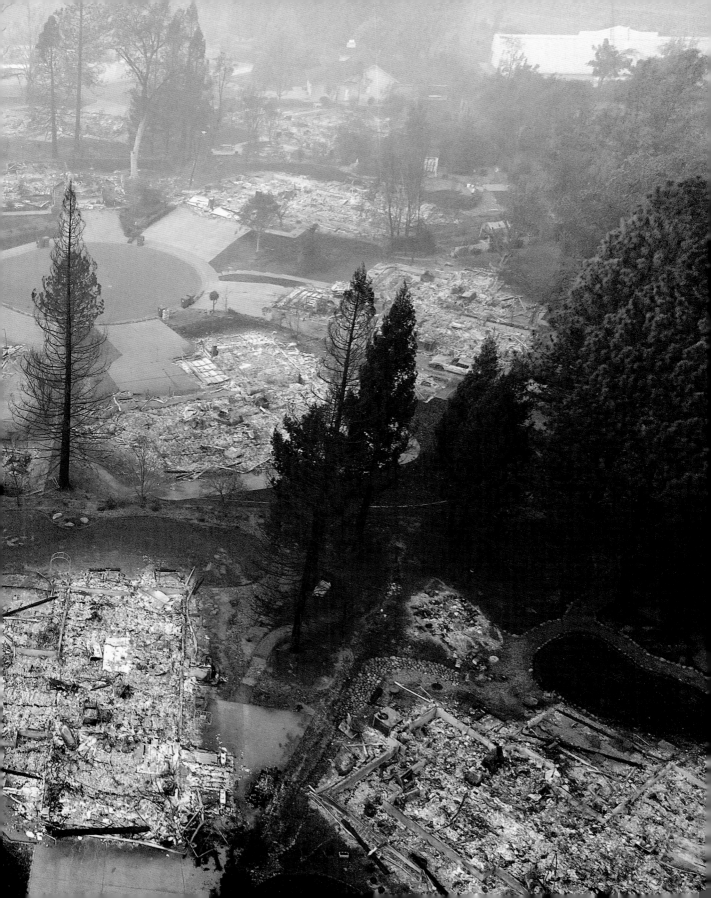

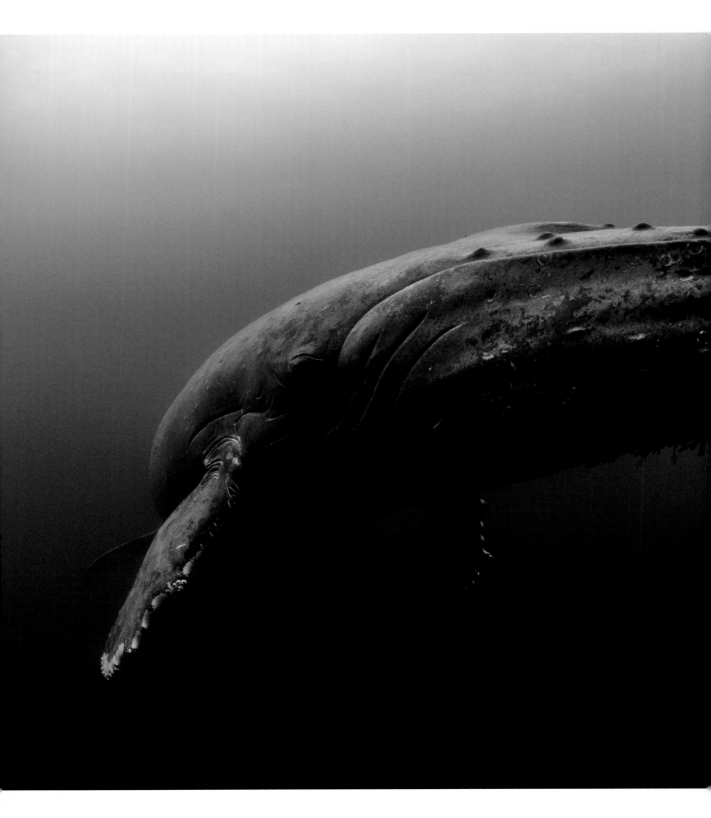

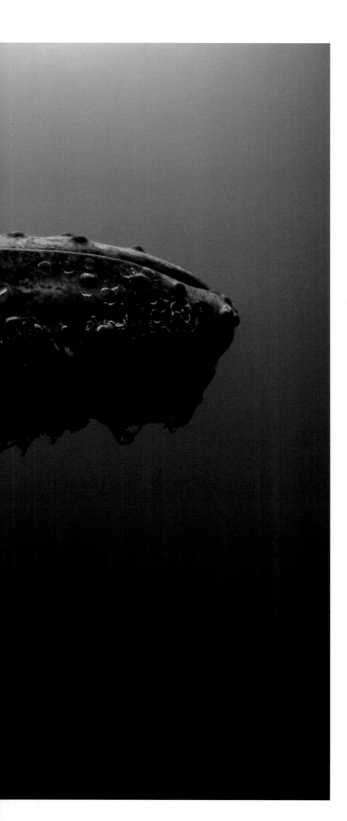

Whales

As climate change continues, rates of extinction will increase, and the twenty-first century may witness one of the greatest periods of species loss for tens of millions of years. Whales will not be spared. Today, the largest animals that have ever lived on Earth swim in rapidly warming oceans. Rising temperatures disrupt the currents that deliver vital prey, as well as impacting on the timing and extent of the whales' migrations.

Yet as well as being among the potential victims, whales are also one of the world's natural solutions to climate change. During its life and death, a whale such as the humpback shown here draws down carbon from the atmosphere in two key ways. Firstly, in diving down deep to find food and then excreting waste near the surface, whales deliver much needed nutrients to phytoplankton, which take up carbon as they grow. Secondly, when a whale dies, its body sinks to the ocean floor, where its decomposition is completed entirely by bottom-living organisms that sequester the carbon in the whale's body. If the whale decayed closer to the surface, this carbon would eventually be released back into the atmosphere.

In order for us to limit warming to 1.5°C above pre-industrial periods, it is likely that we will need to draw down millions of tons of carbon dioxide from the atmosphere. It is expected that the cost of the various programmes needed to enable this will consume a significant amount of the global economy. In this context, the value of carbon reduction that an individual humpback whale can make during its life could be the equivalent of a $2 million technological investment, while the collective value of the climate-stabilizing effects of all whale species may exceed a staggering $1 trillion.

> Polar Vortex >>

Straddling Canada and the USA, Niagara Falls was formed during the retreat of massive glaciers at the end of the last glacial maximum. From late January 2019, extremely cold weather rolled in over eastern Canada, and eastern and mid-western states in the USA, dumping more than 13 inches of snow in some areas. Dubbed the 'Polar Vortex of 2019', temperatures plummeted to levels that hadn't been seen for at least twenty years, and in some places broke all-time records. Niagara Falls appeared to freeze, many of Lake Michigan's piers were encrusted with ice, as seen overleaf, and the city of Chicago was plunged into a deep freeze.

The reason behind this extreme weather was a weakened jet stream. The jet streams are high-speed, high-altitude winds that circle the Arctic, effectively containing the polar region's cold air. Starting in January 2019, large deviations or 'wiggles' in the jet streams extended down over parts of Canada and northern USA, which allowed the Arctic air to 'escape'. As it did, temperatures plummeted. At least twenty-two people were killed due to this extreme weather, which subsequently moved westwards during February before retreating in March.

Although it's tempting to think that unusually cold periods such as this might indicate that global warming has stopped, or been reversed, this is simply not the case – global temperatures for January 2019 were significantly higher than twentieth century averages.

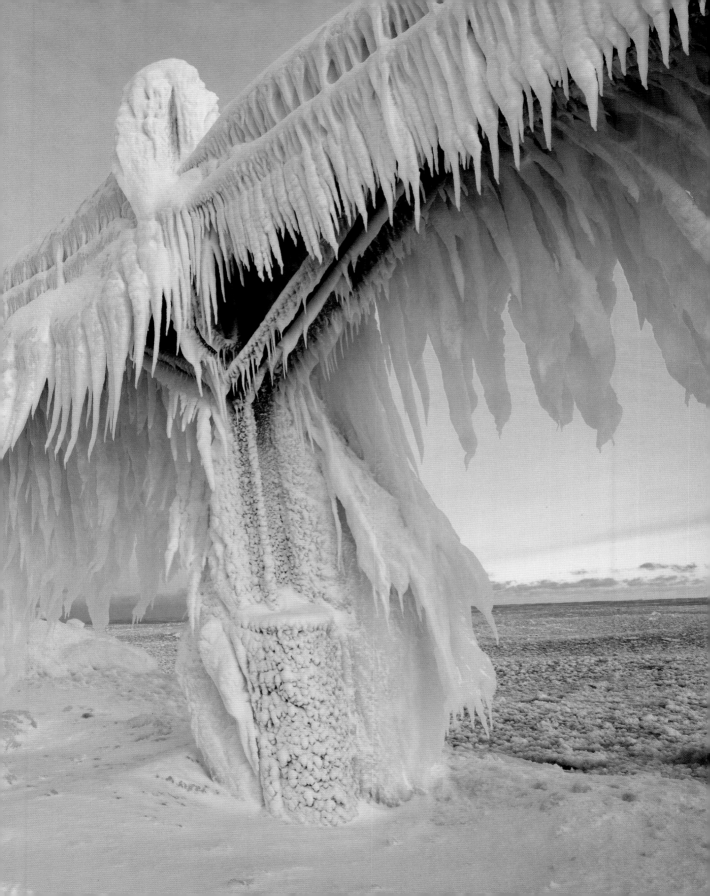

Borneo Burning (I)

For many farmers in the Indonesian states of Kalimantan and Sumatra, fire is the cheapest way to clear land in order to prepare it for planting. The annual burning that is undertaken in these regions releases smoke that covers large parts of South-east Asia, and is one of the biggest drivers of the South-east Asian Haze that has been afflicting the region since the early 1970s.

A significant number of fires are also produced by illegal 'slash-and-burn' operations, which involve cutting down areas of rainforest to make way for palm oil plantations. As well as burning recently cut vegetation, these fires can ignite peat beds that have dried out during hot and dry weather. In some places, these peat beds can be up to 65-feet thick, and once they are alight they can burn for many months, releasing thick clouds of smoke. From February to September these fires are usually so widespread that their smoke seriously affects the air quality in Indonesia, Malaysia, the Philippines, Thailand, Singapore and Vietnam.

This photograph – captured by NASA's Aqua satellite on 15 September 2019 – shows large regions of Kalimantan obscured by vast plumes of smoke. The health impacts of the smoke produced by these fires has led to restrictions on outdoor activities across the region, as it can irritate eyes, skin and airways, and is associated with an increased risk of stroke and heart disease. The South-east Asian Haze has also become a global driver of climate change. During the 2015 haze event, the fires in Kalimantan and Sumatra were emitting 11.3 million tons of carbon dioxide a day – more than all of the economies of the European Union combined.

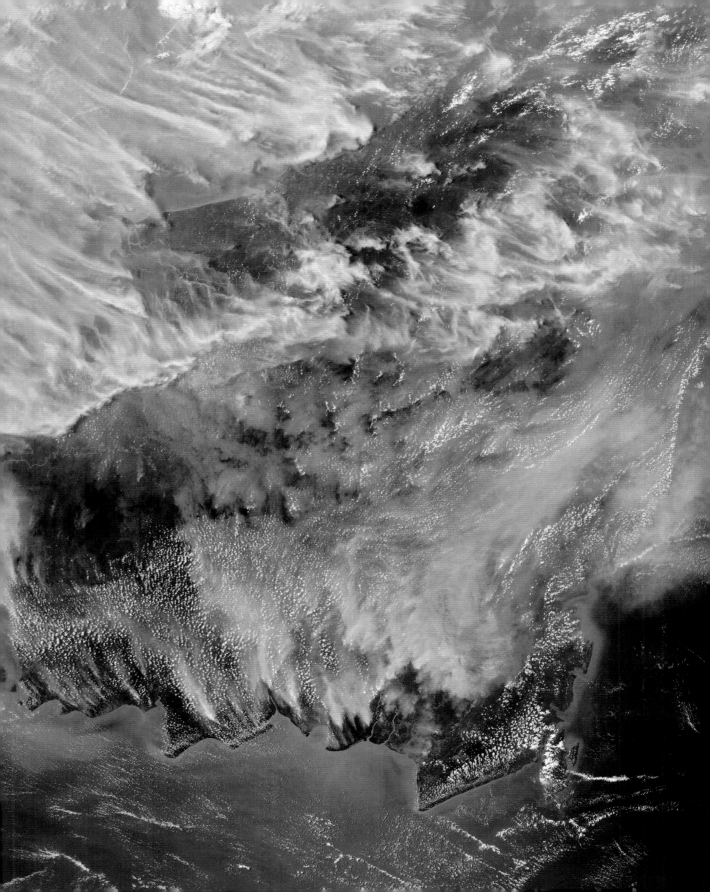

Borneo Burning (II)

The burning of Borneo's rainforests doesn't only affect the health of human populations across South-east Asia – it is also having a devastating impact on the region's orangutans. Although there is evidence that it once roamed widely across South-east Asia, the Bornean orangutan (*Pongo pygmaeus*) is one of three orangutan species now confined to Sumatra and Borneo. Each of these species is listed as critically endangered by the IUCN, and since 1950 their numbers have decreased by 60 per cent, as the direct result of multiple human impacts. Although some animals are killed for bushmeat, and some mothers killed so their infants can be sold as exotic pets, most have perished as a consequence of land-use changes. Over the past century the increase in farming and oil palm plantations has cleared millions of hectares of land in the region, forcing the orangutans into ever-smaller areas that can support fewer animals.

Their long-term future will also be shaped by human impacts on the climate. As climate change continues, so the risk of wildfires increases, creating a two-pronged attack on the habitat that is vital for the orangutans' survival. This photograph was taken on the same day as the satellite image on the previous page, on Salat Island in Kalimantan. Owned by the Borneo Orangutan Survival Foundation, this island currently provides orangutans with a safe haven, but unless a significant and sustained reduction in land-use and climate change is achieved, the long-term prospects are bleak for this great ape species.

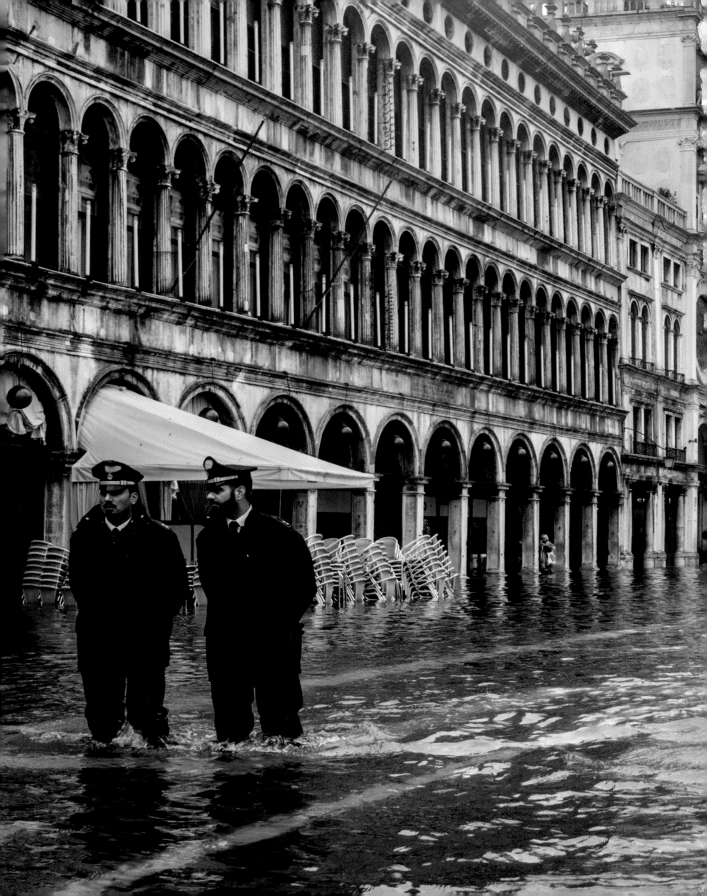

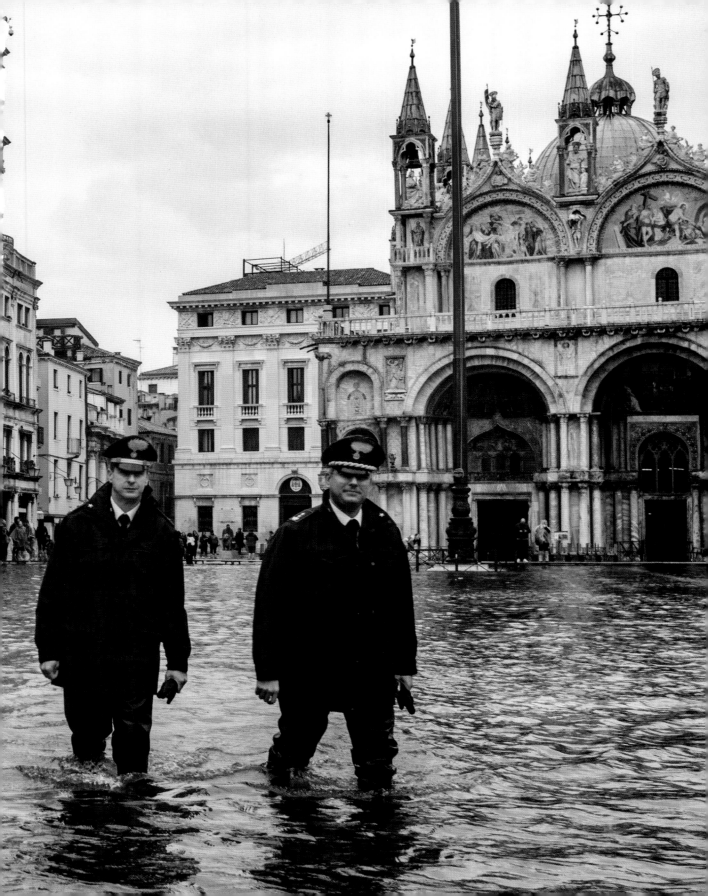

Comprising 118 small islands in a lagoon off the north-east coast of Italy, Venice is a world-famous tourist destination that receives 20 million visitors a year. However, its location at the top of the Adriatic Sea has meant that the city has constantly had to battle against flooding. A combination of high spring tides and storm surges driven by north-easterly winds can create very high water levels in the lagoon. These can lead to high-tide events that are known locally as 'acqua alta' (literally, 'high water'), which can swamp St Mark's Square, as shown on the previous page, and much of the rest of the city. Five of the ten highest acqua alta events ever recorded have occurred in the past twenty years.

Climate change poses a long-term threat, as global sea levels may increase between two and three feet by the end of the twenty-first century. This is clearly a problem for a city where many buildings stand on top of wooden piles driven deep into the lagoon mud. These buildings are already sinking, so in the absence of major adaptation works, serious flooding would become an increasingly frequent event for Venice.

In an attempt to reduce this, and provide a longer-term future for the city, a flood-protection scheme was proposed in the 1980s. Construction started in 2003, but serious setbacks meant it wasn't ready for use until October 2020, with full completion set for late 2021. With a final estimated cost of 5.5 billion Euros, rich nations can afford this type of climate-mitigation scheme, but many people threatened by sea level rise will have to flee from the rising waters. Low carbon-emission scenarios suggest that by the end of the twenty-first century, 190 million people will live below projected high tide levels, but if emissions continue as they have done for the past fifty years, up to 630 million people will be exposed to major flooding events on an annual basis.

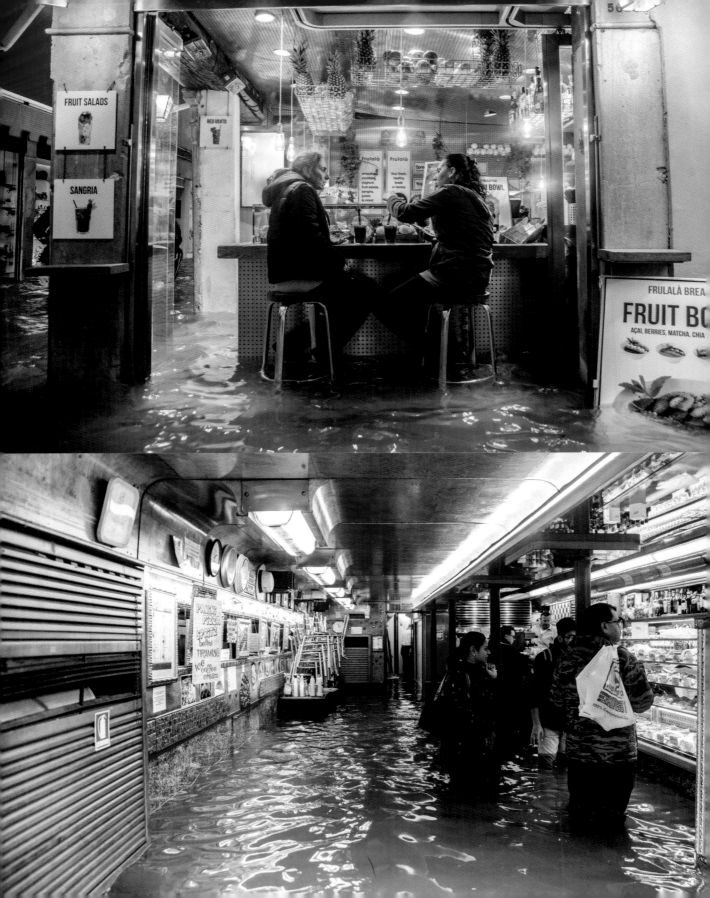

The Danger Zone

When you survey the vast changes that have happened to the Earth system over its 4.6-billion-year history, it can be easy to conclude that whatever we do to the climate doesn't really matter. Massive volcanoes, mile-wide meteorite impacts and the eruption of methane have all unleashed disaster on the biosphere at one time or another, but life has recovered. It may have taken tens of millions of years in some instances, but life carries on.

Humans are still some way from being able to produce a disruption that would rival the Great Dying of 252 million years ago, but our cause for concern is not the fate of the biosphere over the next few million years, but in the next few decades and centuries. While we can be sure that the biosphere will adapt eventually to our impacts on the climate, we can have no confidence in us withstanding the changes we have created (albeit unwittingly at first). But to start to understand the threats that climate change may pose to us, we must appreciate the impacts that humans have already had.

Tens of thousands of years ago, seven-ton mastodons roamed North and Central America; a giant sloth that was larger than a family car lived in South America; the Moa – a flightless bird more than 12 feet tall – called New Zealand its home; and mammoths, rhinos and sabre-toothed tigers were found across wide regions of Europe. All of these animals vanished soon after humans entered their habitat, having migrated from Africa, and all were most likely hunted to extinction or out-competed by humans. The only continent that still has significant populations of large animals, or megafauna, is Africa, which can be explained by these animals having evolved alongside humans. The megafauna in other continents would have been unable to adapt quickly enough to the sudden appearance of an intelligent two-legged, pack-hunting, tool-using species.

Other species have become extinct indirectly, as a consequence of their habitats being modified or destroyed by humans. Each year, humans reduce the number of

2018
July: Sweden experiences one of its largest wildfires in recent history.

July: Following an intense heatwave across Europe, wildfires ignite across much of Greece.

2018
8–25 November: California's Camp Fire becomes the deadliest wildfire the USA has seen since 1918, burning 240 square miles and killing at least 85 people.

2019
28 June: Record temperature of 46°C recorded in France during European heatwave.

2019
4 November: USA gives formal notice to withdraw from the Paris Agreement, joining Iran, Iraq, Libya, Yemen, South Sudan and Turkey as countries not endorsing the agreement.

15 November: Flooding in Venice, Italy, reaches its highest level in fifty years.

2018
20 August: Swedish schoolgirl, Greta Thunberg, makes her first 'school strike for climate', sitting outside the Swedish parliament to protest against inaction on climate change.

2019
January–February: Northern USA and Canada gripped by severe polar vortex.

2019
25 July: Record temperature of 38.7°C recorded in Cambridgeshire, UK.

Zimbabwe suffers several months of drought, leading to numerous wildlife deaths.

2019–20
From September 2019 to March 2020, Australia battles a series of major bushfires that had been made more likely by climate change.

The German *Eiswein* ('ice wine') harvest suffers its first near-total failure as grapes fail to freeze.

trees worldwide by 15 billion, and while there are still some 3 trillion trees left on the planet, research has concluded there would be nearly double that in the absence of humans.

There are now very few environments that have not been altered profoundly by human hands and it seems clear that industrialization has greatly accelerated species loss. Over the past 500 years the total number of land species has fallen by around 13 per cent, and collapsing insect populations indicate that a new wave of ecosystem disruption may be unfolding. Yet while we know some of the general relationships between biodiversity and the resilience of ecosystems, we are largely ignorant as to how continued extinctions will affect the Earth system; there may be gradual and reversible changes, or there may be little apparent change until a tipping point occurs.

This is one reason why continued climate change is such a hazard, as it will place further stress on species that are in many places barely hanging on. It is not just the amount of warming we will produce, but also how fast it happens. If we warm the climate slowly, then many species will be able to migrate to more clement locations, but if the pace of climate change outruns the ability to adapt, up to one in six of *all* species could be threatened with extinction. It is hard to imagine such devastation being played out on the biosphere and our civilization would not be insulated from such impacts. The wellbeing of humans is inextricably meshed with the natural world. Ecosystems are intimately involved in providing fresh water, protecting communities from floods, pollinating crops, and regulating regional and global climates. This is why some of the greatest dangers of climate change will not come from extreme weather events, but from initially invisible changes in the composition and functioning of ecosystems. We alter them at our own peril.

2020
Research shows global CO_2 concentration levels have risen by approximately 20ppm (parts per million) per decade since the year 2000 – up to ten times faster than any point in the previous 800,000 years.

2020
April: Lockdowns around the world, as a result of the COVID-19 pandemic, lead to the largest ever monthly decrease in global carbon dioxide emissions.

2020
June: Carbon emissions in China recover to levels exceeding the pre-lockdown conditions at the start of the year.

2020
16 August: An air temperature of 54.4°C is recorded at Furnace Creek visitor centre, Death Valley – the highest temperature ever recorded.

2020
21 January: Taal volcano erupts in the Philippines, spewing large amounts of sulphur into the atmosphere.

2020
May: Mauna Loa records the highest ever monthly average concentration of carbon dioxide in Earth's atmosphere: 417ppm.

2020
July: Following unprecedented rainfall, the Japanese island of Kyushu experiences widespread flooding.

2010–2020 confirmed as the warmest decade ever recorded.

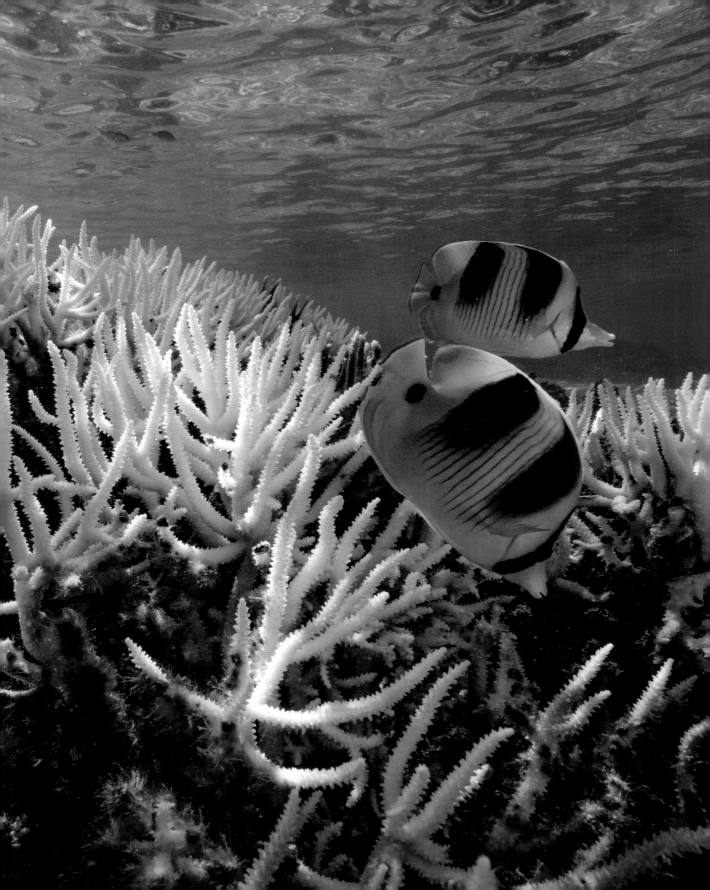

Coral Bleaching (I)

Corals are a symbiosis of polyps (which build a hard carbonate structure) and algae that live within the soft tissues of those polyps. The polyps benefit from this arrangement as they consume excess sugars that the algae produce via photosynthesis, while the algae – which produce the vibrant range of colours we associate with coral on a healthy reef – is provided with a safe and stable environment in which to live. However, when exposed to high sea temperatures, this symbiotic relationship is disrupted, leading to a bleaching episode that can see the diverse colours of a reef fade to a monochrome landscape. Photographed on 9 May 2019, these corals on the reefs that fringe the Society Islands in French Polynesia were in the advanced stages of a bleaching event, illustrating the scale of the damage that can be produced by higher-than-normal water temperatures.

The first widespread coral-bleaching episodes were witnessed in the late 1970s. The physiological mechanisms involved are complex, with a range of triggers involved, such as very intense sunlight, increased sediment and bacterial infection. However, it is now clear that the most common factor behind mass coral-bleaching events has been extreme heat. If sea temperatures are consistently between 1°C and 2°C above their normal level, polyps start to expel the algae. If the water temperature decreases within a few days, algae can re-enter the polyp and start to photosynthesize again, but if that does not happen, the coral polyps starve and die. Soon they begin to decay, leaving behind their hard calcium carbonate skeletons. Other forms of algae quickly take the opportunity to colonize these ghostly structures, leading to the transformation of a diverse coral reef into a dark green mat of thick algae. In the absence of reef-building polyps, the structure of the reef will then start to collapse as wind and wave damage takes is toll.

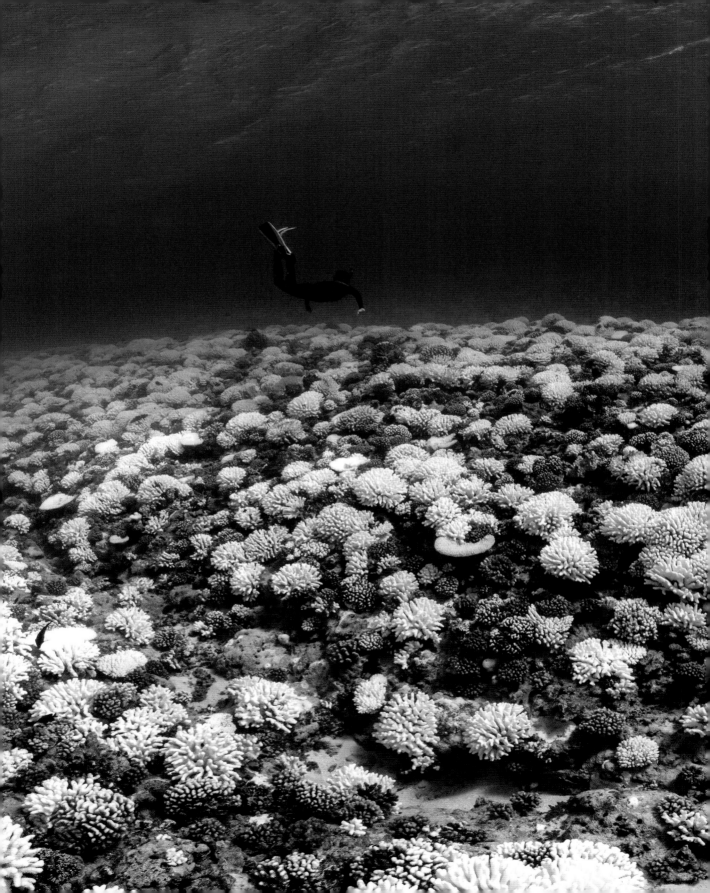

Coral Bleaching (II)

Severe regional bleaching was expected to impact any given reef approximately once every thirty years, but since the 1980s this has accelerated to the point that reefs are, on average, experiencing bleaching events every six years. These will become more frequent and more intense as climate change continues. As pristine reefs take at least ten years to recover from a bleaching event, it is becoming clear that many reefs are being progressively destroyed by repeatedly high sea temperatures. The Great Barrier Reef experienced back-to-back bleaching events in 2016 and 2017, for example, which saw a coral mortality rate in excess of 90 per cent in some regions. It is unlikely that the reef – which is one of the world's largest and most diverse ecosystems – will be able to recover these losses given continually increasing temperatures, so the long-term outlook is grim. If the climate warms to 2°C higher than pre-industrial levels, it is likely that most of the world's coral reefs will have been destroyed.

To counter this, a number of conservation and research projects are currently exploring how genetic techniques may be able to produce heat-tolerant coral polyps. Along with geoengineering techniques that attempt to reduce local sea temperatures, it is hoped that this might save a tiny fraction of Earth's reefs, although some studies suggest that these natural wonders could have largely disappeared by 2050.

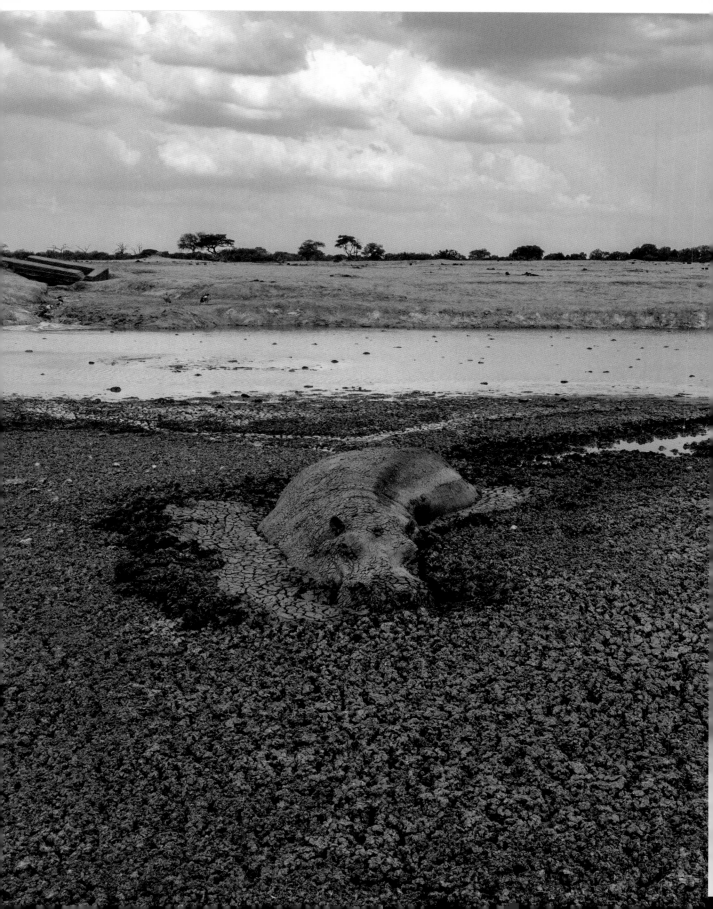

‹ Zimbabwe Drought　　　　　››

The photographs here and overleaf were taken in November 2019, in Zimbabwe's Hwange National Park, which covers an area half the size of Belgium. Following several months of intense drought the park's shrinking water holes left hippos struggling to keep cool, and by the middle of November more than 200 elephants had succumbed to thirst and hunger.

Beyond the immediate deaths that result from extreme weather, climate change also puts wild animals in conflict with people, at a time when human populations are also struggling to adapt to increasingly harsh conditions. As the world's largest land animal, an adult male African elephant can drink more than 50 gallons of water a day. During an intense drought, elephants and other large animals, such as buffalo, are forced to travel greater distances to find water, and sometimes their search takes them beyond the park's boundaries. There, they can find themselves in close proximity with people and their livestock, effectively competing for the vital water that they all need. It is no coincidence that the number of fatal animal attacks increased significantly during the 2019 drought.

As climate change continues, there will undoubtedly be much greater pressure on the remaining areas in which elephants and other megafauna can flourish. The need for both people and elephants to find food and water in ever-harsher conditions will only lead to more conflict between them, and as food security and livelihoods are threatened, the temptation to earn money from poaching may also increase. While there are hopes that such conflicts can be managed, and that international bans on ivory are maintained, this is not guaranteed.

Australian Bushfires (II)

The scale and speed of the fires that broke out during the 2019–2020 bushfire season prevented many animal species from being able to respond to them effectively. Burrowing animals fared relatively well, as bushfires can move swiftly, so the heat and smoke does not have time to penetrate far below ground. For other animals, though, the only means of survival is to escape by land or air. This wallaby, licking its burnt paws after escaping a bushfire near Nana Glen in New South Wales, was one of the lucky ones, as bushfires can quickly encircle fleeing animals, providing them with nowhere to go. It is not just the flames that can kill, either. The infernos can extend upwards to more than 200 feet, and create temperatures up to 1,600°C, which is high enough to vaporize vegetation and melt iron. The smoke can also kill, and in 2019–2020 highly hazardous air pollution reached cities including Sydney. It is likely that more human lives were lost due to the health impacts of this toxic air than to the fires themselves.

Australian Bushfires (III) »

The Green Wattle Creek bushfire, near Tahmoor, south-west of Sydney, devastated just over 1,000 square miles of the Southern Highlands and exacted a terrible toll on Australia's ecosystem. The continent's flora and fauna has evolved over millions of years as the gigantic island has moved via continental drift. As an example, the nightcap oak (*Eidothea hardeniana*) evolved more than 70 million years ago. When these trees first appeared, Australia was further to the south and connected to Antarctica, but has since moved further north. As a consequence, its climate has become hotter and drier, which has progressively squeezed the natural range of the nightcap oak. That, in addition to the much more recent and rapid impacts of land use change by humans, has whittled the entire population of this ancient tree species down to some 100 individuals, which grow in a single creek within the warm temperate rainforests of the Nightcap Range in New South Wales. As the nightcap oak produce new trees by resprouting – a form of clonal reproduction – some of these trees are likely to be thousands of years old.

The 2019–2020 bushfires that ravaged the forests of New South Wales did not spare the Nightcap Range, and at least 10 per cent of the nightcap oaks were destroyed by fire, with a further 30 per cent damaged. For such a small population, these losses may prove irreversible, and further heatwaves, droughts and bushfires could see the nightcap oak exterminated within years.

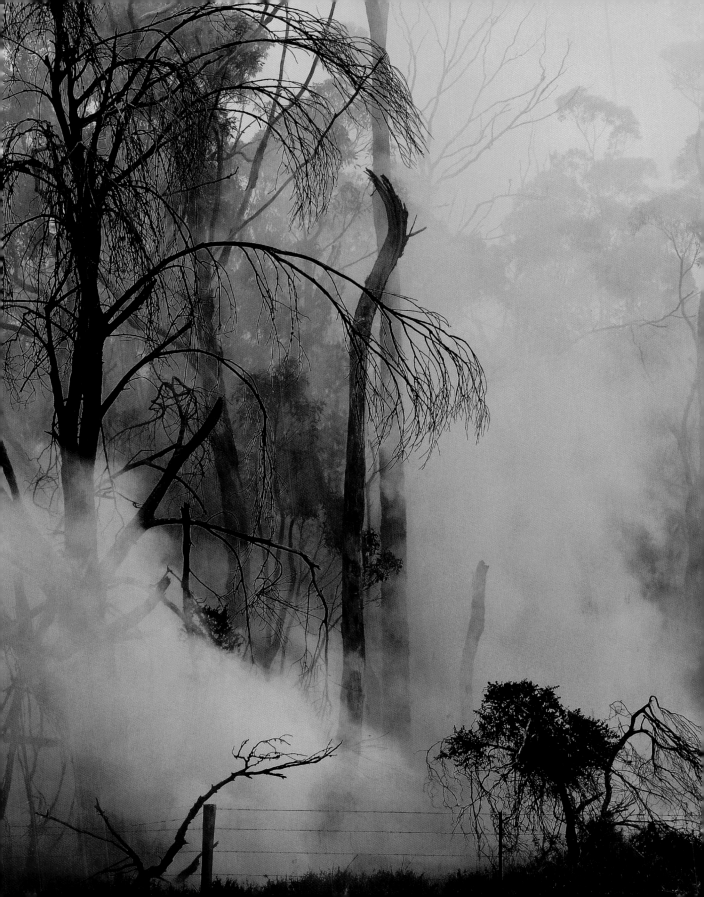

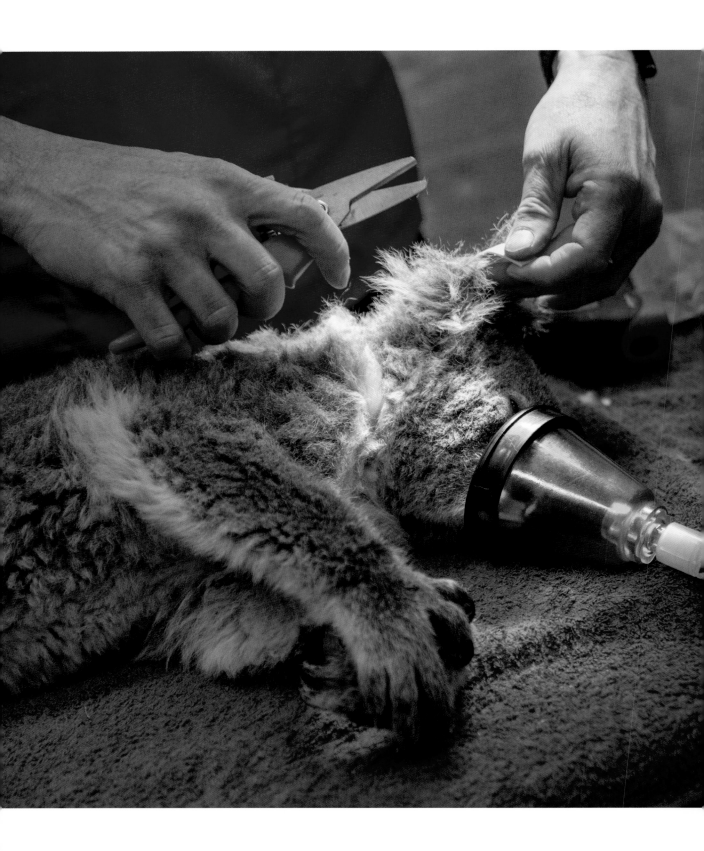

Australian Bushfires (IV)

It is estimated that around 3 billion animals were killed or displaced by the 2019–2020 bushfires, including 143 million mammals, 2.46 billion reptiles, 180 million birds and 51 million frogs. Among this number was the koala – an iconic and endemic Australian species. While some koalas were fortunate enough to be evacuated away from the fire and receive treatment, such as this sedated individual in Queanbeyan, many more perished. Given the size and intensity of the fires, the total number of koalas killed will never be established fully, but some estimates put the loss of this vulnerable species at around 8,000 individuals. Many koalas that escaped the flames succumbed to dehydration and starvation due to the loss of their natural habitat.

Bushfires are capable of wiping out huge numbers of Australia's flora and fauna in a relatively short space of time, but an equally serious threat is playing out at a much slower pace. As temperatures continue to increase, species need to move to higher altitudes in order to find conditions they are able to tolerate. This cannot be an indefinite process. Eventually, like the nightcap oak, species become isolated at the top of mountains and ridges, leaving them highly exposed to further environmental change. It may not be apparent immediately, but the incredibly diverse flora and fauna of Australia is already becoming increasingly vulnerable, even before the fires reach them.

Eiswein

Working in freezing conditions in Nordheim am Main, southern Germany, these workers were photographed during the early hours of 30 November 2016 harvesting the grapes that would be used to produce the region's famous *Eiswein* (literally, 'ice wine'). This unique dessert wine uses grapes that have frozen on the vine, as this process concentrates the sugars, forming the basis of the highly desirable sweet wine. Once they are frozen, the grapes need to be harvested as quickly as possible, as they can start to rot if temperatures rise.

In this way, the wine is highly dependent on the grapes ripening and freezing at the same time, and vintners who produce Eiswein are highly tuned to the vagaries of the weather – very late or very early frosts can lead to the failure of complete crops. However, during the winter of 2019–2020 most of the Eiswein-producing regions didn't experience temperatures that were cold enough to freeze the grapes, making this the first year that the Eiswein harvest almost failed completely.

Globally, the winter of 2019 went on record as one of the warmest ever in the northern hemisphere, but as well as a progressive increase in global temperatures there has also been a shift in the timing of mid-winter. The coldest conditions in Germany are now experienced in January, or sometimes February, with warmer conditions towards the end of the year encouraging grapes to ripen sooner. This means there is an ever-reducing overlap in terms of when the grapes are ripe and when they might freeze. With continued climate change, the already rare Eiswein risks becoming a delicacy of the past.

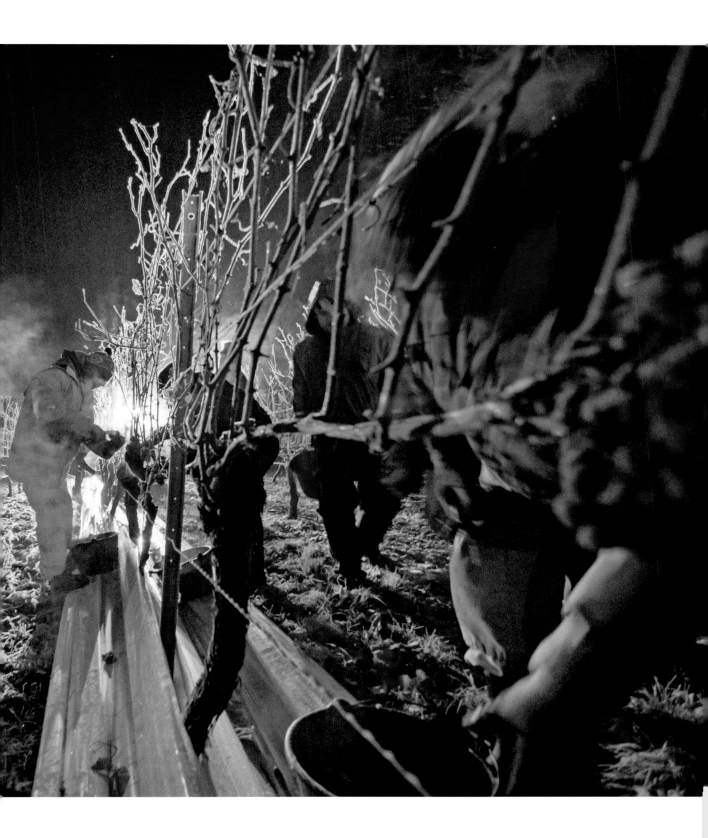

Columbia Glacier

These two false-colour satellite images of the Columbia
Glacier in Prince William Sound, Alaska, were taken
thirty-three years apart and clearly show how far and how
fast the glacier has retreated in that time. In 1986, the
glacier extended down to the mouth of Columbia Bay,
but by 2019 most of this region was ice-free, as the front
edge of the glacier has retreated 12 miles back towards the
Chugach Mountains, which are the source of its ice. Such
rapid ice loss signals a tipping point. As glaciers flow, their
huge masses of ice scour the underlying soil and bedrock.
This material is pushed along by the glacier, much like a
bulldozer, and it builds up along the glacier's front edge

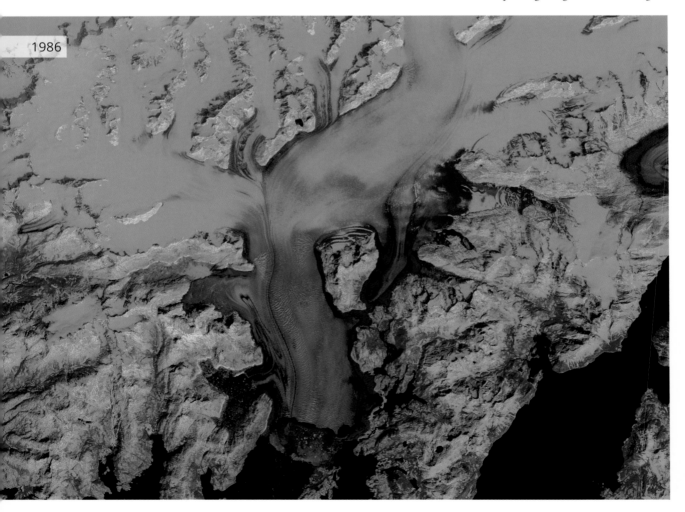

1986

in mounds called moraines. Moraines are critical features for tidewater glaciers such as the Columbia Glacier, as they effectively serve as a wall that keeps sea water out, slowing the glacier as it flows into the sea. Human-caused climate change may have sufficiently warmed the seas surrounding the Columbia Glacier that its leading edge has melted back behind the moraine dam, exposing the bottom of the glacier to warmer sea water. This would further increase the rate of melting, accelerating the glacier's retreat. Once this process begins, it is effectively irreversible until the glacier retreats completely off the water and is grounded once more.

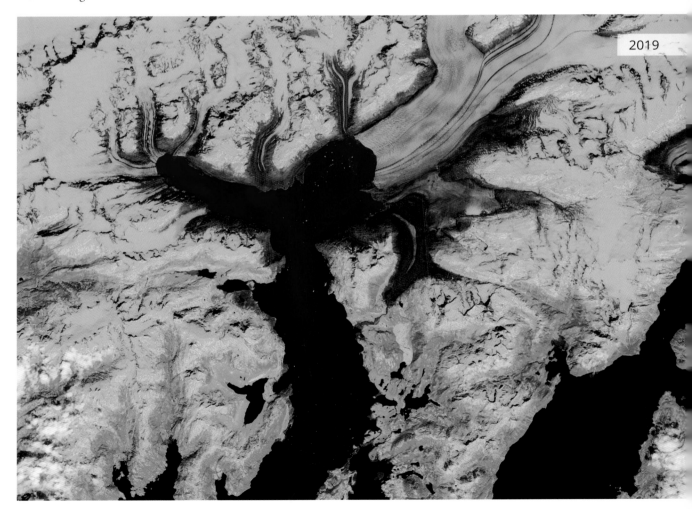

2019

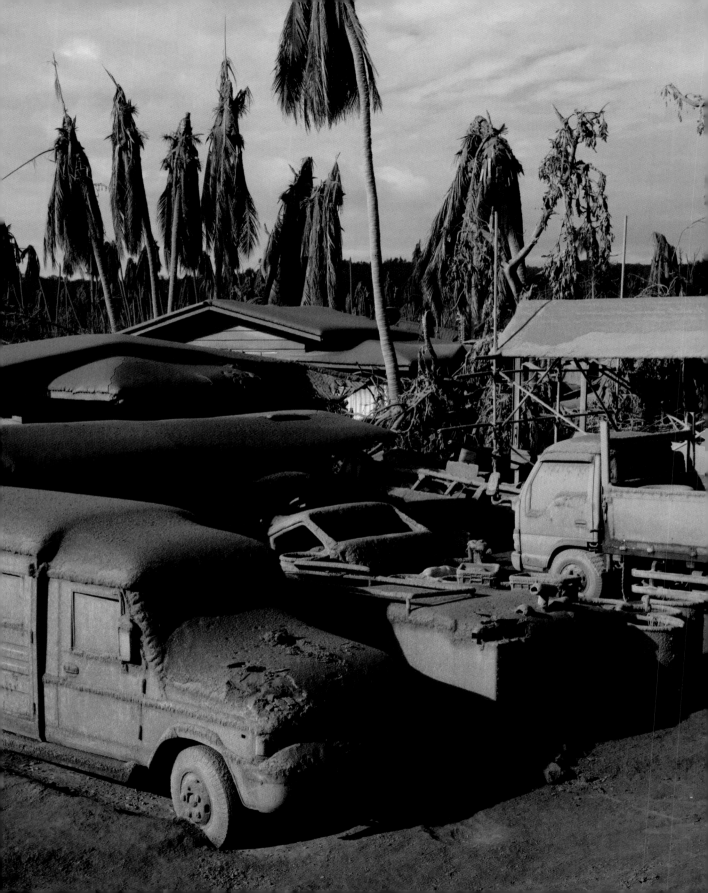

<Taal Eruption >>

On the morning of 21 January 2020, Taal volcano, in
the Philippine province of Batangas, suddenly started to
exhibit significant seismic activity. Having lay quiet for
forty-three years, the volcano erupted that afternoon, and
by the end of the day a nine-mile high column of steam
and ash was rising above the Philippines' second-most
active volcano.

The type of ash ejected by a volcano determines
the impact that an eruption will have on the climate at
a local, regional or even global level. Volcanic eruptions
that produce large amounts of sulphur have the potential
to produce significant climate cooling, as the sulphur
will react with water and gases in the atmosphere to
produce highly reflective sulphur dioxide. However, for
this to have a global impact the sulphur must be injected
sufficiently high into the atmosphere, so the height of a
volcano's ash column also plays a part in the impact of
any eruption. For a tropical volcano such as Taal, once
the ash column rises above nine miles it is likely to remain
suspended in the atmosphere for several years.

The location of a volcano is important too, as
large eruptions can potentially alter the Inter Tropical
Convergence Zone (ITCZ). This is a band of low pressure
that circles the equator, within which the northern and
southern hemisphere trade winds come together. Where
these winds come together most strongly affects the
location and intensity of monsoon rainfall and other
weather processes, and this can be influenced by volcanic
eruptions. If an eruption happens in the northern
hemisphere it can push the ITCZ further south. This
could prove catastrophic for regions such as the Sahel in
Africa, as it could mean that vital rains are pushed south
of the region.

> Japan Floods

Located on the southern Japanese island of Kyushu, the city of Hitoyoshi regularly experiences periods of heavy rainfall due to its humid and hot tropical climate. However, on 4 July 2020 more than four inches of rain fell every hour, triggering landslides and widespread flooding that left Hitoyoshi submerged. As the Kumagawa river burst its banks, bridges were washed away, and road and rail connections were destroyed, greatly increasing the challenge faced by the emergency services as they responded to hundreds of incidents. In total, seventy-seven people lost their lives.

An important cause of the flooding was the Meiyu front, which is a 2,500-mile-long weather system that spans a region from Tibet to Japan. It is formed along a length of jet stream winds that effectively separate colder Arctic weather systems from southern tropical systems. Along this front, large convective weather systems draw up vast amounts of moisture from the South China and Bengal seas, which is then transported eastwards. As these very moist winds meet the landmasses of southern Japan they rise, which condenses the water vapour into torrential rain. Although such extreme weather events would occur in the absence of any human impact on the climate, it is expected that continued global warming will alter long-lived weather phenomena, such as the Meiyu front, as the dynamics of jet stream winds may change. This could already be behind some of the recent extreme rainfall events. The broader impacts of climate change on Japan are likely to be severe, and the persistent flooding of major river catchment areas will require either costly flood protection schemes or abandonment.

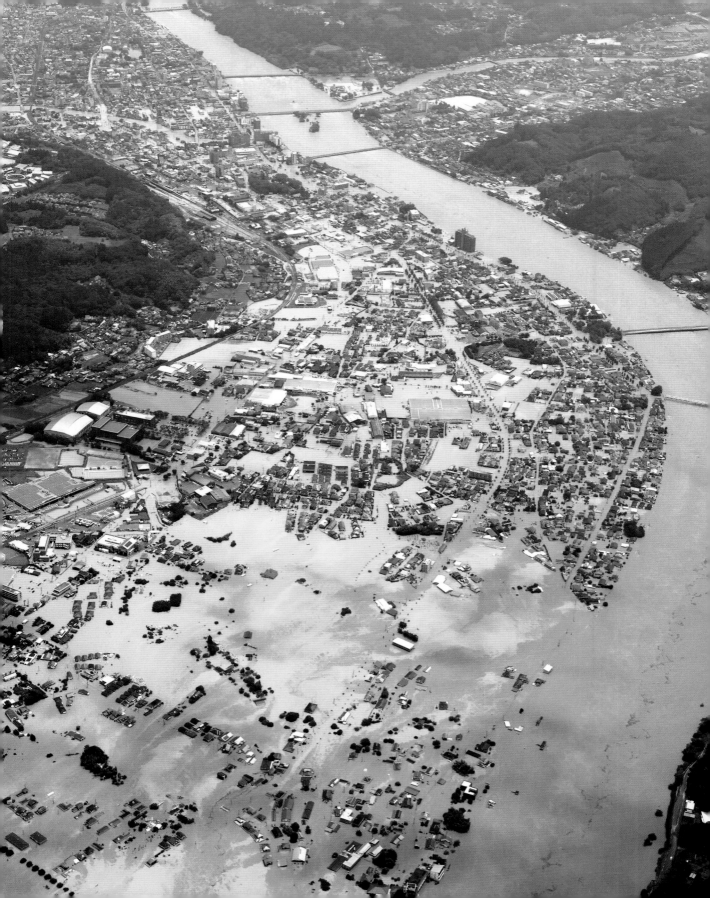

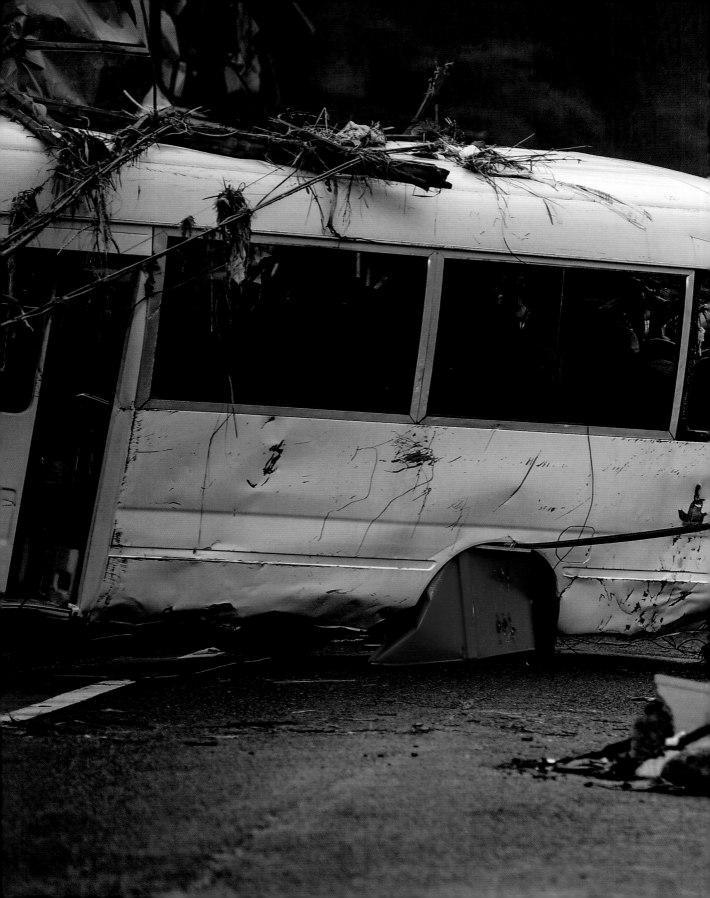

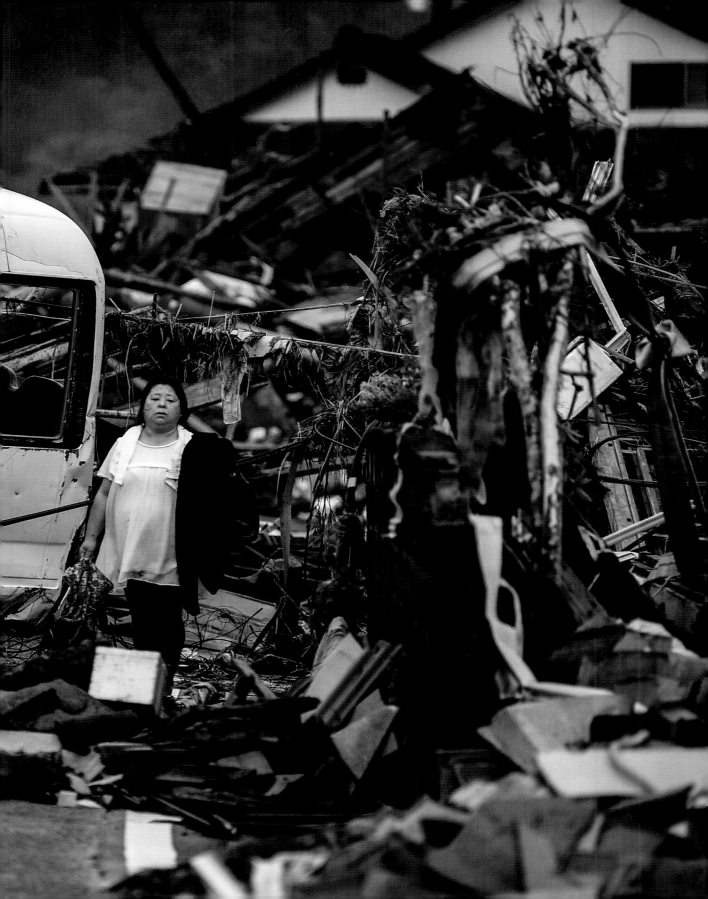

California Wildfires

In this dramatic image, taken in August 2020, a California Department of Forestry and Fire Protection (CAL FIRE) aircraft drops red fire retardant in an effort to protect homes in the Spanish Flat area of Napa. This was to be the most destructive wildfire season in California's history, and it began with an ominously dry January and February. Although widespread rainfall broke the drought in March, things soon dried up again, with the first of several heatwaves falling across the state towards the end of April. By May, temperature records that had stood for decades were being broken across the state, and the first large fires began to burn. More intense heat followed in June and with it more fires. By October 2020, more than 8,000 large fires had burnt almost 6,500 square miles.

The devastation of these wildfires was a direct consequence of hotter and drier conditions producing more fuel. California's residents may have to accept widespread and intense wildfires as the new norm, rather than the exception. This means the role of forest management and town planning is becoming ever-more important. Increasing the number of controlled burns to clear out vegetation and reducing the number of homes that are near or within densely forested areas can reduce both the size and the human cost of wildfires. However, given the trend towards even more extreme weather in California, the question is perhaps not if, but *when* fires of a similar magnitude will devastate the region again.

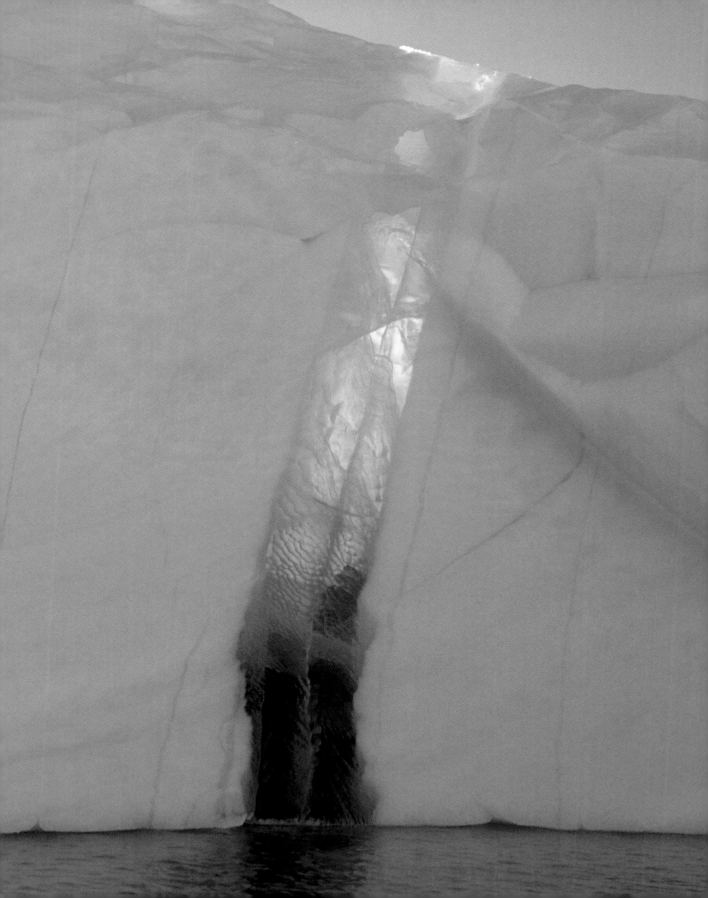

< Melting (I) >>

Greenland and Antarctica represent the last major remains of the once-mighty ice sheets that covered much of the northern and southern hemispheres 20,000 years ago during the last glacial maximum. For the past 2.6 million years, the waxing and waning of the Greenland ice sheet has been one of the central features of the current ice age. Today, more than 680,000 cubic miles of ice covers Greenland, but it is melting rapidly as the planet warms. During the summer, extensive rivers of blue meltwater now flow across Greenland's white glaciers, producing beautiful, but disturbing images.

The Sermeq Avangnardleq glacier, seen overleaf, lies 22 miles north-east of Ilulissat in Greenland. Since 2000, it has been accelerating towards the ocean and can slide down into the water at a rate of several miles per hour. This has transformed it from a smooth and even surface that once allowed people to travel across it quickly using dog sledges, to a heavily cracked surface that needs to be traversed by helicopter.

The glacier's accelerated retreat is the consequence of melting driven by climate change and is representative of the entire Greenland ice sheet. Until the 1990s, Greenland's glaciers were balanced, and the loss from melting and the calving of icebergs was matched by snowfall, which over time compacted into ice and replenished the glacier. However, Greenland's ice sheet is now losing more ice than it gains. In 2011, for example, approximately 350 billion tons of ice was lost, while on 1 August 2019, following a week of high temperatures caused by a heatwave that had seared large parts of Europe, a record-breaking 12 billion tons of meltwater flowed into the sea in just twenty-four hours.

Melting (II)

The effect of ice sheet melting is not only seen on the surface of glaciers, but beneath them as well. In this photograph, a caver explores one of the many sub-glacier caves beneath the vast Vatnajökull Glacier in Iceland. This is one of Iceland's most popular glaciers for tourists and explorers, due to the ice caves that are created by meltwater carving out chambers near the foot of the glacier. Some of Vatnajökull's caves can be so large that they can accommodate whole groups of people, and as increasing temperatures are producing more meltwater, so this creates a greater number of channels, tunnels and caves, which extend deep into the ice.

Like all glaciers, Vatnajökull Glacier grew from snowfall accumulating in layers so thick that it began to compact into dense ice. As the thickness of this ice approaches 150 feet, gravity starts to pull it downwards, and today there are around thirty outlet glaciers transporting ice from Vatnajökull down valleys and mountainsides towards the sea. However, we know that the glacier has been retreating for many years due to climate change. In 1890, the total area of Vatnajökull was more than 3,300 square miles, but in 2017 it had decreased by almost 400 square miles. We also know that the speed of its melting has increased considerably over the last decade: with sustained warming of just 2°C this glacier would largely be gone within 200 years.

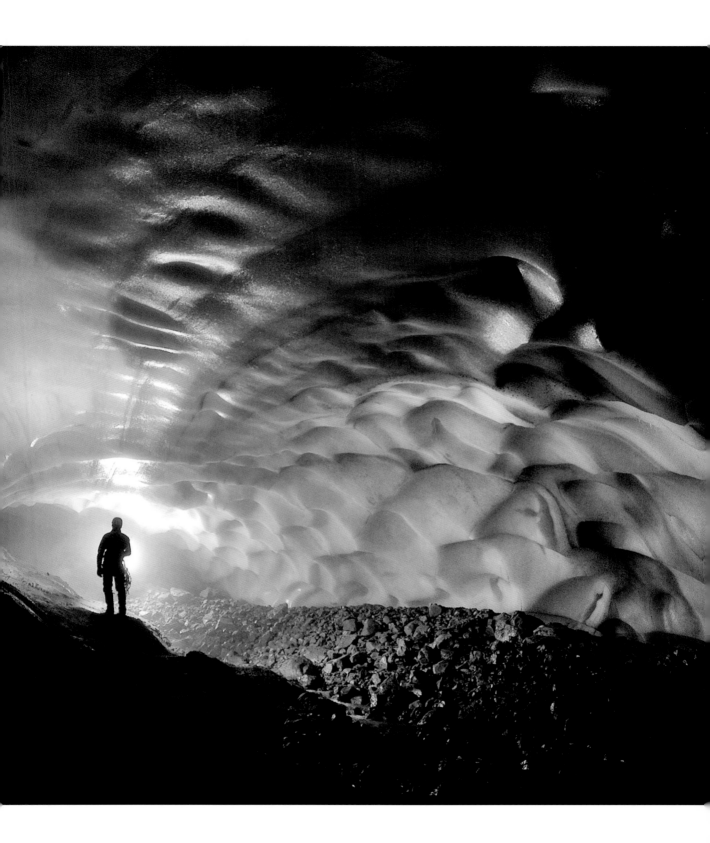

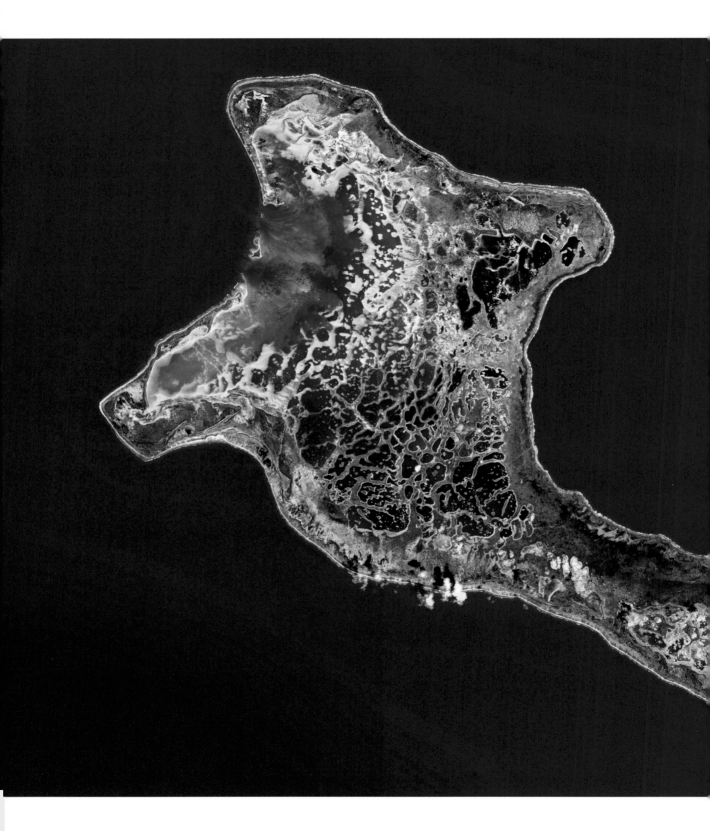

Christmas Island

With a coastline of around 93 miles, Kiritimati – or Christmas Island – is the largest coral atoll in the world. It makes up more than 70 per cent of the total land area of the nation of Kiribati and, according to a 2015 census, is home to 6,456 people. Atolls like this often form over extinct, submerged volcanoes. Reef-building corals thrive in the shallow, brightly sunlit water and over time they form a ring-shaped reef, or atoll, that can partially or completely enclose a lagoon.

Kiritimati, and the rest of the thirty-three atolls and islands of Kiribati, lie within the Line Islands, which extend for more than 1,400 miles across the central Pacific. None of these islands rises far above the surrounding seas, and the highest point on Kiritimati is less than seven feet above the high-tide mark. This makes the islands and their inhabitants extraordinarily vulnerable to sea level rise: if warming continues past 2°C, Kiritimati will disappear beneath the Pacific Ocean within the next century in the absence of significant civil engineering. A UN report in 2016 revealed that half of all households had already been affected by higher sea levels, and a number of people have fled the atoll. Since 2008, intensifying storms and weather-related events have displaced more than 24 million people around the world each year. By the middle of the twenty-first century this figure could increase to more than 140 million, the majority of whom will be living in sub-Saharan Africa, South Asia and Latin America.

The Future

The impacts humans have had on the Earth system are so profound that we have ushered in the new geological epoch of the Anthropocene. However, this does not mean we control the Earth's climate. Dangerous tipping points exist within the twenty-first century that could amplify human-induced warming well beyond the threshold that any industrialized civilization would be able to endure.

>>>

Here Comes the Flood

Earth's oceans are vast. Together they hold more than 321 million cubic miles of water, which is constantly in motion. Pulled by the gravitational fields of the Moon and Sun, huge volumes of water advance and retreat across the globe during daily tides. Weather systems can also affect local sea levels. Storm-force winds can push bands of water in towards the coast, locally raising sea levels tens of feet higher than they would be during a 'normal' high tide.

Underneath these large and noticeable changes a far more subtle, but increasingly clear signal can be detected. Tidal gauges and more recently satellite measurements clearly show that sea levels around the world have risen by around eight or nine inches since the start of the twentieth century. About half of this rise is a consequence of thermal expansion. The problem is, water expands as it increases in temperature, and Earth's oceans have been acting as an immense heat sink within the climate system. More than 95 per cent of the additional heat produced by global warming has warmed the oceans, and while this has significantly reduced the speed of climate change, it has also increased sea levels. Between 1900 and 1990 studies show that sea levels rose by an average of 0.06 inches per year as Earth's climate warmed. By 2000 that rate had doubled, and by 2016 was estimated at 0.13 inches per year.

This acceleration is due to another primary factor behind sea level rise: the melting of the vast Greenland and Antarctic ice sheets. A warmer world means less ice, and every year around 55 billion gallons of meltwater flows into the ocean from the Antarctic ice sheets. Rates of melting in Greenland are even higher.

The net result is that by the end of the twenty-first century the global sea level may have increased by 40 inches or more. This has the potential to produce the greatest human migration in all of human history. Eight of the world's ten largest cities lie in coastal locations, and more than 100 million people around the world live on

2022
The Intergovernmental Panel on Climate Change (IPCC) publishes its AR6 Synthesis Report, containing a Summary for Policymakers (SPM) based on assessment reports from three working groups.

2025
Dogger Bank wind farm comes online, producing 5 per cent of all of the UK's electricity and becoming the largest wind farm in the world.

2030
Key targets to be met by countries signed up to the 2015 Paris Agreement include a reduction of at least 40 per cent in greenhouse gas emissions (from 1990 levels), a renewable energy target of 32 per cent and an improvement in energy efficiency of at least 32.5 per cent.

2035
Low carbon sources now provide more than half of global electricity generation based on 2019 International Energy Agency rates of growth.

2040
Global emissions of carbon dioxide peak in order to limit warming to no more than 2°C by 2100. The Arctic ocean is now experiencing regular summers during which it is largely free of ice; once passed this tipping point there are no prospects for ice to recover during human-relevant timescales.

2050
The global population reaches 9 billion, but the rate of increase has slowed. This continues the trend established since the early 1970s, which has seen population levels start to stabilize in increasing numbers of countries.

2050
Two thirds of homes around the world have air-conditioning units installed within them, which at times become the largest consumer of electricity. Demand for electricity to run these units drives an increase in new power stations.

land that would be submerged by a sea level rise of this magnitude. People living far from the coast would also be at risk of deadly and destructive flooding, as higher sea levels, combined with powerful winds, would produce storm surges that could reach many miles inland.

Rising seas would increase saltwater contamination of freshwater aquifers that are vital for drinking water and crop irrigation. Meanwhile, coastal ecosystems such as mangroves, marshes and mudflats would become seriously degraded or destroyed, while small islands, reefs and atolls – important hotspots for biodiversity – would simply vanish beneath the waves.

Consequently, we will need to adapt to higher sea levels. For a small number of regions and cities this may mean new and expensive flood defence schemes, while in other regions 'soft' measures such as restoring coastal habitats would be much more effective. Not all coastal communities can be protected, though, and for many people the only viable response to rising sea levels will be

to retreat to higher ground. Millions of people will lose their homes and livelihoods in the process, and those living on small island nations may be forced to abandon their homelands entirely.

Rising sea levels will not only displace those living in relatively poor nations, either. Large sections of the eastern seaboard of the USA already require significant 'beach nourishment', which involves restoring beaches with sand that is sometimes dredged from many miles away. In the absence of this continual replacement these beaches would soon be washed away by storm waves, and this process cannot be continued indefinitely in the face of ever-rising sea levels. At some point this century, some of these coastal communities will need to be abandoned.

2055
Large regions of the Amazon rainforest have passed tipping points and are starting to turn into a savannah state. It is not known whether the large stores of carbon in the soil will be retained or released into the atmosphere.

2070
If carbon dioxide emissions continue at the same rate of increase since 2020, global concentrations of carbon dioxide will reach 500 ppm, putting the climate on course for warming of more than 3°C.

2080
Global sea levels have risen by 12 inches since 2000. In the absence of extensive coastal defence schemes, low islands such as the Maldives and Tuvalu, face the risk of complete abandonment.

2095
Following its rapid dieback, the hot, dry soils of the Amazon rainforest are now releasing a billion tons of carbon into the atmosphere, rather than being absorbed by the rainforest, which no longer exists.

2060
Global energy use has increased by more than 50 per cent from 2020 levels as industrialization and development continue to sweep across nations.

2075
More than 90 per cent of the Sundarbans marshland in Bangladesh and India is regularly submerged during flooding events, making it uninhabitable for the remaining Bengal tigers and other wildlife.

2090
The risk of global maize crop failures reaches 50 per cent each year as the intensity of droughts and floods increases globally. This produces sharp price rises and plunges millions of people into food poverty and hunger.

*** ALL FUTURE EVENTS ARE BASED ON CURRENT RESEARCH ABOUT POSSIBLE SCENARIOS – THEY WILL BE STRONGLY AFFECTED BY HOW MUCH CARBON HUMANITY EMITS IN THE TWENTY-FIRST CENTURY**

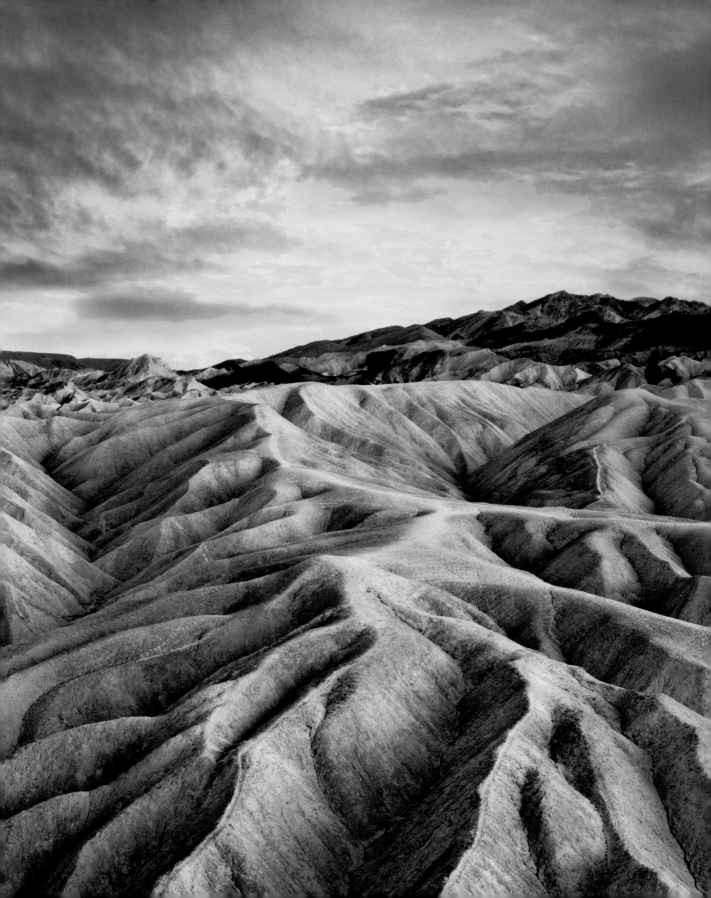

Death Valley

On 16 August 2020, the thermometer in the weather station at Furnace Creek Visitor Centre in Death Valley, USA, hit 54.4°C – the hottest air temperature ever recorded. Death Valley also holds the record for the hottest land temperature, when the ground on the valley floor reached 93.9°C in July 1972. Yet while these extreme temperatures push humans to their physiological limits, Death Valley is also very dry. This lack of humidity allows us to sweat more effectively, so while extended periods in the valley in direct sunlight during the day could prove fatal, taking cover in the shade and drinking plenty of water can enable us to survive.

However, as humidity increases, the amount of heat that can be dispersed through the evaporation of sweat is reduced. Dangerous levels of temperature and heat are measured in terms of the 'wet-bulb temperature', which is the lowest temperature that air can be cooled to through the evaporation of water. When the wet-bulb temperature reaches 35°C, humans are unable to shed any heat into the air. In fact, heat will start to flow into the body, leading to a rise in core body temperature. Unconsciousness and death will follow.

At current rates of climate change, it was thought that lethal wet-bulb temperatures would be experienced somewhere in the tropics by the middle of the twenty-first century, but recent research has discovered that these conditions already exist in some parts of the world. An analysis of weather data found that episodes of extreme humid heat have more than doubled since 1979, and there are now coastal locations in the subtropics where you could – at times – drop dead if you were not within an air-conditioned building.

Wildfire Tornadoes

Fire whirls, as shown in this photograph, are whirlwinds that are formed when the rising heat from a wildfire produces a vortex of spiralling winds. These winds can contract into a tight funnel that can suck in more combustible gases and material, increasing the intensity of the fire. With a large wildfire, rising columns of hot gases suck in the surrounding air at speeds of up to 80mph, providing large amounts of oxygen that enable the blaze to continue. Under extreme conditions, a fire whirl can increase in size and intensity to become the catastrophically destructive meteorological phenomenon of a 'fire tornado'.

A true fire tornado is exceptionally rare, and only one has been documented in North America. It was produced by the California Carr fire on 26 July 2018, when the fire – which had been burning for three days – collided with cold, dense air. This created a large area of turbulence that produced a huge plume of hot, rising air, which interacted with higher-altitude winds to generate a swirling mass that quickly grew in intensity. At its peak, the fiery vortex grew to more than 1,000 feet wide and 18,000 feet high, generating winds of up to 165mph. Temperatures at the heart of this fire tornado likely exceeded 1,500°C. Although climate change was not directly responsible for this terrifying phenomenon, it is increasing the duration and intensity of wildfires around the world, which will make extreme fires far more common.

Heat

The heatwave that enveloped Europe in 2003 led to the hottest summer the continent had experienced for hundreds of years, and claimed the lives of more than 70,000 people in the process. Although the temperatures in some European countries were even higher in 2019, far fewer lives were lost, which demonstrates the importance of climate change adaptation.

Humans are physiologically adapted to be able to withstand high temperatures, with sweating and the dilation of blood vessels near the surface of the skin both helping to move heat out from the centre of the body. These processes cannot be sustained indefinitely, though. Thankfully, during a heatwave, heat stresses are typically reduced by cooler evening conditions.

What made the 2003 European heatwave different was multiple evenings of sustained high temperatures and humidity that offered no respite. Because of this, public health policies now include the creation of cooling areas in cities and cold rooms within which people can take refuge. This type of infrastructure offers residents the vital opportunity to cool down, and can be built rapidly in rich, developed nations. But it is far from clear how people living in poorer areas will be able to afford the adaptation costs of ever-more intense heatwaves. For some, the only option will be to retreat indoors if outdoor physical activity becomes too dangerous in the intense daytime heat.

Insects

These dead bumblebees are just a tiny fraction of the number of bees that have been lost to human impacts over the past decade. Bees live incredibly challenging lives, which typically involve travelling large distances to collect nectar and pollen, and return it to their hive. Becoming disorientated and unable to find either food or their nest is often fatal, so bees have evolved exquisitely adapted vision, learning and memory, which they use to navigate complex and shifting landscapes.

It is now clear that habitat destruction and the increased use of pesticides have had a devastating effect on bee populations around the world. This decline is mirrored by many other insects, and it is estimated that 40 per cent of all insect species are currently in decline. Climate change poses yet another threat. The number of days where extreme heat is experienced is set to increase, and research has now revealed there is a clear link between periods of hot weather and the local extinction rates of bees. The immediate concern about plummeting bee numbers is their central role in pollinating crops, which could have an obvious impact on humans. Many other insects will also suffer during prolonged heatwaves, and many of these will be key components of complex food webs. As their numbers decrease, so will the number of animal species that eat them: birds, reptiles and mammals will all be affected. The more we understand about the complex ecological interactions that have insects at their heart, the more we realize that the silent loss of vast numbers of insects could lead to the collapse of ecosystems around the world.

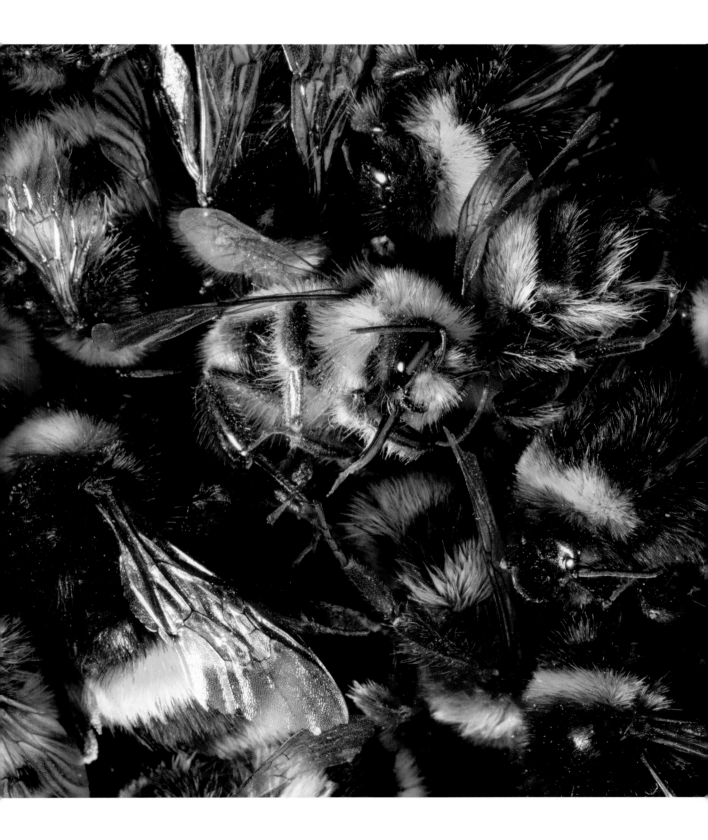

Smoke

This aerial photograph shows Sydney Harbour in Australia, blanketed by smoke from the large-scale burning of bushland in the nearby Blue Mountains. These fires were lit intentionally by the fire department, as part of a hazard-reduction exercise to limit the size of uncontrolled fires later in the bushfire season. However, while these fires are managed and kept under control, they still produce large amounts of hazardous air pollution. Research has concluded that the smoke from these fires most likely led to fourteen premature deaths within Sydney.

Smoke exposure increases chronic and acute respiratory illnesses, as fires can produce vast amounts of harmful fine particulate matter. Once inhaled, these tiny fragments can be absorbed directly into the bloodstream, travelling around the body and becoming concentrated in organs such as the lungs and brain. This can not only lead to lung inflammation and increased asthma attacks, but over longer timescales it has been shown that it also increases the chance of developing a number of different cancers. As climate change leads to a greater prevalence of drought conditions, the frequency and intensity of wildfires is expected to increase, producing more air pollution, and with it more sickness and death.

As well as leading to larger and more polluting fires, climate change will also increase our exposure to ozone. Low-level ozone, which occurs at ground level, is created when waste gases from factories, power plants, and petrol and diesel motor vehicles react in strong sunlight and at high temperatures. Exposure to high levels of this type of ozone can lead to respiratory problems, particularly in children, the elderly, people with underlying diseases and those who work outdoors. As a result, the health impacts of climate change could be just as severe as the heatstrokes that will occur due to extreme temperatures.

Dust

Like smoke from fires, dust is a major threat to public health. Consisting of tiny, suspended, irregularly shaped fragments, dust storms are associated with a range of infectious and non-infectious ailments. A number of studies have demonstrated a clear link between the intensity of dust storms and health impacts, with influenza, pneumonia and meningitis just some of the diseases that can be made more damaging. As with other respiratory illnesses, it is often the elderly and the young who are most at risk, such as this Afghan child hiding from a dust storm at a refugee camp in Kabul.

Since 2010, dust storms have been increasing in frequency. Up to half of the dust in today's atmosphere comes down to two changes in land use: overgrazing, which strips vegetation, and deforestation. Both expose the underlying soil to winds that can lift it into the air. Protecting forests and altering farming practices could therefore reduce the amount of dust that people are exposed to, but these adaptations alone may not be sufficient. The high temperatures and droughts caused by climate change are drying out soil, making it more vulnerable to winds – winds that are becoming stronger as extreme weather increases.

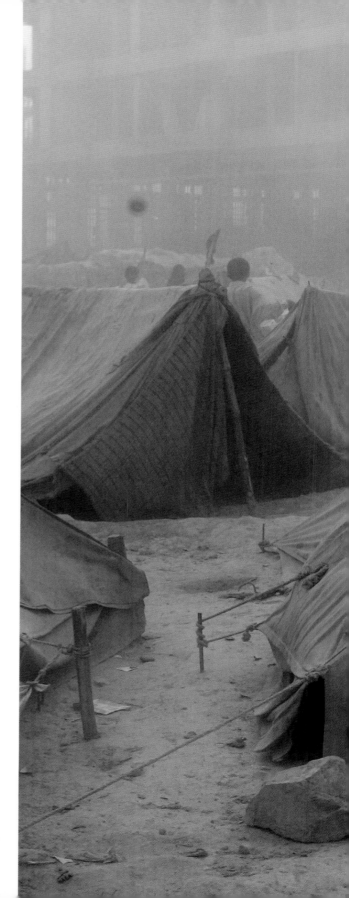

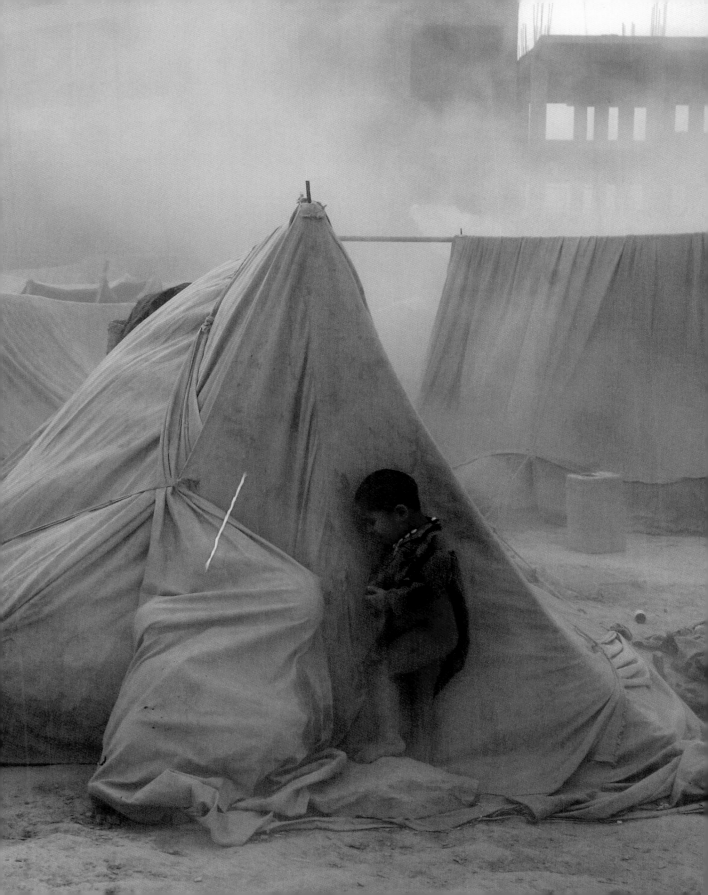

‹‹ Geoengineering

Twenty thousand years ago, during the last glacial maximum, the Rhône Glacier was the largest in the Alps, covering a significant part of Switzerland. Since then, as Earth has warmed, it has retraced its steps. Scientists have discovered that the glacier has proved sensitive to variations in the climate, advancing and retreating in response to very minor changes. Between 2011 and 2016, the Rhône Glacier retreated by almost 500 feet, so in an attempt to prolong its life, sections are now covered with white blankets between June and September. These shade the glacier from the Sun during the Alpine summer, reducing the rate of melting by up to 70 per cent. A more ambitious project coordinated by Utrecht University hopes to save Switzerland's Morteratsch Glacier by blowing reflective artificial snow across its surface.

Geoengineering can include any number of technological projects aimed at protecting or restoring Earth's climate, but it most frequently refers to two types of proposal. The first includes attempts to remove large amounts of carbon dioxide from the atmosphere in order to reduce the climate impacts humans have produced. The second involves measures that aim to offset some of the warming we have produced by spraying aerosols into the upper portions of the atmosphere, which would reduce the amount of energy from the Sun that reaches the surface of the planet. In both cases, these schemes typically involve altering atmospheric conditions on a planetary scale, so for either to be practical, significant technological advancements would be needed, along with extensive research into possible side effects.

Flood Protection (I)

In 2012, Hurricane Sandy brought New York to its knees. Of the $70 billion of damage that the storm caused across the USA, $19 billion occurred in New York City. Despite this, the state and city of New York continue to be ill-prepared for hurricane-force winds, storm surges and huge deluges of rain, even though rising sea levels and more intense storm surges could produce more catastrophic flooding in the future.

Over the next ninety years, sea levels could rise by up to six feet, which would lead to the regular flooding of low-lying areas in New York, even in the absence of extreme weather events. Therefore, New York – like other coastal cities around the world – needs to adapt rapidly to a warmer world. But flood-protection schemes are both complex and expensive. The most high-profile (and controversial) option is to build a series of flood barriers that would surround the city. This would include six miles of storm surge gates, stretching from Sandy Hook, New Jersey, to Breezy Point, Queens, and along the East River. An additional twenty-six miles of levees and floodwalls would make this one of the world's largest flood-protection schemes, and also one of the most expensive, with the cost of construction estimated to be up to $62 billion. However, as New York City is home to more than $1.3 trillion of real estate, there is perhaps an economic justification for such a scheme. Cleaning up after catastrophic flooding could prove far more costly.

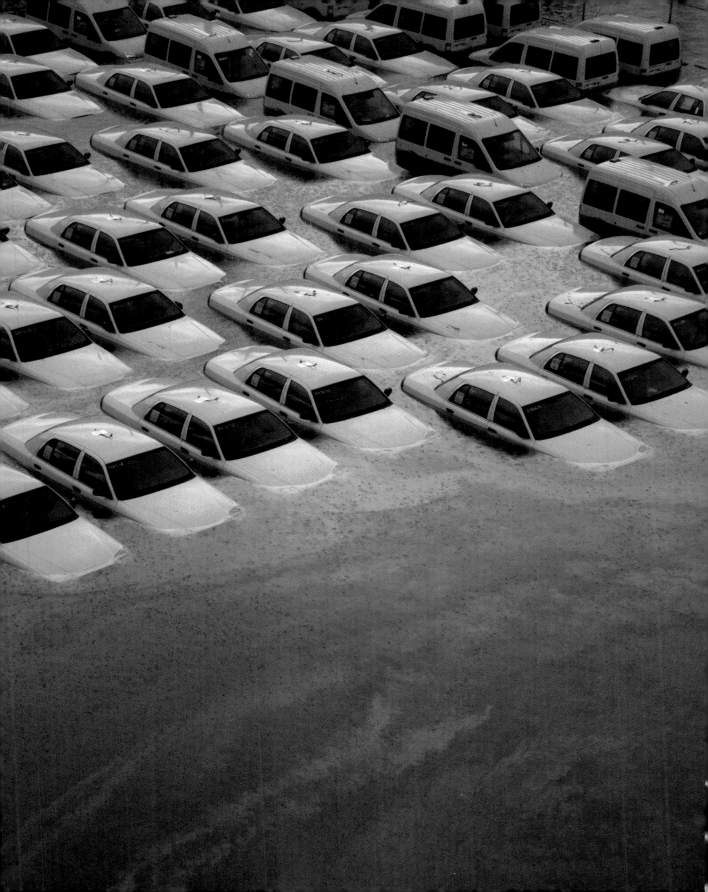

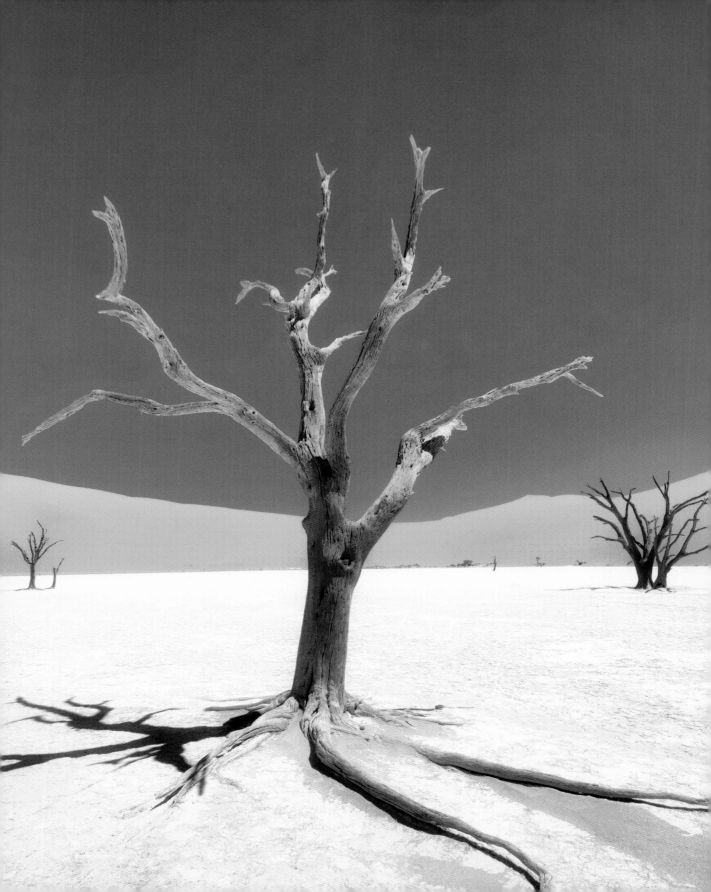

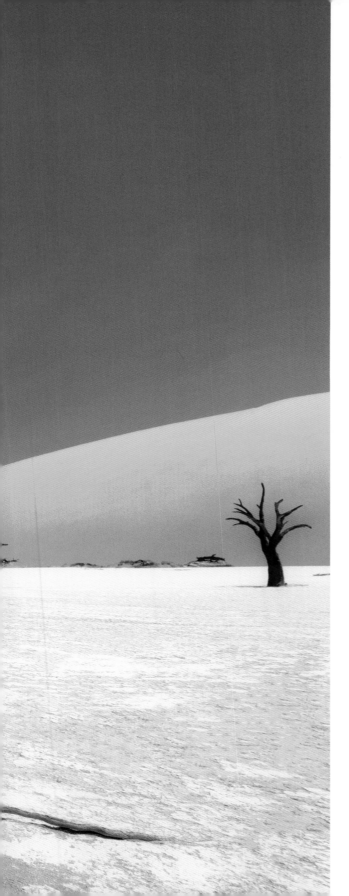

Namib Desert

Surrounded by some of the highest sand dunes in the world, Deadvlei (which translates as 'dead marsh'), was formed around 1,000 years ago, when a period of heavy rainfall created pools of water on the valley floor. These developed into marshes within which a population of camel thorn trees thrived. Some 200 years later, the area was plunged into severe drought, and as the surrounding sand dunes grew, they throttled the supply of water to the marsh. The trees soon died, but 800 years on their desiccated remains still stand, their decomposition slowed by the intensely hot and dry air of the Namib desert.

In more recent years, Namibia has been ravaged by alternating periods of drought and flood. This has particularly impacted the north of the country, where the majority of the Namibian population lives. Although the populace has so far tolerated these extremes, the potential for climate change over the course of the twenty-first century could far exceed their adaptive capacity. Global warming of 2°C would mean that the average annual rainfall in Namibia would decrease by 7 per cent, with around seventy-five extra days of extreme heat.

Further warming would produce even greater hardship. If global temperatures increase by 3°C by the end of this century, the rate at which groundwater is replenished could drop by 70 per cent, exposing millions of people to the risk of dehydration. Such extreme conditions would lead to the depopulation of some areas, adding abandoned towns and roads to the sun-parched trees of Deadvlei as testament to the vital role that water plays in life on our planet.

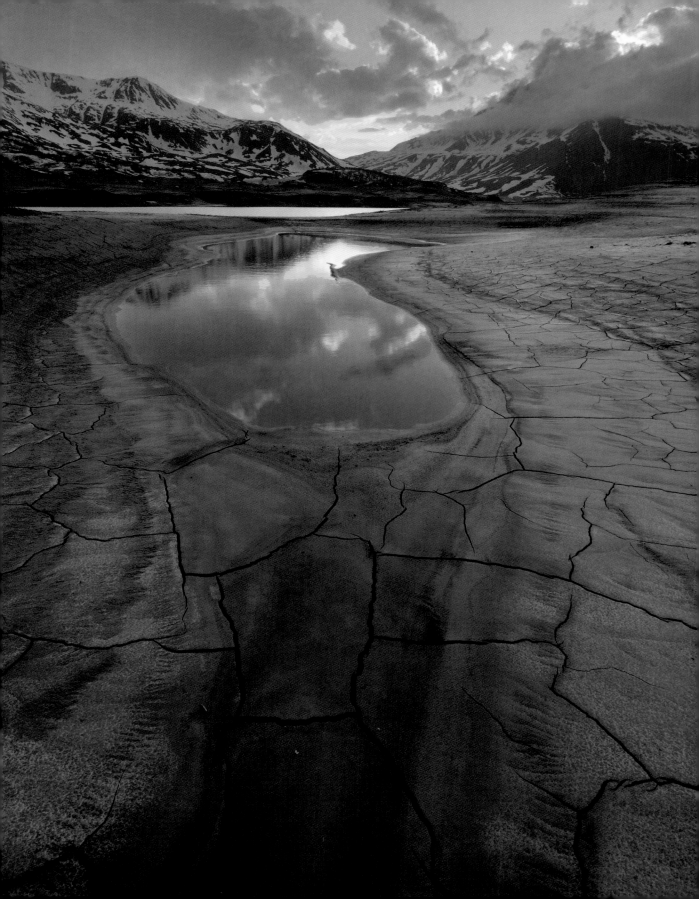

Dry Lakes

The Alps are at the centre of Europe, both geographically and culturally. People travel to the mountains from around the world to ski in winter, and hike and bike in summer, making them a prime tourist destination. But it is their role in the continent's water cycle that makes them vital for the health and well-being of tens of millions of people who live in lowland areas. The Alps' watershed is so vast that it captures 40 per cent of the continent's fresh water, leading it to be dubbed the 'water towers of Europe'. As well as channelling rain into the headwaters of the rivers Danube, Rhine, Po and Rhone, millions of gallons are also stored as snow and ice in glaciers at higher altitudes.

Climate change is impacting the Alps' water cycle, though, with potentially disastrous results over the course of the twenty-first century. We are already seeing changes in rainfall and snowfall patterns, with periods of very hot and dry weather accelerating the melting of the region's glaciers. These droughts are being punctuated by floods and landslides that silt streams and rivers, and alter catchment areas. Together, these factors are increasing the variability of the water supply over the course of any given year, at the same time as the demand for water for irrigation intensifies during dry periods. Consequently, as this photograph of Mont Cenis lake in the French Alps shows, the abundant and clear waters of the Alps that were once taken for granted are at risk of becoming a scarce commodity.

Amazon Rainforest　》》

The Amazon is Earth's greatest store of biodiversity, but significant regions are now threatened with almost complete collapse. This could have far-reaching global climate impacts, as the Amazon rainforest currently absorbs between 5 and 10 per cent of human carbon emissions, making it vital if we want to limit warming to no more than 1.5°C. However, over the past fifty years, 17 per cent of the forest has been destroyed, and at current rates of deforestation more than one quarter will have disappeared by 2030. This not only reduces its ability to absorb our greenhouse gases, but also makes the Amazon region more sensitive to climate change.

Most of the rain that falls on a rainforest comes from the forest itself – vast amounts of water is drawn up by the dense coverage of towering trees. This water evaporates from the leaves, rising and condensing to form heavy clouds that then release rain back on to the forest. Deforestation disrupts this process, but it is only part of the problem. As well as delivering water, clouds also reduce temperatures in the forest. Consequently, fewer trees not only decrease water availability, but also increase temperatures and, beyond a certain temperature, soil will start to release carbon dioxide into the air.

Research has shown that over the past thirty years the amount of carbon absorbed by the world's intact tropical forests has decreased, and within ten years, the Amazon's ability to sequester carbon from the atmosphere may end. Further warming could then transform it into one of the world's largest *sources* of greenhouse gases.

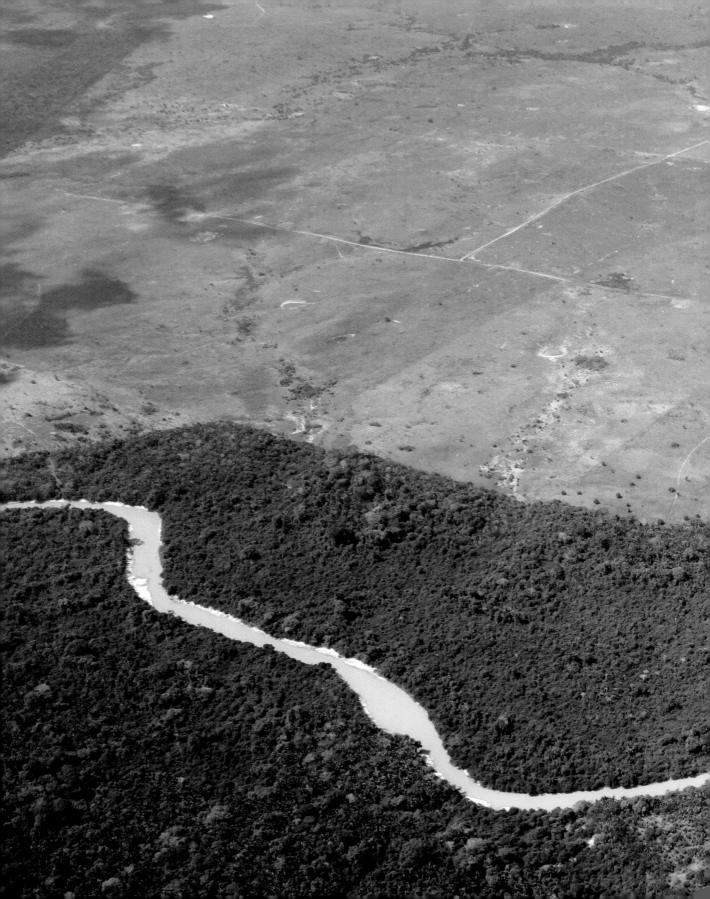

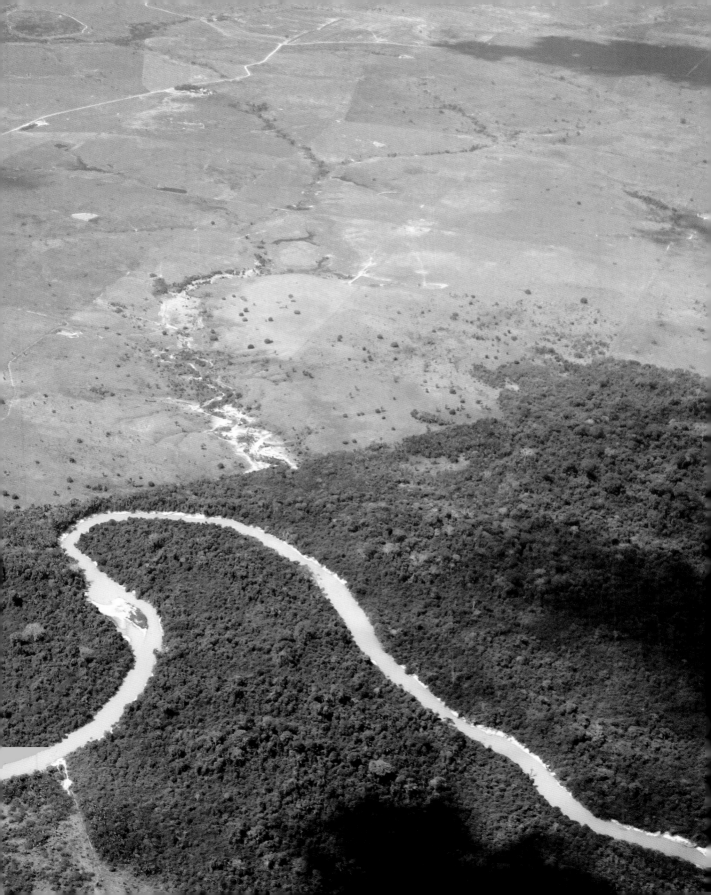

Mosquitoes

This macro photograph of a mosquito reveals the delicate structures on its pair of antenna. The covering of fine hairs are called 'sensilla' and are the sense organs that enable mosquitoes to detect minute concentrations of molecules that include carbon dioxide. They use this to home in on the exhaled breath of humans and other animals from which they get a meal of blood.

Mosquitoes currently lead to the deaths of around one million people every year, as they transmit dengue fever, yellow fever, zika and malaria. It is the change in the distribution of the malaria-carrying anopheles mosquito that represents one of the great unknown risks of climate change. The anopheles mosquito requires hot and humid conditions, so it is very likely that a warmer world will extend its range. As climate change continues, some mountainous areas that are currently free from malaria will see an increase in infections, while the warmer weather at lower altitudes will allow mosquitoes to reproduce more rapidly. Based on current and expected rates of climate change, the area most at risk from increased malaria is the highlands in east Africa.

At the same time, though, some places will become too dry and too warm for mosquitoes, so these areas may see a decrease in infections. Temperatures in areas along the edges of west African deserts, for example, are already near-optimal for the anopheles mosquito. Increased temperatures from further climate change and projected decreases in rainfall would slow their reproduction and could lead to a reduction in the number of malaria infections in these areas.

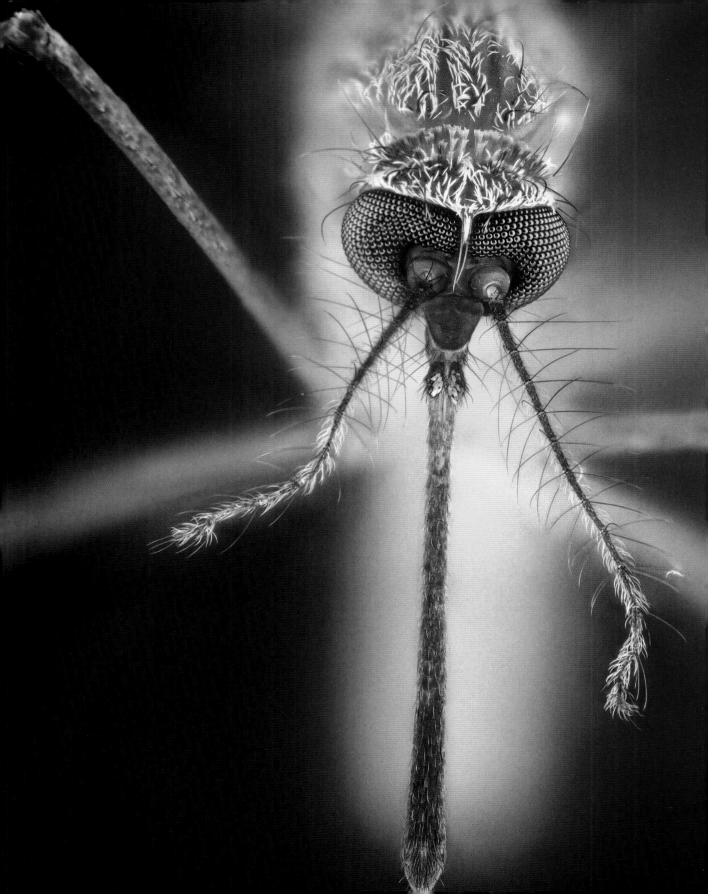

Bengal Tigers

Tigers once ranged widely from Turkey to China, from the foothills of the Himalayas to the islands of Malaysia and Indonesia. But over the past century their numbers have decreased by more than 95 per cent. The Bengal tiger was once widespread across the Indian subcontinent, but there are now thought to be fewer than 2,500 individuals within conservation areas in Nepal, Bangladesh, Bhutan and India. Their numbers have plummeted due to the destruction of their habitat and hunting by humans, but they are now threatened by climate change as well. This is because one of the largest populations of Bengal tigers – perhaps as many as 500 individuals – lives within the Sundarbans, a 4,000 square mile area of marshland straddling Bangladesh and India.

Approximately 70 per cent of the Sundarbans is less than three feet above sea level, making it incredibly vulnerable to rising sea levels. Unless rapid action is taken to reduce the burning of fossil fuels, it is predicted that 96 per cent of the area will be lost by 2070, making it uninhabitable for the tigers. By the end of the twenty-first century many other tiger populations could follow, putting these apex predators at risk of extinction due to rapid human-caused climate change. Having evolved within the relatively stable Holocene climatic period, the Bengal tiger – like many other species – will be unable to adapt quickly enough to the unprecedented changes we are making to the Earth system.

Children »

Children are least responsible for climate change, but are most vulnerable to its impacts. Changes in rainfall and temperature have the potential to devastate harvests and threaten food security. Developing countries in Asia, Africa and Latin America are expected to see their harvests reduced by between 9 and 21 per cent by the 2080s, which could lead quickly to malnutrition among the young. Continuing climate change will also increase the frequency and magnitude of natural disasters, and during floods, droughts and heatwaves it is children (along with the elderly) who are affected most. The need for some people to abandon their land and seek sanctuary – sometimes across international borders – exposes children to further risk.

Beyond the basic needs for survival, climate change also undermines children's opportunities to grow and thrive, as weather-related disasters disrupt education and reduce economic opportunities. Perhaps most importantly, though, climate change disproportionately affects the young because it is over their lifetimes that serious impacts will unfold. Older people have lived most of their lives within a largely stable climate, but continuing climate change is bringing about a 'new normal', in which extreme weather, and the widespread social disruption it brings, is more frequent. It is into this far more turbulent world that babies are being born, and in which children must grow up.

Green Turtles

A single female green turtle can lay hundreds of eggs
in a nesting year, but only around one in a thousand
turtles that hatch will make it to adulthood. Even fewer
will enjoy a life of eighty years or more. The problem is,
their growth and development is fraught with hazards.
In some areas they are hunted for their meat and shells;
their nesting sites are raided by humans and other animals
for highly nutritious turtle eggs; an increasing number of
nesting sites are being disrupted by beach developments;
and more juvenile and adult turtles are suffering the
impacts of ocean plastics and oil spills.

Adding to all of these challenges is human-caused
climate change. As sea levels rise and storms increase
in intensity, some of the turtles' nesting sites are being
washed away, while higher temperatures have been found
to change the turtles' sex ratio. As is the case with many
aquatic and terrestrial reptiles, the sex of developing
turtles is strongly affected by the temperature of the nest.
If the temperature is below 27°C, all of the developing
turtles will be male, but if the temperature is above 31°C,
all will be born female (temperatures that significantly
exceed 31°C can lead to the death of all the developing
embryos). Usually, the temperature fluctuates between
these two extremes, so an approximately equal sex ratio
is produced. However, warmer global temperatures
are increasing the ratio of female-to-male turtles, with
research at the northern Great Barrier Reef revealing that
99 per cent of non-adult green turtles in the region are
female. If the average global temperature were to increase
beyond 2.5°C by the end of the century, this could
further increase the ratio of female turtles, potentially
leading to population extinction, both at the Great
Barrier Reef and further afield.

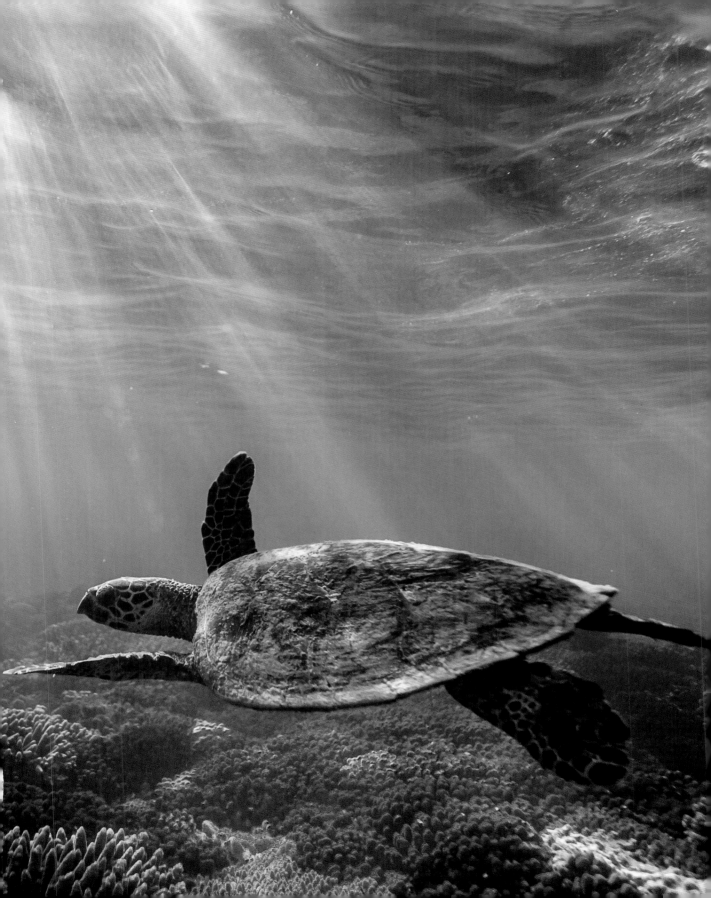

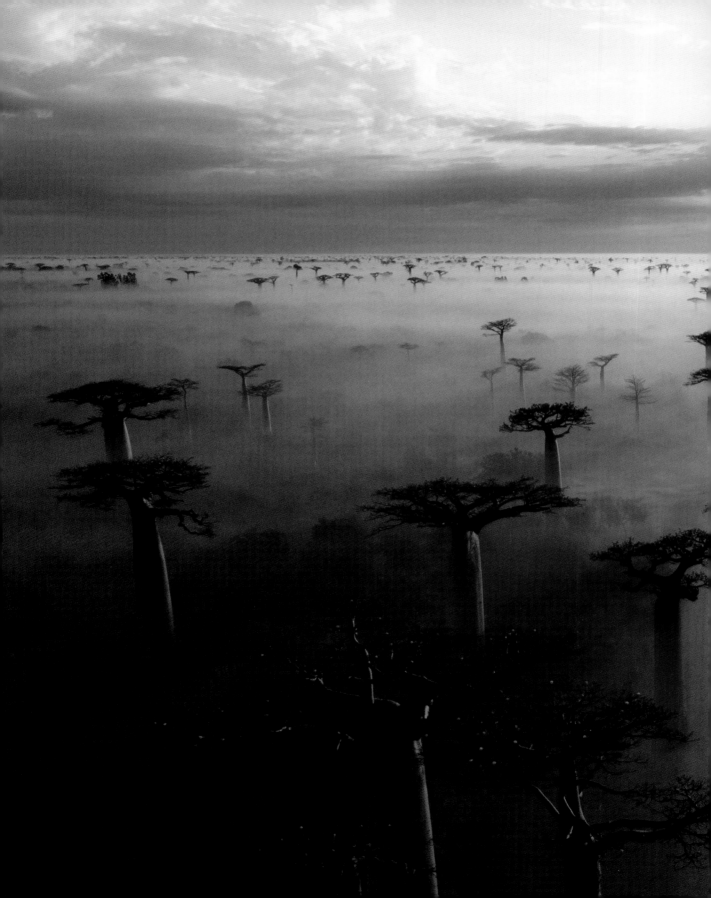

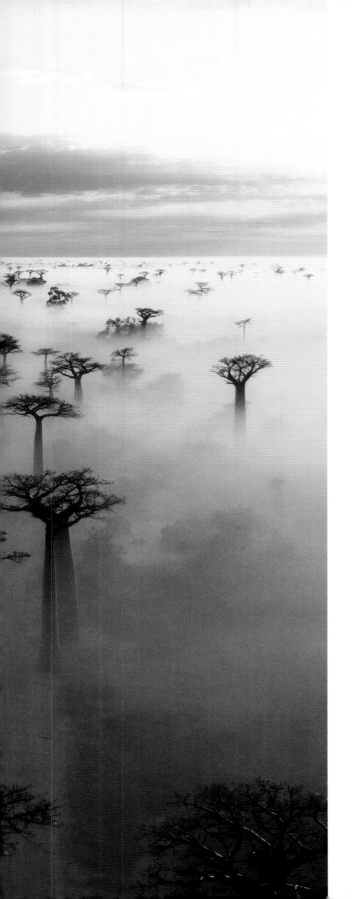

Baobab Trees

Baobab trees are among the oldest living organisms on the planet. As of July 2020, there were considered to be eight baobab species, six of which grow in Madagascar, one is native to Australia and the last is confined to Africa and the Arabian Peninsula. The trees thrive in the harsh, hot and dry conditions of these regions thanks to long roots that can draw up moisture from deep in the soil, and leaves that are shed during dry seasonal weather in order to conserve water.

Yet despite such adaptations there are indications that baobab trees may be critically vulnerable to climate change. In Africa, nine of the thirteen oldest baobab trees died between 2005 and 2020, some of which were 2,500 years old. It is thought that this could be due to changes in rainfall produced by the preceding 250 years of human-driven climate change. While some species can respond to climate change by moving to cooler or wetter areas, baobab trees are confined to protected parks, with human land use outside these parks preventing new seedlings from becoming established. Just as important, the giant tortoise and elephant birds that once ate the baobab fruit and distributed its seeds have become extinct, preventing another means of dispersal. As a result, two of Madagascar's baobab species are now recognized as being vulnerable to rapidly warming conditions. If temperatures and rainfall patterns continue to change, these trees may vanish completely by the end of the twenty-first century.

Hothouse Earth

Since the Industrial Revolution, humans have increased the average temperature of the planet by 1°C. We can already see the consequences of this additional energy in the climate system, with more intense heatwaves, wildfires and floods. But how much warmer will it get over the course of the rest of the century? How much worse could it get? Despite tremendous progress in our scientific understanding this is a question we still cannot answer, because future warming will be driven by future emissions, and it is unclear what those will be.

In 2015 the international community agreed for the first time to restrict emissions of greenhouse gases to limit warming to 2°C, yet the annual emissions of carbon dioxide continue to rise each year. Rapidly decarbonizing our societies is an unprecedented challenge that requires international cooperation. In order to continue the process of development that could lift very large numbers of people out of poverty, we know that some low-income countries will need to increase the amounts of fossil fuels they burn, and increase their currently very small carbon

emissions. But this demands more rapid decarbonization in rich, industrialized nations.

If global emissions of greenhouse gases reach 'net zero' before the middle of the twenty-first century, there is a good chance we will limit warming to no more than 2°C. The term 'net zero' does not mean all burning of coal, oil and gas will end, but that for every ton of carbon dioxide released into the atmosphere, another ton is removed. This could be achieved through mass tree-planting programmes that reforest large swathes of the tropics, or high-tech schemes that take carbon dioxide from the air, compress it, and then store it deep beneath the planet's surface in depleted gas and oil fields. Most likely, a mix of methods will be needed at vast scales.

But what if we don't reach this target? What if we continue to burn fossil fuels and drive global heating? It is important to understand that incremental increases in carbon dioxide concentrations may not produce smooth rises in temperature. There is a danger that we may trigger reinforcing processes in the climate

2100
If the 2015 Paris Agreement objectives are met, the amount of carbon is now beginning to decrease and the global temperature increase is limited to 2°C above pre-industrial levels.

2100
If the climate policies of 2020 continue for the rest of the century, warming could be 3°C above pre-industrial levels. Multi-regional crop failures are increasing, as are devastating storm surges and deadly heatwaves, while migration from low-lying regions is increasing.

2130
An increase of 5°C exceeds the permafrost tipping point, which starts to thaw, releasing methane and CO_2 into the atmosphere.

2100
If carbon emissions remain unchecked, multiple tipping points in the climate system are passed, rapidly heating the climate by 5°C. Many industries collapse, leading to mass migration, mass famine and an unprecedented loss of human life.

2120
Virtually all Alpine glaciers have retreated from valleys and are limited to high altitudes, impacting on the water security of more than 100 million people across the European continent.

2150
Near complete loss of global coral reefs from bleaching and ocean acidification. Most coral reefs were heading for destruction when warming passed 1.5°C.

system that greatly amplify the warming we produce. The melting of Arctic sea ice is already producing an amplifying warming effect, as it exposes darker sea water that absorbs more heat and increases temperatures further. We may also have already initiated tipping points in parts of the Greenland and Antarctic ice sheets, so even if temperatures were stabilized at current levels, vast amounts of ice will continue to melt, raising global sea levels by many feet. Although this would be a very slow process that unfolds over thousands of years, other tipping points could spin up far more rapidly. The continued destruction of the Amazon rainforest, in conjunction with hotter and drier conditions, could quickly flip the region into a savannah. The permafrosts in the far north are already beginning to melt, and as they do they will release large amounts of methane that will increase temperatures even further. Meanwhile, large inputs of meltwater from the Greenland ice sheet could abruptly shut off the ocean currents that transport huge amounts of heat from the equator northwards.

There is an increasing amount of research that indicates climate tipping points could interact in ways that amplify warming across the globe. This would tip Earth's climate towards a 'hothouse' state in which the average temperature by 2100 is 4°C higher than pre-industrial levels. Humans and many other species have never experienced such rapid global warming. We would see collapsing food production, entire regions in the tropics becoming uninhabitable, a global population reduced to three billion people and a mass extinction rivalling anything the biosphere has experienced for many tens of millions of years.

It was Professor Hans Joachim Schellnhuber who best captured the contrasts between our current climate and a hothouse world. When asked what the difference was between 2°C and 4°C of warming his answer was as concise as it was chilling: 'Civilization'.

2300
The biosphere is deep within a mass extinction event driven by habitat loss and runaway climate change. One in six of all land and ocean species is threatened with extinction. There is a widespread collapse of ecosystems across the globe.

3000
As sea levels rise by 30 feet, two-thirds of the world's mega-cities – currently home to 1 billion people – will be submerged.

100Ka (kilo annum)
If carbon emissions halt sometime before the end of the twenty-second century, global geological carbon sinks restore atmospheric concentration to pre-industrial periods.

2200
Most of Earth's tropical rainforests have been destroyed. Reinforcing feedbacks between tree loss and further warming produces a rapid period of deforestation, with these previously large stores of carbon now releasing carbon dioxide into Earth's atmosphere.

2500
The complete collapse of the West Antarctic Ice Sheet raises global sea levels by an additional 15 feet.

4000
Tipping points triggered in the early twenty-first century have produced runaway melting in vast sections of the Antarctic ice sheet. Global sea levels have risen over 65 feet.

5Ma (mega-annum)
The total number of species recover to pre-industrial levels after human impacts are finally absorbed by the Earth system. Depending on the intensity of the human-caused mass extinction event, this point in the biosphere's history may be reached a few million years sooner, or tens of millions of years later.

*** ALL FUTURE EVENTS ARE BASED ON CURRENT RESEARCH ABOUT POSSIBLE SCENARIOS – THEY WILL BE STRONGLY AFFECTED BY HOW MUCH CARBON HUMANITY EMITS IN THE TWENTY-FIRST CENTURY**

Emperor Penguins

The fortunes of the Antarctic emperor penguin are entwined with the ice upon which it lives. Standing over three feet tall, and weighing up to 90 pounds, it is the largest of all penguin species and the only one to breed during the Antarctic winter. As such, it relies on stable ice sheets to raise its young. Research into the vulnerability of emperor penguins to climate change shows that the continued emission of greenhouse gases at current rates would produce warming that would significantly destabilize much of the Antarctic ice sheet that the penguins use as their breeding grounds. If emissions continue to increase as they have done, or if tipping points are passed that further increase the release of greenhouse gases, 80 per cent of all Antarctic colonies will be lost by 2100, putting this species on the path to extinction. Even if temperature increases are limited to no more than 2°C, approximately one third of all colonies would still be lost over the same timescale.

Living in Floodwaters

After days of torrential rain in 2011, the roads on the outskirts of Bangkok, Thailand, were transformed into canals. Boats became the only means of transport and the lives of more than 9 million people were disrupted for several weeks. As sea levels rise these periods of flooding are likely to increase unless natural catchment areas can be expanded, flood embankments raised and more underground drainage built. But civil engineering at such a scale would consume a significant proportion of the country's economy, and such intensive climate change adaptation is currently unaffordable. This is the same situation faced by many nations threatened by rising sea levels.

Assuming our climate impacts are reduced significantly, by the end of the twenty-first century it is estimated that more than 200 million people could live in areas that are permanently below the high-tide line. However, under high-emission scenarios this figure increases to 630 million people living on land below projected annual flood levels. This means that sea-level rise could be one of the biggest drivers of migration over the course of this century and beyond, with climate change causing the greatest movement of people in all of human history. The scale of the subsequent humanitarian challenge is hard to calculate; about the only thing we can be certain of is that it would dwarf all contemporary refugee crises.

Algeria

The oasis garden of Adjder spans the horizon 60 miles
north-west of the town of Timimoun, in south-central
Algeria. Maintained for hundreds of years, the gardens
have provided vital food in an otherwise inhospitable
landscape. The sculpted edges of each garden are created
by sand fences constructed along their border, which
prevent wind-blown sand from burying the garden. The
gardens themselves are composed of hardy palm trees,
below which vegetables are grown. Water is drawn from
underground for the crops, but recent strains on the water
supply have led to water levels dropping. Whereas the
water table was once around 15 feet beneath the sands,
it now lies more than 50 feet below the surface, which
means electric pumps have replaced people and cattle for
raising and lowering buckets.

As climate change continues, Algeria faces an
uncertain future. An average temperature increase of at
least 2°C seems certain, which would see a 10 to 15 per
cent decrease in rainfall in the country. This translates to
a higher frequency of hotter and drier periods, which will
put further pressure on the region's already very limited
water resources.

Water

At current rates of change, it is predicted that around 85 per cent of the global population will be living in cities by the end of the twenty-first century. Large cities already consume vast quantities of resources, but the projected increase in the total number of people will place a strain on water systems. Beyond the need to grow more food (which requires more water), there is likely to be a rise in per capita consumption, as a larger number of people will be living water-intensive lifestyles that include watering gardens, cleaning cars, and using washing machines and dishwashers. In some areas, rapidly developing economies will also result in more industry, with manufacturing plants potentially diverting water resources away from agriculture and human consumption.

At the same time as demand increases, so climate change risks disrupting the already fragile sources of fresh water. Although it is anticipated that the amount of water vapour in the air will increase as the climate warms, it is also expected that we will see significant changes in where this moisture condenses and falls as rain. It is likely that a general trend of wet places becoming wetter and dry places becoming drier will develop over the course of the twenty-first century. The future challenge, therefore, is not that the amount of freshwater will decrease, but that it may no longer be where it is needed the most.

It was the promise of diamonds that drew people to this barren spot in the Namib desert, six miles inland from the port town of Luderitz. The first significant finds came in the early 1900s, at which point the town of Kolmanskop rose from the desert, rapidly expanding as miners, and then the services they required, moved to the area. However, as richer diamond mines developed further south, the town's residents left to pursue their fortunes elsewhere. By 1956, Kolmanskop had been abandoned to face the elements in one of the world's oldest deserts.

For the past 55 million years, thousands of square miles along the coast of Namibia have been almost devoid of vegetation, making the Namib a hyper-arid dryland. Drylands are characterized by a scarcity of water and encompass grassland, savannahs and Mediterranean climates. Dryland soils are often very vulnerable to wind and water erosion, and what little soil there is will have low concentrations of organic content, making farming exceptionally challenging. Despite this, drylands are home to 3 billion people around the world, who are among the most vulnerable to climate change.

Most of the cultures and societies living in dryland regions have adapted their way of life to the hot and dry conditions over many thousands of years, and any rapid environmental change risks outpacing their ability to readjust. As human-caused climate change continues, so will the frequency and intensity of heatwaves and droughts, and this will narrow – and in some places completely close – the ecological niche within which people can continue to live. More extreme climate impacts may even produce temperatures that exceed the physiological limits of the human body, leading to more dryland villages and even large towns finding themselves abandoned over the course of the twenty-first century.

Fishing

Approximately 3 billion people around the world rely on wild-caught and farmed seafood as their main source of protein – in Asia, 22 per cent of all protein consumed comes from fish. However, climate change is producing multiple stressors to marine and freshwater fisheries across the planet. Rising sea temperatures are radically altering life in the sea and in freshwater lakes, leading to some species migrating to higher latitudes, which profoundly affects their distribution.

However, climate change impacts go beyond increasing water temperatures. Approximately 30 to 40 per cent of the carbon dioxide that humans have emitted has been dissolved in the world's oceans, rivers and lakes. Although this has reduced our warming impacts, it has also increased the acidity of the oceans, as carbon dioxide reacts with water to form carbonic acid. Many of the tiny animal zooplankton that are at the bottom of marine food chains have calcium shells, so as ocean water becomes more acidic, it is becoming harder for these organisms to form shells; high levels of acidity will quite literally dissolve them. This has the potential to disrupt and even collapse large marine ecosystems, and with it the fisheries that humans rely on.

Meanwhile, changing rainfall is producing droughts and floods that can devastate stocks of freshwater fish. Dip nets were once a common sight along Vietnam's Mekong Delta, as seen here in 1991, but as drought affects the water flow, so fishing has become less sustainable. These impacts are compounded as they are unfolding at a time when food security is being stressed by disruption to land-based agriculture, as well as by a continuing increase in the global population.

Plagues of Locusts >>

Swarms of locusts have been a threat to food security since biblical times, but the autumn of 2019 saw unprecedented numbers of the insects sweep across many eastern African nations. A locust is capable of eating its own body weight every day, which in isolation amounts to less than one tenth of an ounce. However, in a swarm they can devour vast areas, with 40 million locusts consuming the same amount of food in one day as 35,000 people. In 2019, one particular swarm in Kenya was estimated to be more than 35 miles long and around 25 miles wide, which means it would have contained up to 20 billion individual insects. Together, they decimated hundreds of thousands of hectares of crops.

The vast numbers were the result of an unusually wet period in 2018, followed by a very mild winter, and demonstrate that while climate change is emerging as one of the greatest threats to biodiversity on the planet, some species will prosper in a much warmer world. Insects such as locusts can take advantage of the changing conditions to multiply at astronomical rates – in just nine months, the number of east African locusts rose 8,000-fold. A continued increase in the frequency of cyclones in east Africa will potentially lead to plagues of locusts on an even greater scale, which could prove disastrous to the food security of hundreds of millions of people living on the African continent.

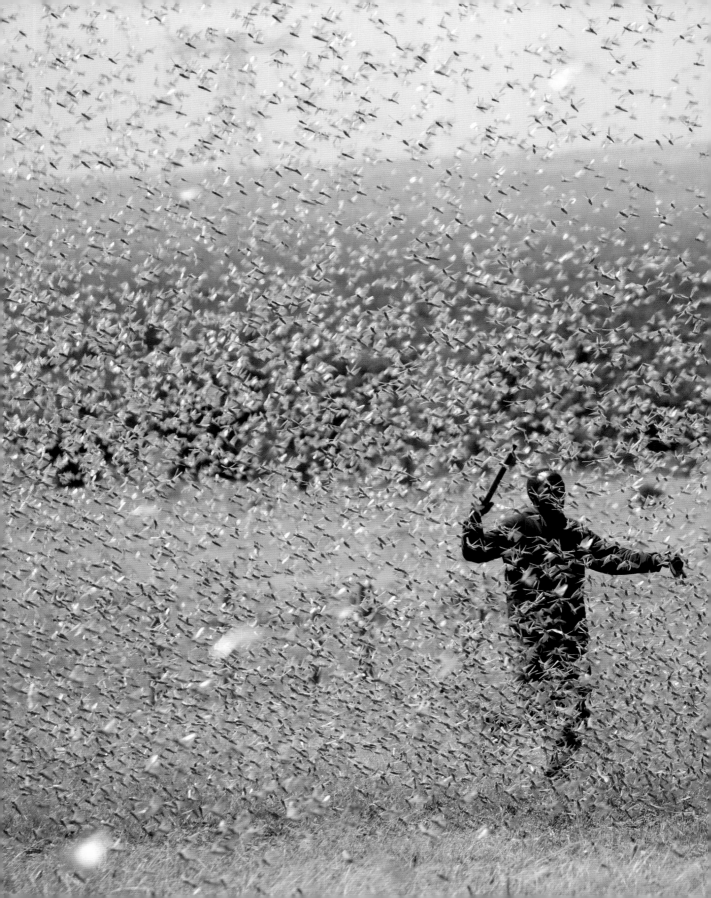

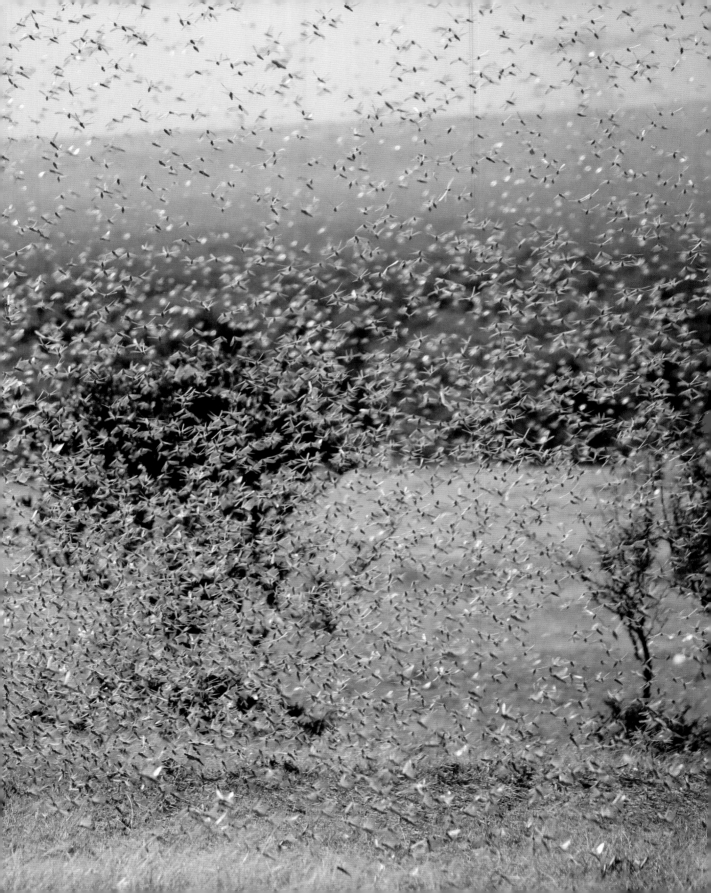

Arctic Oil

In this photograph, excess gas is flared from an oil rig in the ice-strewn Beaufort Sea, located in the Arctic Ocean off the coast of Yukon, Canada, and Alaska, USA. Despite the harsh conditions that make fossil fuel extraction dangerous and expensive, the Beaufort Sea turned rapidly into an important oil and gas field. Since it was first surveyed in the 1950s, a number of large reserves have been discovered, and these are now being developed by an international consortium of energy companies.

However, the oil and gas operations in the region are starting to be threatened by climate change that has in part – and somewhat ironically – been produced by the burning of oil. Vital infrastructure that was built in some Arctic locations is now becoming unstable, as it is constructed on melting permafrost or on the ice itself. Should this destabilization continue, extensive and expensive relocation programmes may be required.

At the same time, continued climate change over longer timescales could open up the Arctic region to further drilling. The U.S. Geological Survey has estimated that the Arctic contains 22 per cent of the Earth's remaining fossil fuels, including 90 billion barrels of oil, 44 billion barrels of natural gas liquids and almost 12,000 cubic miles of natural gas. As the amount of sea ice decreases, regions of the Arctic Ocean are starting to open up to ships and drilling rigs. This will decrease the costs associated with new exploratory surveys and drilling, and the subsequent full-scale commercial development of large oil and gas fields.

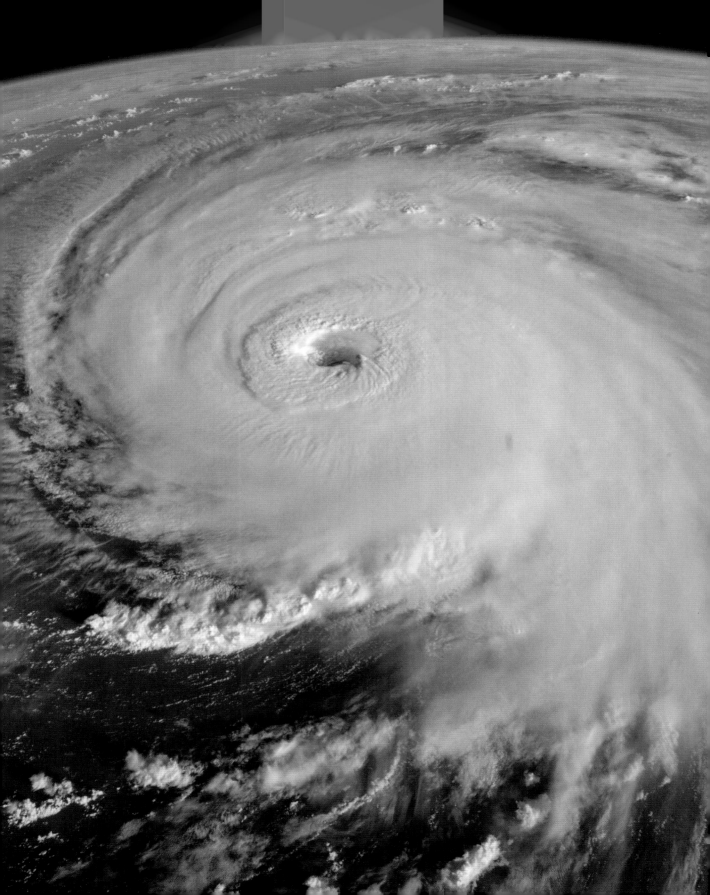

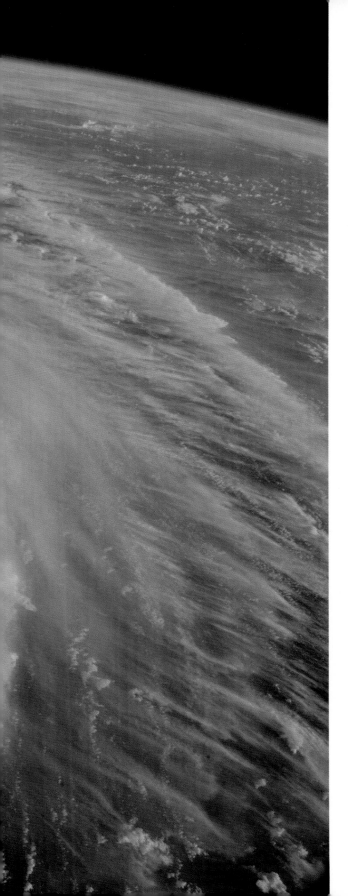

Hurricanes

Hurricanes are perhaps the most spectacular manifestation of climate change, as they transfer the thermal energy of surface water into the kinetic energy of high-speed winds. While hurricanes have been a constant feature of Earth's climate, climate change is producing higher sea temperatures, which is being translated into more destructive hurricane winds. The intensity of hurricanes is measured by the Saffir-Simpson hurricane wind scale, which starts with Category 1 storms that generate sustained wind speeds of between 74mph and 95mph, and runs through to Category 5 hurricanes, which have sustained wind speeds in excess of 157mph and produce catastrophic damage. The hurricane shown here – photographed from the International Space Station – is Hurricane Florence, which was a Category 4 hurricane that particularly impacted North and South Carolina in the USA in September 2018.

When the Saffir-Simpson scale was devised in the 1970s, meteorologists assumed that five categories would be sufficient, and that while some hurricanes might produce wind speeds significantly in excess of 157mph, these would be so infrequent that there would be no need to add further categories to the scale. However, raised sea-surface temperatures caused by climate change, and an increased amount of water vapour in the atmosphere are now increasing the size and intensity of hurricanes. Over the past 30 years, the proportion of tropical storms that have rapidly strengthened into powerful hurricanes has tripled. In October 2015, Hurricane Patricia underwent explosive intensification, transforming from a tropical storm into a massive hurricane in near-record time. With a sustained wind speed of 215mph as it moved across the eastern Pacific, close to Mexico, it was the most intense tropical cyclone ever recorded in the Western Hemisphere. It will not be the last.

Air Conditioning

There are currently around 1 billion air-conditioning units in use around the world, and at current rates of increase this will rise to more than 4.5 billion units by the middle of the twenty-first century. At that point, air conditioning will be one of the largest consumers of electricity, as cooling air is an energy intensive process: a unit that can manage the temperature of a living room requires the same amount of energy as four domestic refrigerators, while air conditioning for an average-sized house is the same as running fifteen fridges. Such is the current demand for air conditioning that every year it consumes the same amount of power that is generated by the entire electricity sector of the UK. The USA currently leads the world in energy consumption for air conditioning, although during the Chinese heatwave of 2018, almost half of the electricity generated for the capital city, Beijing, was being used to power air-conditioning units.

As Earth continues to warm, it is inevitable that more air-conditioning units will be used in an attempt to manage rising temperatures. However, if the electricity used to power these units continues to be supplied by fossil fuels, this will drive climate change and increase temperatures further. This type of reinforcing loop will work in addition to reinforcing loops in the physical climate system, such as the reduction in ice at higher latitudes, which will also raise temperatures. The result? An even greater reliance on air conditioning.

Watermelon Snow

During the summer of 2020, large areas of the Presena Glacier's surface turned from their usually pristine white to a shade of pink. Lying more than 10,000 feet above sea level in the Italian Dolomite mountains, this phenomenon went unnoticed to most people, but it is something that has been observed in ice sheets around the world since the time of Aristotle. The cause is thought to be a bloom of algae that lives on snow and ice. The red colour introduced by pigments in the algae helps protect the organisms from intense sunlight and also gives the sight its alternative name – 'watermelon snow'.

It was the intensity of the Presena Glacier event that captured the interest of scientists studying climate change. A large algal bloom such as this will make the surface of the ice darker, which means it absorbs more of the energy from the Sun, raising the temperature of the ice. This increases the rate of ice melt of a glacier that is already accelerating as a consequence of climate change.

Previously, it had been assumed that any change in the reflectivity of the ice and snow surface was caused by increased soot from forest fires or dust released by drier conditions. However, recent research suggests that glacial algae may be the most important factor behind increased darkening of the Greenland ice sheet, and this may be having a significant warming effect. If that applies to other ice sheets around the world, these tiny photosynthetic organisms could be making a huge impact on the global climate.

Urban Heat Island Effect

Greater Los Angeles is the third-largest urban area in the world, and the homes, offices, factories, freeways and airports of its 18 million inhabitants cover almost 34,000 square miles along the coast of California. This region is already experiencing clear climate impacts, with more intense droughts and floods, and record-breaking heatwaves becoming more frequent. These are being compounded within Los Angeles by the urban heat island effect, as the tarmac, tile and concrete that covers urban areas absorbs far more heat from the Sun than grasslands or forests. Natural ecosystems are also cooler because of evapotranspiration, which is the process of evaporation from plants and soil; this moist air significantly cools the surface as it rises.

As climate change continues, some urban areas will see temperatures increase much faster than the global average, and this will be happening at the same time as rapid urbanization. Today, around 4 billion people across the planet live in urban areas, but this number is likely to increase to around 6 or 7 billion by the middle of the twenty-first century. By then, global temperatures may have increased by 2°C, and in some cities the urban heat island effect would add an extra 1°C or 2°C, leading to potentially lethal temperatures. Increasing the amount of green space within cities is one way that these temperatures could be countered, but this would also increase water demand – and water is already expected to come under increasing stress as more and more people migrate to these populous areas.

Fire Season

Climate change is heightening the fire season across multiple continents. Longer periods of high temperatures, combined with low humidity and less rainfall mean the annual periods over which significant wildfires break out are now 20 per cent longer than they were in the middle of the twentieth century. As climate change continues, so the intensity and destructive impact of these fires will increase: the unprecedented bushfires that ravaged millions of acres of eastern Australia during 2019 and 2020 are now on course to become the new normal. These particular fires were produced by temperatures that are currently considered 'extreme', but by the time the climate has warmed by 2°C or 3°C such conditions will become unremarkable. Indeed, intense wildfires like this blaze in Australia's Blue Mountains may be presenting us with a glimpse of what our world could look like before the end of the twenty-first century.

Forest management techniques, such as controlled burns that reduce the amount of fuel available to wildfires, will continue to be crucial in reducing the worst impacts, while the increased application of planning laws that keep homes away from forests can mitigate the risk that people face. But unless concentrations of greenhouse gases in the atmosphere are stabilized, climate change will continue to produce ever-more destructive fires. By 2050, the amount of destruction produced by wildfires is expected to double, and if the climate warms beyond 2°C then every additional degree of warming could produce wildfires that are four times more destructive. Under such conditions, the only option left for many communities would be to abandon their homes.

COVID-19 >> >>

Iconic locations around the world stood empty during lockdowns imposed as a response to the COVID-19 pandemic in 2020. As economies ground to a halt, carbon dioxide emissions plummeted, but this did not have any impact on climate change. Only significant and sustained reductions in carbon emissions will begin to stabilize concentrations of greenhouse gases in the atmosphere, and until that happens, temperatures will continue to rise.

Additional warming takes the climate system ever-closer to tipping points that have the potential to amplify our effects on the Earth system. Rapid climate change beyond 3°C could collapse our globalized, industrialized economies, while warming at, or greater than, 4°C within the next 100 years could result in the concentration of significant human populations to the far north and south, with large tropical regions abandoned. In this scenario, Earth would no longer be able to sustain today's large human population, which would be reduced to between 3 and 4 billion people.

Such a catastrophe is hard to imagine, yet despite such looming risks, mainstream economic policies continue to be steered by the desire to maintain growth, rather than reducing our impacts on the climate. The central assumption is that decreasing carbon emissions quickly would produce a drag on economic growth. But the inherent risk with such an approach is that errors in our calculations, or simple bad luck when it comes to increased natural climate variability, could both have cataclysmic outcomes. It is not impossible that by the end of the twenty-first century the eerie deserted cities experienced during the COVID–19 pandemic could become the norm. Like the Mayan and Khmer temples of the past, our cities could in time become silent reminders of a civilization that no longer exists.

Lisbon, Portugal

Paris, France

Naples, Italy

Moscow, Russia

Picture credits

Alamy Stock Photo: Science History Images **28-29, 96-97**, /Stocktrek Images, Inc. **37t**, /RKive **37b**, /Francesco Gustincich **Cover, 52-53**, /Nature Picture Library **Cover, 54-55**, /National Geographic Image Collection **Cover, 58-59, 172-173**, /Tom Pfeiffer **66-67**, /Alpha Stock **Cover, 72-73**, /Chronicle **78-79**, /Simon Dack Archive **Cover, 100-101**, /ZUMA Press, Inc. **Cover, 150-151**, /Universal Images Group North America LLC **236-237**, /Hemis **246-247**, /Hans Verburg **248-249**, /REUTERS /Stephen Coates **250-251**, /Richard Barnes **284-285**, /Bill Gozansky **286-287**, /REUTERS/Baz Ratner **292-293**, /imageBROKER **298**, /Russian Look Ltd. **312-313**

Abram Powell © Australian Museum **142-143**

Getty Images: Xuanyu Han **14-15**, /@ Mariano Sayno/ husayno.com **20-21**, /Anton Petrus **Cover, 31**, /mammuth **32-33**, /shaunl **38-39**, /Aumphotography **40-41**, /© Marco Bottigelli **43**, /© Rod Strachan **Cover, 44-45**, /Ralph Morse/The LIFE Picture Collection via Getty Images **46-47**, /by Marc Guitard **57**, /The Royal Photographic Society Collection/ Victoria and Albert Museum, London **62-63**, /Education Images/Universal Images Group via Getty Images **64**, /Bettmann **74-75, 77**, /Corbis via Getty Images **80-81**, /W. Eugene Smith/The LIFE Picture Collection via Getty Images **Cover, 84-85**, /ullstein bild/ullstein bild via Getty Images **86**, /Alain Nogues/ Sygma/Sygma via Getty Images **Cover, 90-91, 92-93**, /Dave Einsel/Stringer **108-109**, /Craig Warga/NY Daily News Archive via Getty Images **Cover, 112-113**, /Mint

Images - Art Wolfe **Cover, 114-115**, /-/AFP via Getty Images **Cover, 116**, /Milos Bicanski/Stringer **118-119**, /Matt Blyth **Cover, 120-121**, /Justin Sullivan **123**, /Per-Anders Pettersson **124-125**, /Carl Juste/Miami Herald/Tribune News Service via Getty Images **128-129**, /Mario Tama **130-131**, /Nathan Blaney **Cover, 133**, /KARL-JOSEF HILDENBRAND/DPA/AFP via Getty Images **134-135**, /Dan Kitwood **136-137, 139**, /Citizens of the Planet/Education Images/Universal Images Group via Getty Images **140-141**, /JUSTIN TALLIS/AFP via Getty Images **Cover, 144-145**, /Ben Nelms/Bloomberg via Getty Images **146-147**, /Darryl Dyck/Bloomberg via Getty Images **Cover, 148-149**, /K M Asad/LightRocket via Getty Images **Cover, 152**, /Zakir Chowdhury/Barcroft Media via Getty Images **Cover, 154-155**, /MARCO BERTORELLO/AFP via Getty Images **156-157**, /DigitalGlobe via Getty Images **160-161**, /Visual China Group via Getty Images **162-163**, /Owen Vachell **164-165**, /MAJA SUSLIN/AFP via Getty Images **166-167**, /ANGELOS TZORTZINIS/AFP via Getty Images **168-169, 170-171**, /AFP PHOTO / ALEXANDER GRIR via Getty Images **174-175**, /JOSH EDELSON/AFP via Getty Images **178-179**, /Justin Sullivan **180-181**, /Rodrigo Friscione **182-183**, /Stuart Hendrie **185** /Ulet Ifansasti/ Stringer **190-191**, /Giacomo Cosua/NurPhoto via Getty Images **Cover, 192-193, 195t, 195b**, /Alexis Rosenfeld **Cover, 198, 200-201**, /Rebecca L. Latson **203**, /ZINYANGE AUNTONY/AFP via Getty Images **204, 206-207**, /David Gray **Cover, 208-209**, /Wolter Peeters/The Sydney Morning Herald via Getty Images **210**, /Kate Geraghty/The Sydney Morning Herald via Getty Images **212-213**, /John Moore **214-215**,

Index

Acknowledgements

This book captures a tiny fragment of the knowledge that has been generated by thousands of scientists over centuries of enquiry. It is my great fortune that some of these scientists are my colleagues and friends. They, along with my students, have taught me so much. Many years before any evidence of academic ability, my parents kept their faith in me and gave me the opportunities that I did not deserve. They never stopped believing. Writing a book about possible climate catastrophes during a global pandemic was at times a struggle. In this and all other endeavours I was powered by the strong nuclear force generated by
Alex, Leo and Mandi.